REVEALING KRISHNA

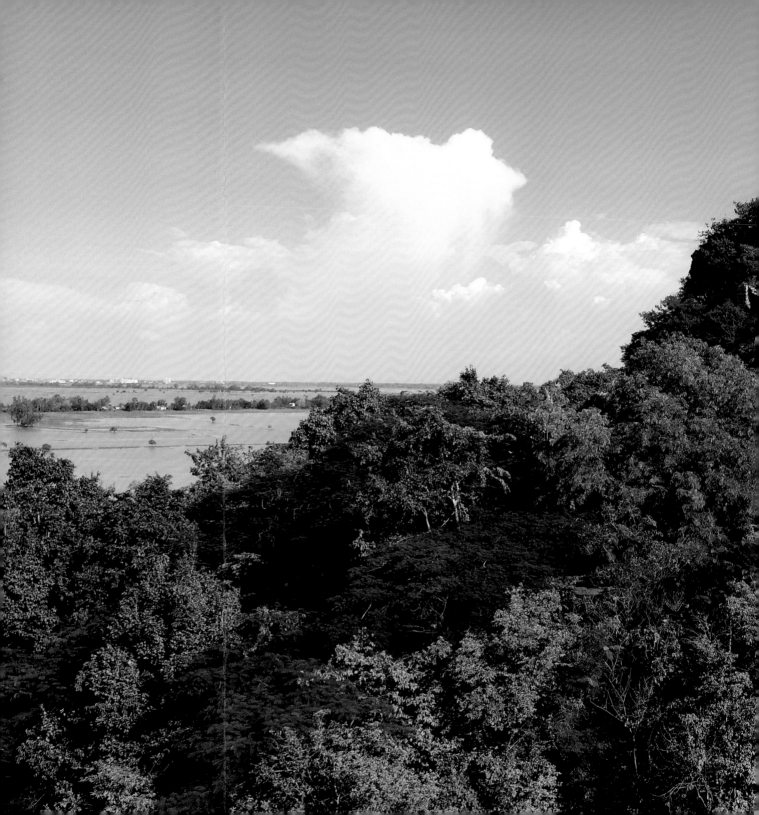

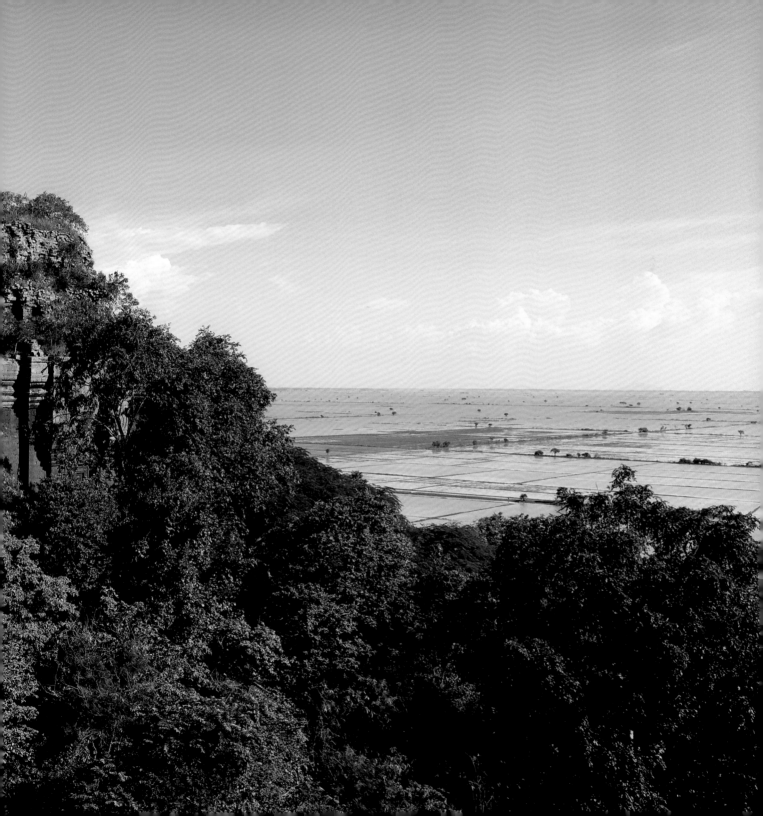

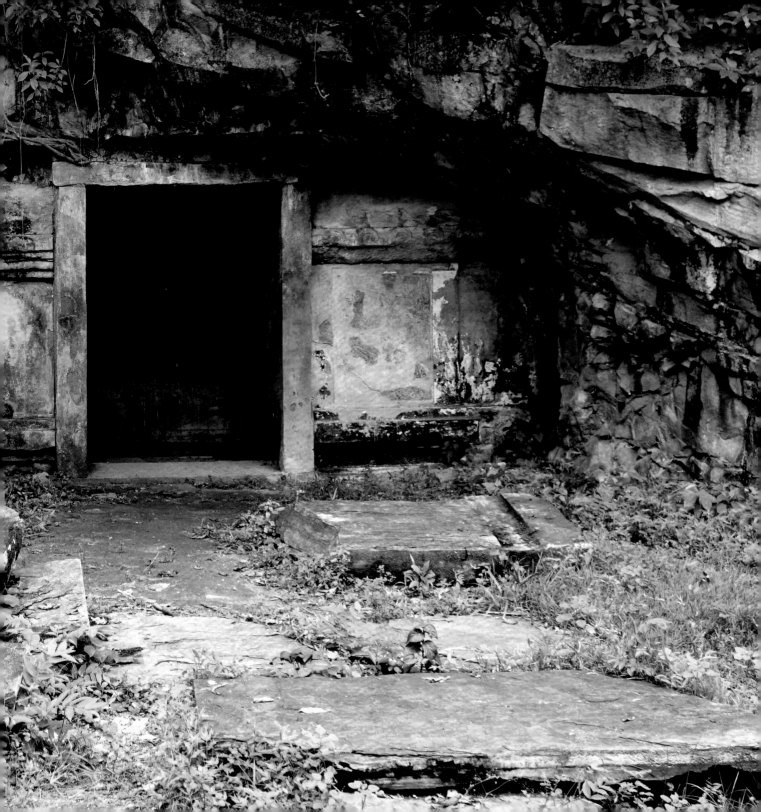

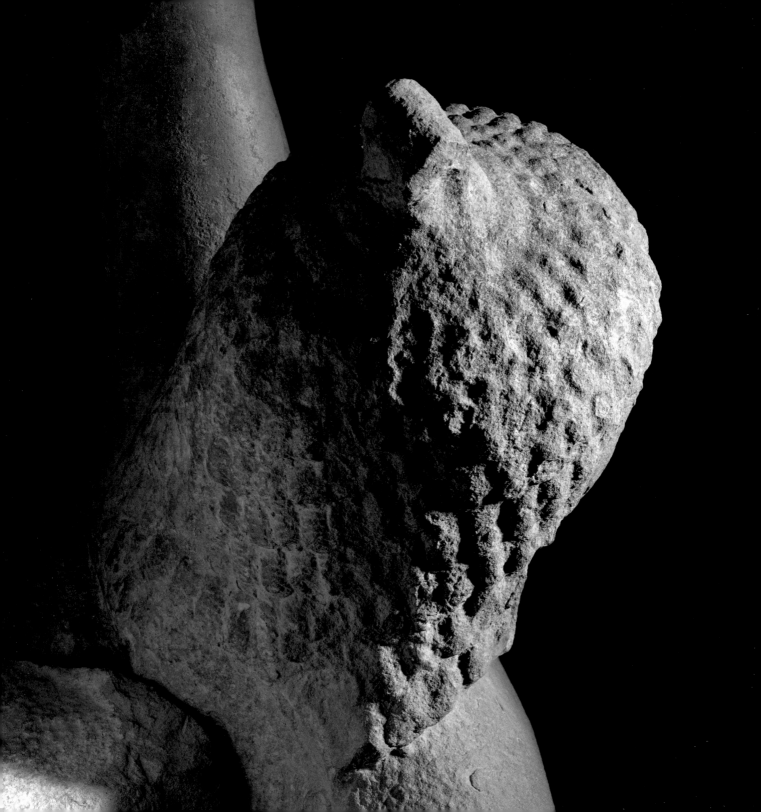

REVEALING KRISHNA

Essays on the History, Context, and Conservation of *Krishna Lifting Mount Govardhan* from Phnom Da

EDITED BY SONYA RHIE MACE AND BERTRAND PORTE

The Cleveland Museum of Art in association with D Giles Limited, London

For
Robert L. Brown
with felicitations on his retirement

THIS PUBLICATION IS MADE POSSIBLE
IN PART BY THE ANDREW W. MELLON
FOUNDATION.

Published in association with D Giles Limited
on the occasion of the exhibition *Revealing
Krishna: Journey to Cambodia's Sacred Mountain*,
on view at the Cleveland Museum of Art from
November 14, 2021, to January 30, 2022.

ISBN 978-1-911282-78-5

Library of Congress Control Number:
2021901144

NOTE TO READERS: When Cambodian
surnames precede given names, they appear in
capital letters in this book. All measurements
are in centimeters or meters; height precedes
width precedes depth.

Produced by the Cleveland Museum of Art
Thomas Barnard, Director of Publications
Exhibition managed by Mollie Armstrong
Publication managed by Rachel Beamer
Edited by Amy Bracken Sparks
Proofread by Kathleen Mills
Indexed by Jonathan Farr
Designed by Thomas Barnard
Maps by Carolyn K. Lewis
Color management by Maurizio Brivio
Printed and bound in Italy by Elcograf S.p.A.

The Cleveland Museum of Art
11150 East Boulevard
Cleveland, OH 44106-1797
www.clevelandart.org

First published in 2021 by GILES,
an imprint of D Giles Limited
66 High Street
Lewes, UK
BN7 1XG
www.gilesltd.com

front and back cover: *Krishna Lifting Mount
Govardhan*, c. 600. Southern Cambodia, Takeo
Province, Phnom Da. Sandstone; 203.1 x 68 x
55.5 cm. The Cleveland Museum of Art, John L.
Severance Fund, 1973.106

pages 2–3: Northeast peak of Phnom Da in
2019. Southern Cambodia, Takeo Province.
Photo: Konstanty Kulik

pages 4–5: Cave D of Phnom Da in 2019.
Southern Cambodia, Takeo Province. Photo:
Konstanty Kulik

The story of the Cleveland Krishna spans five decades of evolving museum practices and conservation discoveries, and more than a century of radical global change. The work discussed in this book and seen in the exhibition foregrounds international and interdisciplinary collaboration, while the installation of the sculpture and related works breaks new ground regarding the presentation of historical context. The Cleveland sculpture is allowed to remain fragmentary, but its display is complemented by innovative digital experiences that show how the sculpture would have looked installed in its cave sanctuary, situated on a mountain rising above the flood plain of the Mekong River delta.

The exhibition *Revealing Krishna: Journey to Cambodia's Sacred Mountain* includes unprecedented loans: the Harihara from the Musée national des arts asiatiques–Guimet, and eight exceptionally important sculptures from the National Museum of Cambodia and the Angkor Borei Museum. Homing in on the site of Phnom Da and its relationship with the nearby ancient city of Angkor Borei, the show offers a focused exploration of ancient Khmer civilization. *Revealing Krishna* presents works excavated from the environs of Angkor Borei made between 550 and 700, along with in-depth presentations on the history and landscape of that area.

The CMA's George P. Bickford Curator of Indian and Southeast Asian Art Sonya Rhie Mace assembled a remarkable team of specialists to contribute their expertise to advancing the study of this foundational subject in the history of Southeast Asian art. Taking the Cleveland Krishna as a starting point, the authors have explored the iconography of the sculpture, the layout of the site from which it came, and its relationship with the other seven monumental images of Vishnu and his incarnations found at Phnom Da. The fascinating history of the discovery in multiple pieces and phases, the work's glamorous provenance, its several restorations and reconstructions, and a scientific analysis of the stone are also included, as well as the CMA's recent reconstruction, the result of decades of research and technological advances. The essays introducing other, contemporaneous works of art from the same region affirm the extraordinary sophistication and diversity of southern Cambodian visual culture in the sixth and seventh centuries, surviving only in traces but including objects made in many materials: stone, metal, and clay. This volume concludes with essays that place Phnom Da

and Angkor Borei as sites of inspiration to the better-known Angkorian world of the ninth to thirteenth centuries.

Without philanthropic and grant support, neither the necessary research, conservation, and collaboration nor the exhibition and publication would have been possible. It is only thanks to a grant from the National Endowment for the Arts, a Bank of America Conservation Grant, the support of our technology partner Microsoft, and the generosity of many individuals and corporations close to the museum that this ambitious project has come to fruition.

It has been an honor for us to work with Her Excellency PHOEURNG Sackona of the Ministry of Culture and Fine Arts of the Kingdom of Cambodia; CHHAY Visoth, director of the National Museum of Cambodia; and KONG Vireak, former director of the National Museum of Cambodia. We are extremely grateful for the enduring trust they have placed in us as partners in our collective effort to care for and share our ever-expanding knowledge of the magnificent arts of Cambodia.

William M. Griswold
Sarah S. and Alexander M. Cutler Director
The Cleveland Museum of Art

The exhibition is organized in cooperation with the Ministry of Culture and Fine Arts of the Government of the Kingdom of Cambodia and in collaboration with the National Museum of Cambodia, the École française d'Extrême-Orient, and the Musée national des arts asiatiques–Guimet.

The Cleveland Museum of Art gratefully acknowledges these valued exhibition sponsors:

Principal support is provided by Rebecca and Irad Carmi, Mary Lynn Durham and William Roj, the Rajadhyaksha Family, and DLZ Corporation. Major support is provided by Raj and Karen Aggarwal, the E. Rhodes and Leona B. Carpenter Foundation, and the Eugene V. and Clare E. Thaw Charitable Trust. Additional support is provided by DLR Group | Westlake Reed Leskosky, Carl T. Jagatich, the John D. Proctor Foundation, Mr. and Mrs. Paul E. Westlake Jr., and in memory of Dr. Norman Zaworski, MD. Generous support is provided by Dr. Michael and Mrs. Catherine Keith.

Official Technology Partner

This exhibition is supported in part by the National Endowment for the Arts.

All exhibitions at the Cleveland Museum of Art are underwritten by the CMA Fund for Exhibitions. Generous annual support is provided by Mr. and Mrs. Walter R. Chapman Jr., Janice Hammond and Edward Hemmelgarn, and the Womens Council of the Cleveland Museum of Art.

We recognize Dr. Gregory M. Videtic and Mr. Christopher R. McCann, who are graciously linked to this exhibition through the Leadership Circle.

The restoration of *Krishna Lifting Mount Govardhan*, expertly undertaken by Cleveland Museum of Art conservation specialists, was funded by a grant from the Bank of America Art Conservation Project.

The HoloLens experience was created in collaboration with Microsoft and the Interactive Commons at Case Western Reserve University.

Water tank with lotus, east of the northeast peak of Phnom Da, August 2019. Photo: Konstanty Kulik

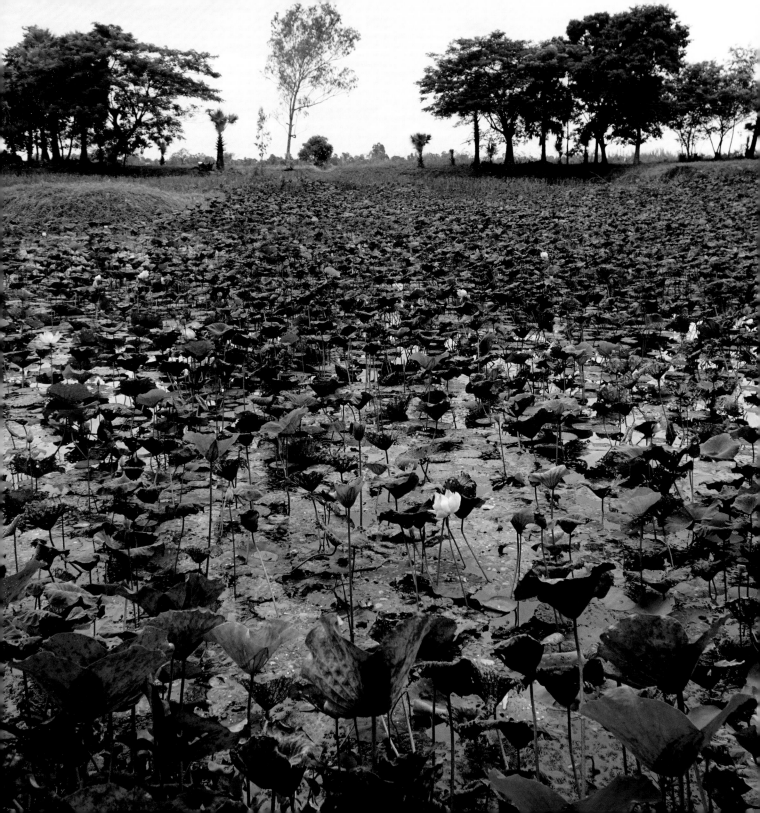

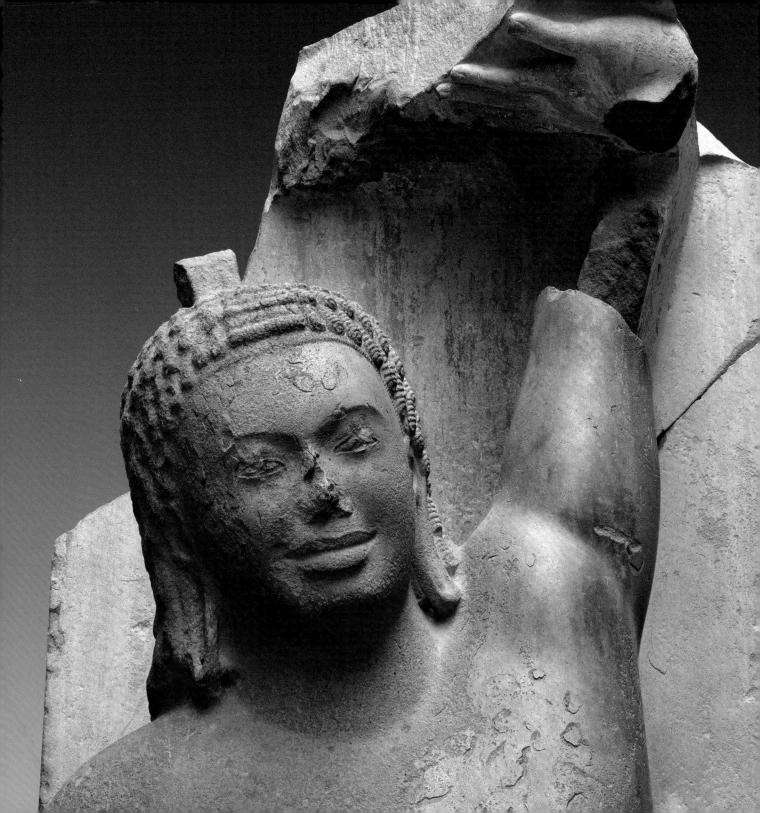

ACKNOWLEDGMENTS

Krishna Lifting Mount Govardhan (detail, pl. 6).

A project the scope and caliber of *Revealing Krishna* comes once in the career of a fortunate curator. Its genesis and success are due first and foremost to Bertrand Porte of the École française d'Extrême-Orient (EFEO) at the National Museum of Cambodia (NMC) in Phnom Penh. As the world's leading specialist in the stone sculpture of Phnom Da and Angkor Borei, his intimate familiarity with the sculptures themselves and knowledge of French and Khmer documents acquired over the course of nearly a quarter century have resulted in his unmatched expertise in this body of material. His essay includes recent discoveries, many published here in English for the first time. We at the Cleveland Museum of Art are thrilled to have his participation as content editor of this publication and to be the beneficiaries of his always reliable and helpful insights that led to the new reconstruction of *Krishna Lifting Mount Govardhan* (pl. 6), the treasure of Cambodian art we hold in our care.

The leadership of the NMC, the Ministry of Culture and Fine Arts of the Kingdom of Cambodia, and the Inter-ministerial Committee for International Loan of Cambodian Works of Art and Antiquities supported our work and approved the incredible loans to the exhibition with a spirit of collaboration and trust for which we are truly honored. With H. E. PHOEURNG Sackona at the helm along with CHHAY Visoth, KONG Vireak, PRAK Sonnara, and OUK Sokha, all international transactions were effected smoothly; thanks also to the efficient assistance of MUONG Chanraksmey. Many members of the Conservation and Education staff at the NMC expended much time and effort, notably co-author CHEA Socheat, HOR Kosal, KHOM Sreymom, KHUN Sathal, NGUON Sophal, PHY Sokhoeun, SOK Soda, and VON Noeun, as well as KEO Touch. Our sincere thanks go too to the members of the staff who stayed after hours for several successive nights while we took the scans and photographs of the sculptures in the NMC. We are extremely grateful to the museum for generously supplying all needed resources and granting the permissions that were necessary for the fulfillment of the project. At the Angkor Borei Museum, CHEA Sambath was our most invaluable and knowledgeable guide to the sites of the region and records of the collections, and we are grateful too to Mrs. CHEA for her beautiful hospitality every day we spent on site. The US Embassy in Phnom Penh provided all the essential diplomatic support under the terms of both Ambassador William Heidt

15

and Patrick Murphy, with NORN Soreimeas, Jay Raman, and Arend Zwartjes ensuring the smooth conclusion to our international collaborative transactions.

In Paris, the unprecedented loan of the Harihara (pl. 2) from Phnom Da was made possible by the support of the director of the Musée national des arts asiatiques–Guimet, Sophie Makariou, and the gracious advocacy of the museum's Curator of Southeast Asian Art Pierre Baptiste. Adil Boulghallat and Laurent Laly carried out the complexities of safely remounting and transporting the fragile stone masterpiece to Cleveland. Pierre and his erudite colleague at the Guimet, Thierry Zéphir, also made major contributions to this book with essays and images that brilliantly contextualize Krishna and the sculptures of Phnom Da in both art and narrative, through time and across geographical regions. I also wish to thank Dominique Reninger for kindly facilitating my access to the photographic archives at the Musée Guimet.

The EFEO, whose members over the last century rigorously documented archaeological discoveries at Phnom Da and Angkor Borei, kept meticulous re-cords without which we would have little information about Krishna and related sculptures and monuments. At the archives in Paris, Clément Frœhlicher-Chaix, Isabelle Poujol, and Rose-Aimée Tixier provided access to the materials we needed to understand the history of discoveries at Phnom Da. The inimitable Charlotte Schmid has been a patient interlocutor, sharing many aspects of her decades of in-depth research in the struggle to understand the early iconography of the gods of Phnom Da.

Thanks to Bertrand's introduction, contributing authors ANG Choulean and Christian Fischer joined our team. Christian produced the scientific analyses we needed to proceed with the long process of reassigning the stone fragments of the Cleveland Krishna, which was the initial inspiration for the exhibition. ANG Choulean's learned anthropological perspective brings this volume's collection of essays full circle by associating Phnom Da with the ancient myth of the origin of the Khmer people and following its elusive thread to stories and practices current in Cambodia today.

Stanislaw Czuma (b. 1935), my esteemed predecessor on whose broad shoulders I stand in our shared mission to bring Krishna closer to whole, gave his insights, recollections, and valuable information every step of the way. I credit Robert L. Brown—in honor of whose recent retirement this book is dedicated—for introducing me to the glories, history, and issues in the study of Southeast Asian art; I rely on his wisdom, guidance, and encouragement to this day. Allison Carter, Elina Gertsman, Phyllis Granoff, Miriam Stark, and Philippe Stoclet shaped my understanding of the history and meaning of Krishna and Phnom Da. Former CMA Director Deborah Gribbon provided exceptional early support. At the Ingalls Library and Archives, Peter Buettner, Leslie Cade,

Matthew Gengler, and especially Beth Owens located all necessary research materials. Further thanks are to be extended to Disapong Netlomwong and Nicolas Revire in Bangkok.

The *Revealing Krishna* project revolves around conservation and how changes in the field over the last century affected the restoration of the Cleveland Krishna and related works of art. For this reason, five conservators (Chea, Edelstein, Porte, Snyder, Sturm) and one conservation scientist (Fischer) contributed to this book. At the CMA in the objects conservation lab, Beth Edelstein, Carlo Maggiora, Margalit Schindler, Colleen Snyder, Samantha Springer, and Amaris Sturm allowed the Krishna project to all but consume their lives for long stretches of time. I am personally overcome with admiration and gratitude for the skill, perseverance, and care they devoted to Krishna. Grants from the Bank of America and the Andrew W. Mellon Foundation largely funded their ability to do so, and successive Directors of Conservation Per Knutås and Sarah Scaturro led them with full support, facilitated by the administrative skills of Joan Bewley and the photographic work of Joan Neubecker. The conservation project benefited greatly from the input of colleagues near and far, with special thanks to Michael Butler, Michael Pollino, and Luke Traverso (Case Western Reserve University [CWRU] Engineering); David Saja (Cleveland Museum of Natural History); Norman Weiss (Columbia University); Erik Risser and William Shelley (Getty Villa); Federico Carò, Carolyn Riccardelli, Debbie Schorsch, and George Wheeler (Metropolitan Museum of Art); and Adam Jenkins.

Digital technologies were indispensable to our solving the disposition of fragments that belong to the Cleveland Krishna but were located in either Cleveland or Phnom Penh. Many friends and colleagues lent their expertise. Beginning in 2014, Marcus Brathwaite, Ian Charnas, Benjamin Guengerich, and Joel Hauerwas of Sears think[box] at CWRU have been constant partners in the world of 3-D scanning and digital modeling. Brian Adkins and Tracy Albers at RP+M handled our large-scale 3-D printing needs. For the magical combinations of photogrammetry and LiDAR scans of the Phnom Da sculptures and Cave D, not to mention the photography, drone footage, and sound captured in Cambodia for the exhibition and the publication, we thank the awe-inspiring David Korzan, Konstanty Kulik, and Michał Mierzejewski of The Farm 51 in Gliwice, Poland. In Phnom Penh, Nicholas Josso completed the all-important scan of the Phnom Penh Krishna. Dale Utt of True Edge Archive refined the 3-D models for the exhibition interactives and produced the digital re-creation of the Cleveland Krishna in Cave D (see fig. 9) with artistry and ingenuity that surpassed all expectations. Raymond Kent filled our spaces with the sounds of Cambodia. We enjoyed the privilege of partnering with Interactive Commons at CWRU headed by Mark Griswold and Erin Henninger, along with James Gasparatos and Henry

Eastman, and working with scriptwriter Nick Fitzhugh for the development of
the HoloLens 2 experience. Their dazzling talents transformed the 3-D models
into the visible dream of holograms, and Microsoft, represented by Ryan Gaspar,
generously donated the hardware. The Digital Innovation and Technology
Services team at the CMA, headed by the indefatigable Jane Alexander with the
assistance of Maddie Armitage, Michael Dreiling, Anna Faxon, Shawn Green,
Haley Kedziora, and Anurag Saxena, coordinated all the digital efforts used
in the conservation, exhibition, and publication. Ethan Holda and Jeff Judge
managed the months-long prototyping of the customized projections in the
exhibition. Thanks, too, go to Lynn Kiang and Katie Lee of Dome Collective in
New York whose sublime design vision brought elegance and flair to the digital
components of the exhibition. I am grateful to MEAS Prasithipheap for his years
of steady assistance and friendship. KHIN Pothai of Naga Trails Productions
organized an exceptional crew in Cambodia, including CHUM Sokvong, DEAB
Sarith, DEAN Chomreuon, KIM Vimalay, LY Polin, H. E. PRUM San, SENG
Sopharab, and SRITUE Patcharakiti. LEANG Seckon and Jaroslav Poncar also
kindly provided important photographic resources. Without them all, we could
never have acquired the images needed to reveal the history of the Cleveland
Krishna sculpture and its context in the southern Cambodian landscape and
broader visual world.

Exhibition administration, design planning, and publication management
were led by the CMA's Chief Exhibition, Design, and Publications Officer Heidi
Strean, Director of Design and Architecture Andrew Gutierrez, and Director of
Publications Thomas Barnard. In the Asian Art Department I'd like to thank
Clarissa von Spee and Katie Kilroy Blaser for their unwavering support, and we
received welcome encouragement and assistance from the curatorial department
including Virginia N. and Randall J. Barbato Deputy Director and Chief Curator
Heather Lemonedes Brown, Bridget Hornberger, and Katie Bujnak. Special
thanks are due to Exhibition Project Manager Mollie Armstrong, Publication
Project Manager Rachel Beamer, Exhibition Registrar Elizabeth Saluk, Senior
Editor Amy Bracken Sparks, and Head of Collections Management Mary Suzor.
Finally, without the courage and unflagging devotion to the merits of this project
on the part of our director, William M. Griswold, none of this work could have
proceeded, and our collaborative successes would have gone unrealized.

The generosity of friends and foundations who gave the copious financial
resources we needed to complete our ambitious vision is staggering. In
particular Raj and Karen Aggarwal, Rebecca and Irad Carmi, Carl Jagatich, John
Proctor, Vikram Rajadhyaksha, Bill Roj and Mary Lynn Durham, Jack Walton,
and Paul Westlake gave with unfettered confidence. The talented members of
our philanthropy department, led by Colleen Criste, worked tirelessly to secure

gifts and awards from the National Endowment for the Arts, the E. Rhodes and
Leona B. Carpenter Foundation, the Jolie-Pitt Foundation, and the Eugene V.
and Clare E. Thaw Charitable Trust. I also revel in the good fortune that author
and activist Loung Ung is my neighbor in Cleveland, and we are deeply grateful
for her connecting us with Angelina Jolie and the Cambodian families and
communities in Ohio and beyond. For his unswerving indulgence, I thank my
husband Matthew J. Mace, and, as always, Young H. Rhie, Vita, and Gregory for
their patience and pride.

Sonya Rhie Mace
George P. Bickford Curator of Indian and Southeast Asian Art
The Cleveland Museum of Art

Plate 1. *Vishnu with Eight Arms*, c. 600. Southern Cambodia, Takeo Province, Phnom Da. Sandstone; 288.5 (without the c. 45 cm tenon) x 146.5 x 61.5 cm. National Museum of Cambodia, Phnom Penh, Ka.1639. Photo: Konstanty Kulik

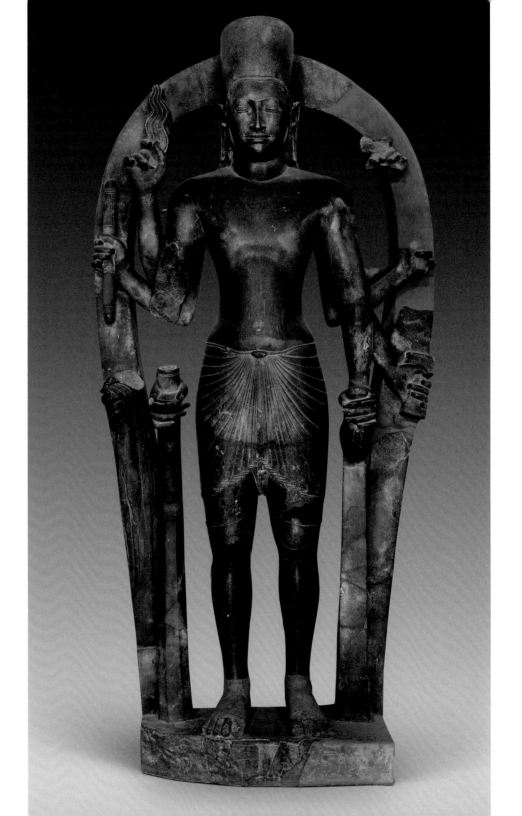

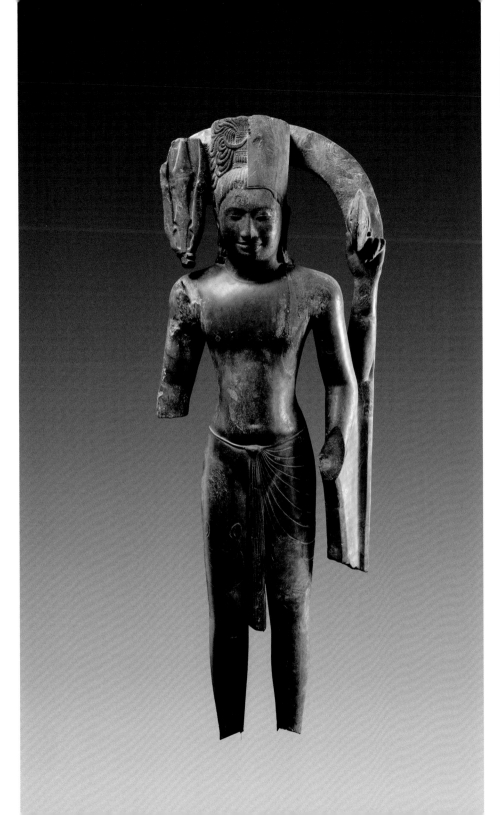

Plate 2. *Harihara* ("Paris Harihara"), c. 600. Southern Cambodia, Takeo Province, Phnom Da. Sandstone with gilding; 173 x 75 x 23 cm. Musée national des arts asiatiques–Guimet, Paris, MG 14910. Photo © RMN-Grand Palais / Thierry Ollivier / Art Resource, NY

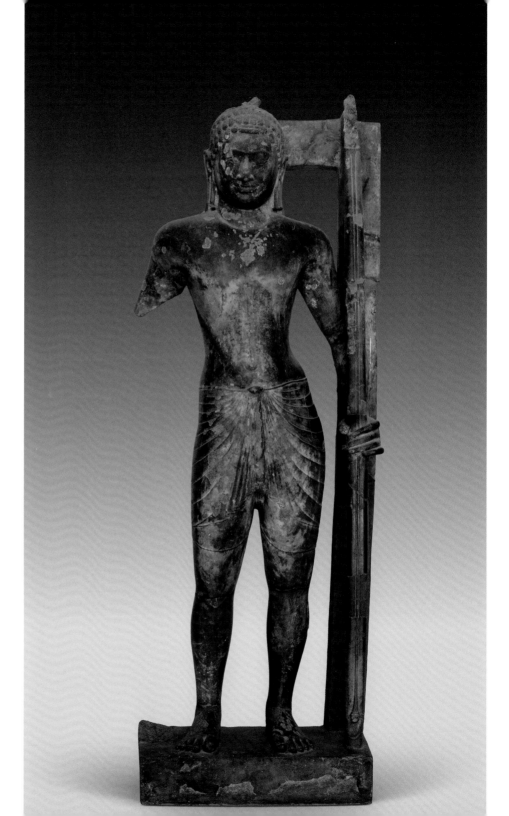

Plate 3. *Rama*, c. 600. Southern Cambodia, Takeo Province, Phnom Da. Sandstone; 189 (without 43 cm tenon) x 70 x 34 cm. National Museum of Cambodia, Phnom Penh, Ka.1638. Photo: Konstanty Kulik

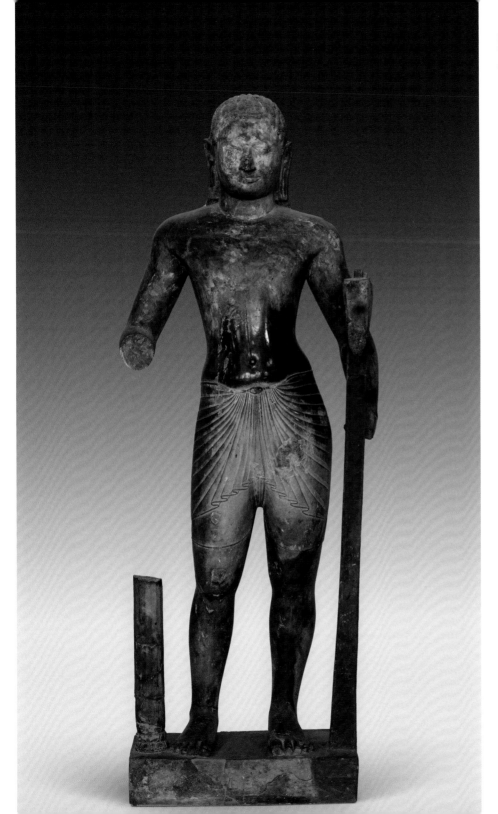

Plate 4. *Balarama*, c. 600. Southern Cambodia, Takeo Province, Phnom Da. Sandstone; 185.5 (without 49 cm tenon) x 69.5 x 36.5 cm. National Museum of Cambodia, Phnom Penh, Ka.1640. Photo: Konstanty Kulik

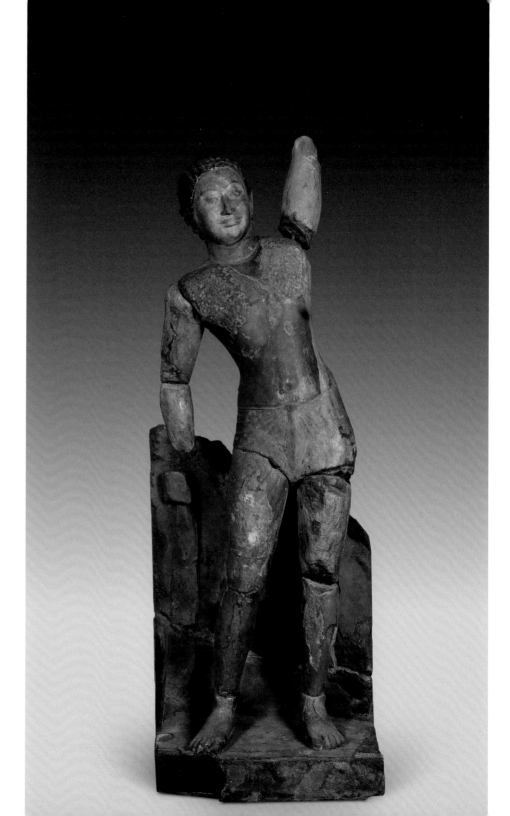

Plate 5. *Krishna Lifting Mount Govardhan* ("Phnom Penh Krishna"), c. 600. Southern Cambodia, Takeo Province, Phnom Da. Sandstone with remains of lacquer and gilding; 188 (without 43 cm tenon) x 68 x 42 cm. National Museum of Cambodia, Phnom Penh, Ka.1641. Photo © NMC

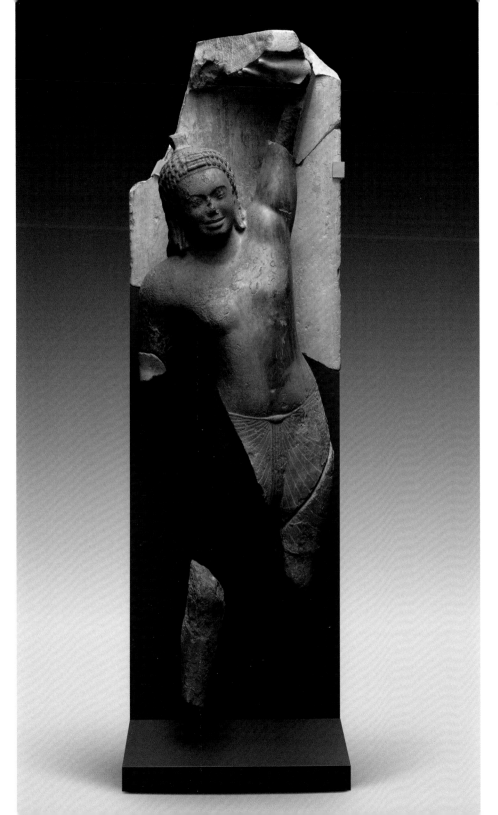

Plate 6. *Krishna Lifting Mount Govardhan* ("Cleveland Krishna"), c. 600. Southern Cambodia, Takeo Province, Phnom Da. Sandstone; 203.1 x 68 x 55.5 cm. The Cleveland Museum of Art, John L. Severance Fund, 1973.106

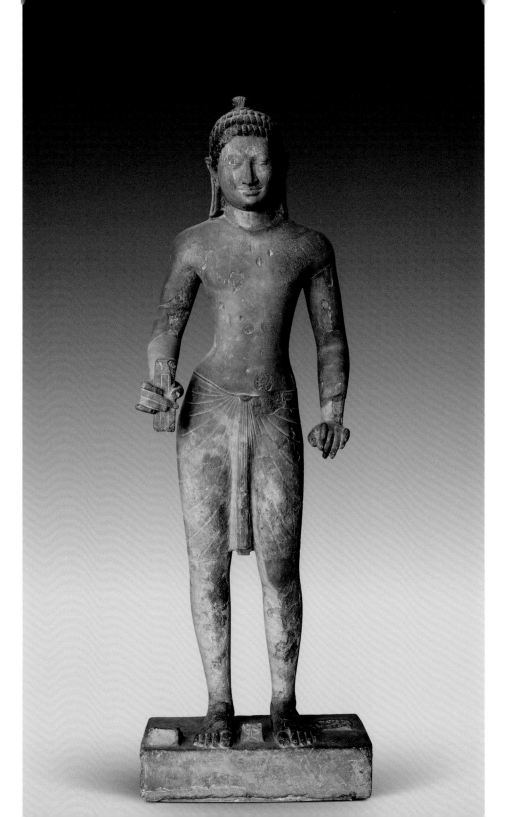

Plate 7. *Deity*, c. 600. Southern Cambodia, Takeo Province, Phnom Da. Sandstone with remains of lacquer and gilding; 176 (without 44 cm tenon) x 58.5 x 41.5 cm. National Museum of Cambodia, Phnom Penh, Ka.1608. Photo: Konstanty Kulik

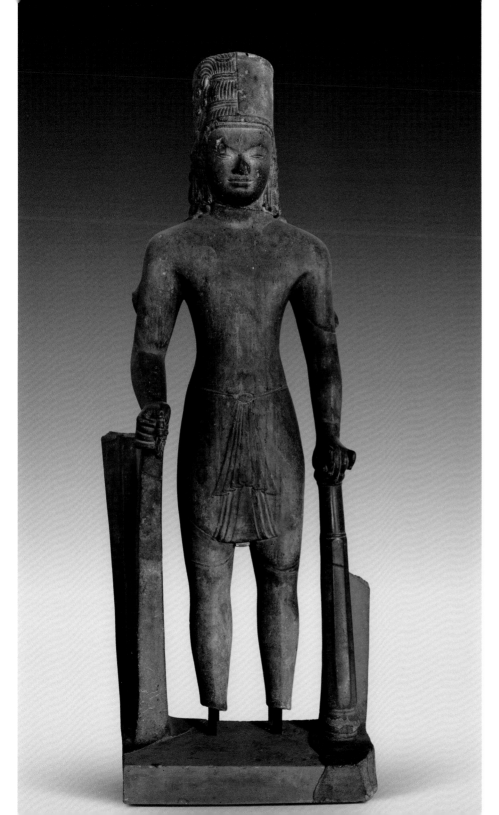

Plate 8. *Harihara* ("Phnom Penh Harihara"), c. 650. Southern Cambodia, Takeo Province, Phnom Da. Sandstone; 202 x 80 x 51.5 cm. Body: National Museum of Cambodia, Phnom Penh, Ka.1614; Head: Musée national des arts asiatiques–Guimet, Paris, MG 14899. Photo: Konstanty Kulik

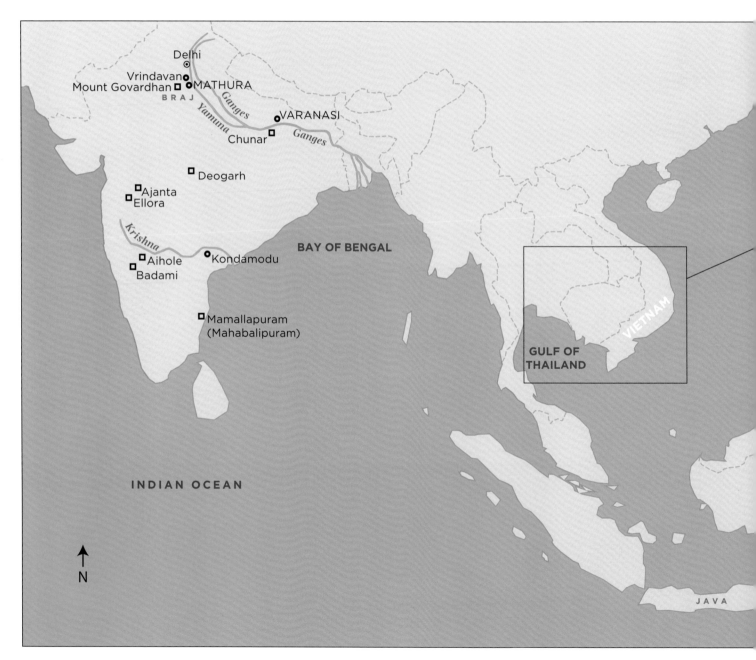

Delhi

Vrindavan
Mount Govardhan MATHURA

BRAJ

Yamuna Ganges

VARANASI

Chunar Ganges

Deogarh

Ajanta
Ellora

Krishna

Aihole
Badami Kondamodu

BAY OF BENGAL

Mamallapuram
(Mahabalipuram)

VIETNAM

GULF OF
THAILAND

INDIAN OCEAN

N

JAVA

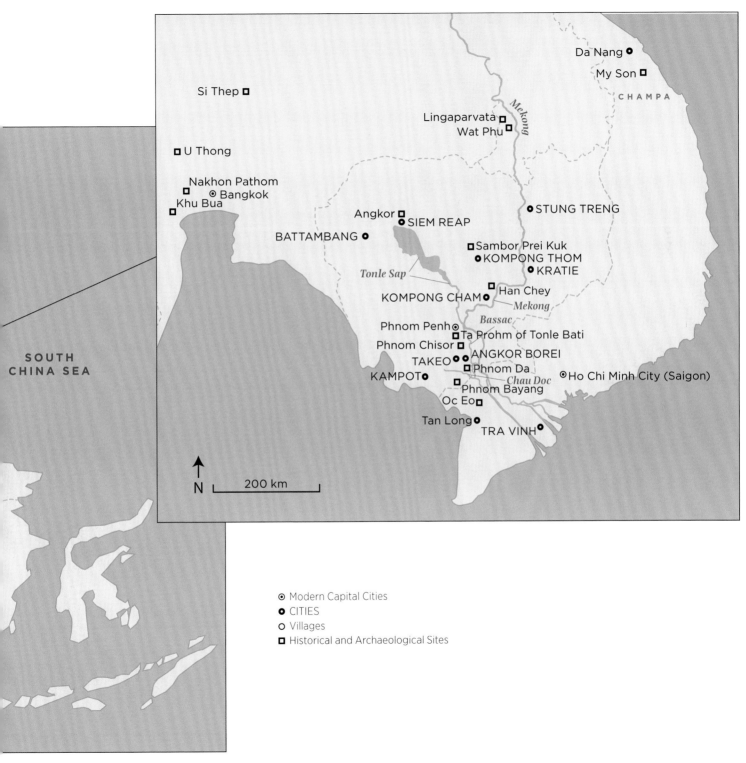

Da Nang ⊙

My Son □

CHAMPA

Si Thep □

Mekong

Lingaparvata □
Wat Phu □

U Thong □

Nakhon Pathom □
⊙ Bangkok

Khu Bua □

Angkor □
⊙ SIEM REAP

⊙ STUNG TRENG

BATTAMBANG ⊙

Sambor Prei Kuk □
⊙ KOMPONG THOM

Tonle Sap

⊙ KRATIE

KOMPONG CHAM ⊙

Han Chey □

Mekong

Bassac

Phnom Penh ⊙
□ Ta Prohm of Tonle Bati

Phnom Chisor □

SOUTH
CHINA SEA

TAKEO ⊙ ⊙ ANGKOR BOREI
□ Phnom Da

KAMPOT ⊙

Chau Doc

⊙ Ho Chi Minh City (Saigon)

□ Phnom Bayang

Oc Eo □

Tan Long ⊙

TRA VINH ⊙

↑
N ├─── 200 km ───┤

⊙ Modern Capital Cities
⊙ CITIES
○ Villages
□ Historical and Archaeological Sites

□ Wat Romlok

Phum Ta Ei ○

Wat Koh □

Bassac River

Wat Kompong Luong

Wat Kdei Ta Ngnuoy □ □
Phum Angkor ○ ◉ ANGKOR BOREI

←
TAKEO
12 km

Tuol Thmor □ □
Wat Komnou
Kunlah Lan □

Tuol Kuhea □

*Eastern
Baray* □ Phnom Bathep

KANDAL PROVINCE
TAKEO PROVINCE

Phnom Ngnel □

Phnom Da

Angkor Borei River

◉ CITY
○ Village
□ Historical and
 Archaeological Sites

Phnom Borei □

Tuol Koh
23 km ↘

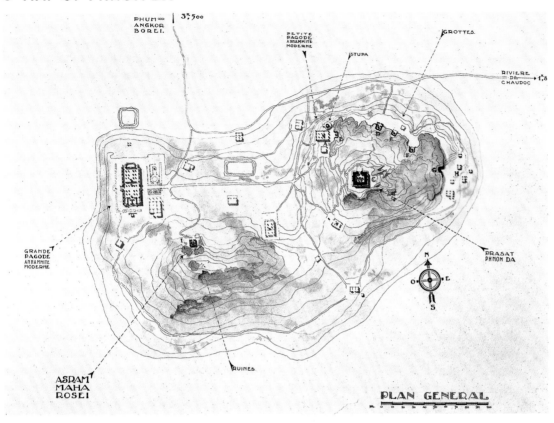

3.1 Topographical drawing of the aerial view of
the two peaks of Phnom Da, 1936 (Mauger 1936,
pl. XIX). © EFEO

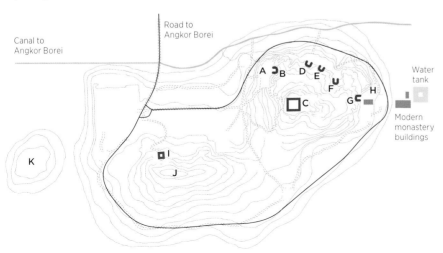

Structural Temples

A Modern Vietnamese
Buddhist Temple
(c. 1910–75)

C Prasat Phnom Da

H Pillared hall or
shrine ruins (before
c. 1975)

I Ashram Maha Rosei

J Brick ruins

K Phnom Ngnel, brick
ruins

Cave Sanctuaries

Cave **B**
Cave **D**
Cave **E**
Cave **F**
Cave **G**

3.2 Topographical drawing of the aerial view of
the two peaks of Phnom Da plus Phnom Ngnel,
2020, after Mauger. © CMA

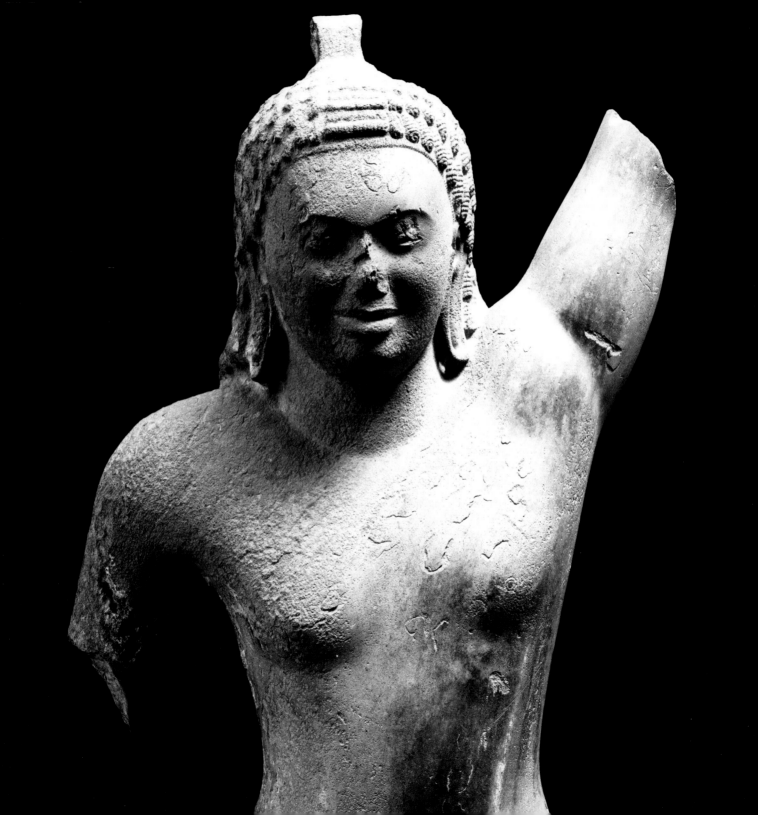

THE CLEVELAND KRISHNA: IMAGE, SITE, AND PROVENANCE
SONYA RHIE MACE

In 1973, after negotiating for eight years, Director of the Cleveland Museum of Art Sherman E. Lee succeeded in acquiring a remarkable sculpture of the Hindu god Krishna from the site of Phnom Da near the ancient city of Angkor Borei in southern Cambodia (fig. 1). At the time, the sculpture lacked arms and legs, but its visual appeal had won the sculpture acclaim for decades among connoisseurs of Southeast Asian art worldwide. As early as 1927 art historian A. K. Coomaraswamy (1877–1947) waxed poetic about this fragmentary work of sculpture:

> The Cambodian figure exhibits a miraculous concentration of energy combined with the subtlest and most voluptuous modelling. Works of this kind are individual creations—not, that is to say, creations of personal genius unrelated to the racial imagination, but creations of a unique moment. It is as though the whole of life had been focused in one body.[1]

To this day, scholars still struggle to answer basic questions about this widely touted pre-Angkorian[2] masterpiece. Whom does the sculpture depict, and what did he represent for the people who made it? Who made it and when? Where was it originally installed, and how did it get from there to Cleveland? One hundred and one years after its first publication in 1920,[3] this essay presents what has since been learned about the Cleveland Krishna and explains the state in which we find it today.

Identifying Krishna
The only aspect of the sculpture that identifies the figure as the Hindu god Krishna lifting Mount Govardhan, or "Krishna Govardhana," is the raised left arm and hand pressed flat against the underside of the top section of its mono-lithic support structure (pl. 6; frontispiece p. 14).[4] Broken from the end of the bicep to the wrist, the arm rises from a powerful shoulder, modeled to suggest musculature bulging under the strain. The hand is hyperextended against the top of the stele with the kind of exaggerated flexion admired among Khmer dancers. The thumb and index finger, however, bend lightly to indicate that the load is perfectly balanced on the heel of the palm, so when viewed from below they

Figure 1. *Krishna Lifting Mount Govardhan* (pl. 6) at the time of its acquisition by the Cleveland Museum of Art in 1973 (detail). H. 119 cm. Photo courtesy CMA Archives 42719

appear relaxed, implying that holding the mountain aloft for seven days is really no struggle for Krishna.

George Groslier (1887–1945), founder of the Musée Albert Sarraut in Phnom Penh, now the National Museum of Cambodia (NMC), first documented the fragmentary L-shaped stone stele with the hand in 1923 (see fig. 63). Although never explicitly stating that the stele belonged to the dismembered body (see fig. 1)—which by then was in the collection of Adolphe Stoclet (1871–1949) and his wife Suzanne Stevens Stoclet (1874–1949) in Brussels, Belgium—Groslier, in a 1924 publication, was the first to accurately guess that the sculpture depicts Krishna.[5] Groslier's tentative identification was not widely accepted, however. Other authors elected to use generic nomenclature, such as "personage," "man with the raised arm," "warrior," and "Stocklet Man" [sic][6] or even propose an alternative Buddhist identity as Lokeshvara.[7]

It was Henri Mauger (1903–?),[8] architect and conservator with the École française d'Extrême-Orient (EFEO), who definitively recognized that the upper stele with hand belongs with the fragmentary sculpture in the Stoclet collection. The disposition of the hand also led him to positively identify the figure as Krishna lifting Mount Govardhan. In his 1935 report written on site at Phnom Da on New Year's Eve, he wrote enthusiastically:

> On the ground in front of Caves D, E, and F, we reconstructed the fragments of a standing divinity, its left arm raised, seemingly a Krishna lifting Mount Govardhana. . . .

> We believe to have once and for all solved the mystery that until now has intrigued all Khmer scholars: the "man with the raised arm" is no longer unidentified.[9]

Thereafter, even when the Stoclets and later the Cleveland Museum of Art opted not to include the hand piece with the torso, the identification held fast.

Along with the upper stele with hand, Mauger also gathered a deposit of limb pieces and a lower stele with feet that all had been apparently discarded in the vicinity of the caves on Phnom Da and hastily assembled some of them on the ground to form a figure without arms, body, or head (fig. 2). We now know that those pieces are parts of at least three different sculptures,[10] but mainly they came from the Cleveland Krishna and another similarly scaled sculpture of Krishna lifting Mount Govardhan, also from Phnom Da, now in the National Museum of Cambodia, Phnom Penh (pl. 5).[11] The sizes and styles of the Cleveland Krishna and the Phnom Penh Krishna are so similar that their limb pieces are easily interchangeable. Even more remarkable is the fact that two monumental sculptures of Krishna raising Mount Govardhan were made at Phnom Da around

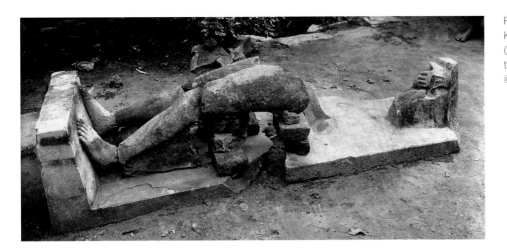

the same time. All attempts to identify either sculpture as a figure other than Krishna lifting Mount Govardhan have fallen short.[12] Throughout the history of Southern Asian art no other two-armed figure raises one arm with the hand pressed flat upon a surface above.

The imagery of Krishna lifting Mount Govardhan was formulated in northern India, though it is difficult to confirm the dating of any example prior to the fifth century AD.[13] A sculpture similar in size to the Phnom Da figures evinces an Indic precedent for Krishna lifting Mount Govardhan as a major devotional icon (fig. 3). The imposing monolith was accidentally excavated while a grave was being dug in Alaipura, a Muslim quarter of Varanasi, near the Ganges River in northern India (map 1).[14] Scholars agree that this magnificent sculpture was made between AD 400 and the mid-500s, a time when large-scale figures of the Hindu god Vishnu and his incarnations were prevalent throughout the subcontinent.[15] The Varanasi Krishna is the only surviving example of this particular iconography known in India that exceeds six feet in height and that would have been the main image for worship in a temple.[16] Unlike the Cleveland Krishna, the Varanasi Krishna includes a carved mountain and halo as an integral part of the sculpture, and the arm that supports it would have been bent at the elbow. His hairstyle and tiger-tooth pendants—worn by children to ward off evil—elegantly allude to his youth, as he was about eight years old, according to the texts that were extant at the time, when he miraculously revealed his power and divinity to his family and fellow cowherd villagers by lifting a mountain and halo to shield them from a deadly rainstorm. Carved from the sandstone quarried at Chunar (map 1), which is celebrated for its bright dun color and capacity to be burnished to a glasslike sheen, the Varanasi Krishna, like the sculptures from Phnom Da (pls. 1–8), would have gleamed under the light of butter lamps when installed in a temple sanctum.

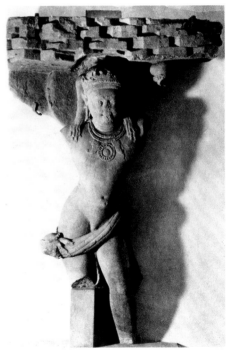

Figure 3. *Krishna Lifting Mount Govardhan* (*Kṛṣṇa Govardhanadhara*, "Varanasi Krishna"), c. 400. Northern India, Uttar Pradesh, Varanasi. Chunar sandstone; h. 213 cm. Bharat Kala Bhavan, Banaras Hindu University, 147. Photo © Francine Tissot, courtesy Thierry Zéphir

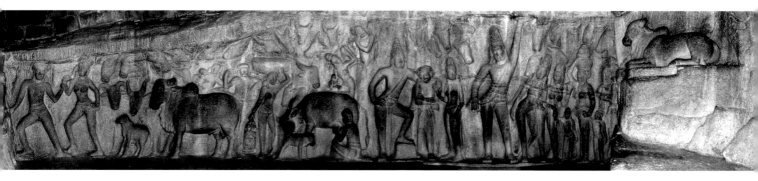

Figure 4. *Krishna Lifting Mount Govardhan*, c. 625. Southern India, Tamil Nadu, Mamallapuram. Granite; 370 x 880 cm. Photomontage © Emmanuel Francis

A grand tableau of Krishna upholding Mount Govardhan was carved as a rupestrian relief at the South Indian eastern coastal site of Mamallapuram, dating to around 625 (map 1; fig. 4). He is surrounded by the cows and herdsmen and cowherd women and children he is in the act of protecting. The feat is so auspicious that the cows' milk begins to spontaneously flow, and one cow, shown licking a calf, needed to be milked on the spot. Krishna's brother Balarama stands confidently nearby, one arm around the shoulders of a worried herdsman. Krishna's left elbow is locked straight, and his hand balances the long low mountain, which is carved in relief above the entire group. His right hand is held down, with the palm out, indicating that he confers the gift of protection. The Mamallapuram image is more regal than the Varanasi Krishna and the Phnom Da Krishnas, since he wears a tall crown and his form is less childlike. Only rarely does Krishna Govardhana in India not include the mountain as part of the sculpture.[17] The Mamallapuram tableau must be noted, because of its prominence at a royal site, its proximity in date to the Phnom Da sculptures, and the similar manner in which Krishna balances the mountain above him with a straight arm. However, neither the Mamallapuram relief nor the Varanasi Krishna can be considered a direct source for the Phnom Da monoliths in terms of artistic style.[18]

Seven major, large-scale sculptures of Krishna lifting Mount Govardhan are known from sites dating from the 400s to 600s in Southern Asia: one each from Varanasi and Mamallapuram, two from Si Thep in Thailand (see figs. 100, 101), two from Phnom Da, and one from nearby Wat Koh, about eleven kilometers north of Phnom Da (map 2; fig. 5). No other exploit or episode from the story of the life of Krishna was singled out with such prominence during this period.[19] The fifth to seventh century marked the time when knowledge of Indian texts, languages, and iconographies began flowing into Southeast Asia,[20] and it happened to also be a historical moment when the image of Krishna lifting Mount Govardhan had reached a cultic high point. Stylistically, the seven surviving images vary by region and time. The Varanasi and Mamallpuram images from

northern and southern India are as different from one another as are the two from Si Thep of the sixth and seventh centuries, and they all are distinct from the three Cambodian works, which are visually closely related to one another. Regional artists, therefore, apparently created their own interpretations of the icon, based on oral or textual descriptions.[21]

In contrast, other sculptures from Phnom Da and the surrounding region can be directly linked to similar figures from India and elsewhere in Southeast Asia in terms of form and style. Buddha images from Wat Romlok (map 2) about fourteen kilometers north of Phnom Da, for example, have obvious connections

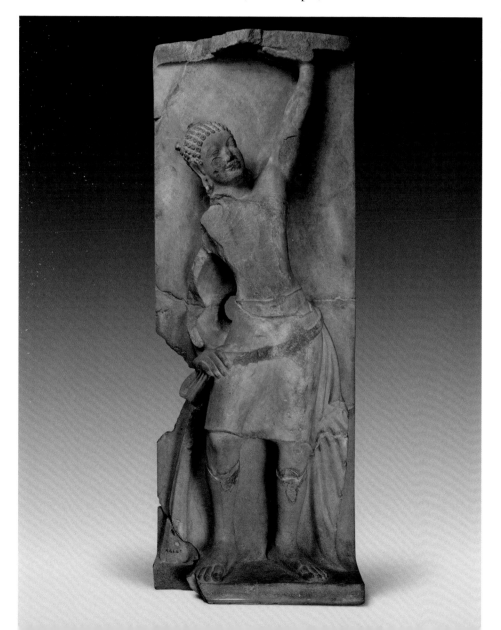

Figure 5. *Krishna Lifting Mount Govardhan* ("Wat Koh Krishna"), c. 700. Southern Cambodia, Takeo Province, Wat Koh. Sandstone; 161 (without 27 cm tenon) x 65.5 x 35.2 cm. National Museum of Cambodia, Ka.1625. Photo: Konstanty Kulik

with figures from Vietnam, Thailand, Indonesia, and India.[22] The four-armed male figure found at Tuol Koh, about twenty-five kilometers south of Phnom Da, has been considered the earliest stone sculptural type from peninsular Southeast Asia, dating to the fifth or sixth century (fig. 6). Identified as Vishnu, or more precisely Vasudeva-Krishna, an adult warrior clan hero for Vaishnavas (followers of Vishnu), he grasps a conch at his hip, and his right hand is in the gift-giving gesture.[23] In spite of its having been carved on the back at the waist, and acknowledging that it may have been unfinished, its static and somewhat two-dimensional impression is wholly distinct from the subtly modeled, sophisticated dynamism of the gods of Phnom Da. In this context, while the Phnom Da

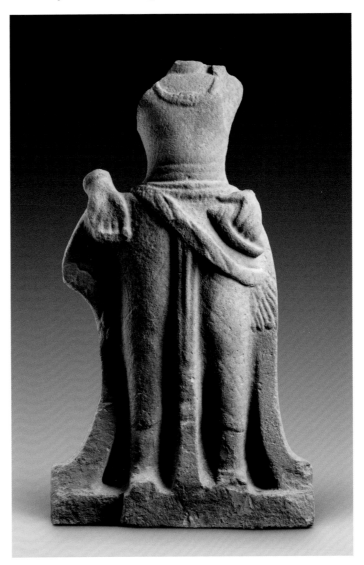

Figure 6. *Vishnu (Vasudeva-Krishna)*, c. 550. Southern Cambodia, Takeo Province, Tuol Koh. Sandstone; 77 (without 18 cm tenon) x 20 x 20 cm. National Museum of Cambodia, Ka.1599. Image courtesy of and © The Metropolitan Museum of Art. Image source: Art Resource, NY

sculptures (pls. 1–8) are not necessarily the earliest works of Hindu sculpture in Cambodia, they do stand as a revelatory new Khmer expression of power and divinity that is a radical departure from anything known prior or elsewhere in the archaeological record. In "The Phnom Da Sculptor" in this book, Bertrand Porte and CHEA Socheat describe the skill and originality of the anonymous artists responsible for this flush of inspiration.

Scholars remain uncertain exactly when this unprecedented expression of Khmer sculptural genius occurred. In his essay in this book, Pierre Baptiste convincingly places the early sculptures of Phnom Da and Angkor Borei around the mid-500s. Alternatively, the creation of such sophisticated statuary depicting Indian religious iconography could have coincided with the upsurge in Sanskrit inscriptions in the region, which are dated from 617 onward.[24] One of the five inscriptions found at Phnom Da appears to have been written during this early period,[25] and a coin and inscription of the king Ishanavarman (reigned 616–637) were found nearby.[26] This sparse epigraphic and numismatic evidence confirms only the existence of religious and royal activity at Phnom Da during the general time frame of the sixth to seventh century, but no dates or names of patrons specify when or for whom or why the monumental sculptures of Phnom Da were made. Given the paucity of firm evidence, a broad bracket of time, designated as c. 600, implying plus or minus fifty years, seems at present to be the best solution for the Cleveland Krishna and the related works from Phnom Da and Angkor Borei.

Gods and Monuments of Phnom Da

Among the eight monumental stone sculptures of gods from Phnom Da, there emerges an iconographic hierarchy of divinities. The Cleveland Krishna is one of five two-armed male figures (pls. 3–7) of approximately life size, all of which were found on the northeastern peak of Phnom Da, where there are, incidentally, five man-made cave sanctuaries (map 3). Two life-size sculptures of the four-armed Harihara are now in Paris and Phnom Penh (pls. 2, 8). The Paris Harihara and the head of Phnom Penh Harihara were found on the adjoining southwestern peak, where there are the remains of a brick structural temple on the summit (fig. 7) and a basalt temple known as Ashram Maha Rosei midway up its northern slope (see fig. 34c, 83a, b). Nearly double the size of the five two-armed gods and the two four-armed Hariharas is the colossal *Vishnu with Eight Arms*, unparalleled in iconography, power, and visual impact (pl. 1; see also figs. 32, 33, 50).[27] Among the eight gods of Phnom Da, only the multiarmed Vishnu and Harihara sculptures stand straight and axially, with the weight placed equally on both legs (pls. 1, 2, 8). Often in the art of India, the straighter the image, the more cosmic the icon. If sculptures are more active and dynamic, they are often of an emanated form, part of the natural, created world.

Figure 7. Brick ruins, southwest summit, c. 600. Southern Cambodia, Takeo Province, Phnom Da. Photo: Konstanty Kulik

Henri Mauger uncovered the Vishnu in 1935 from the rubble inside the large temple, Prasat Phnom Da (frontispiece pp. 2–3; see also figs. 34a, 91), on the summit of the northeastern peak. He found two of the two-armed divinities (pls. 3, 4) with the Vishnu in the Prasat, along with inscription K.830 dated 1106 and other smaller sculptures of c. 1100s, coinciding with a period of expansion and renovation at the site. In their essays in this book, Pierre Baptiste presents his arguments for the chronology of the eight main deities of Phnom Da, with emphasis on the Vishnu and Harihara sculptures and the twelfth-century expansion of Prasat Phnom Da, and Christian Fischer highlights the characteristic typology of the distinctive stone from which they were carved.

All in all, there are eight main sculptures, and eight main sanctuaries on Phnom Da. It is tempting to hypothesize that the cosmic eight-armed Vishnu was originally installed independently in Prasat Phnom Da on the top of the taller of the two peaks, and the four-armed Paris Harihara in the now-destroyed temple on the apex of the slightly shorter peak. The Phnom Penh Harihara (pl. 8) appears to be of somewhat later manufacture, so perhaps it was added to the site at the same time as the Ashram Maha Rosei was constructed there, possibly to serve as the image in its sanctum, but this can only be surmised.[28] Then, the five two-armed gods, incarnations of Vishnu on earth, could each have been meant for one of the five terrestrial caves, and perhaps two of them were moved to join Vishnu at the time of the expansion in c. 1100. The site has been subject to so much manipulation, and there has never been a systematic archaeological survey or excavation, so the original disposition of sculptures and monuments at the site remains conjectural.

The caves are not naturally occurring, but purposefully excavated, with Caves G and B facing due east and west, respectively; Caves D and E face northeast, while Cave F faces north, toward the city of Angkor Borei and in the same direction as the Vishnu in Prasat Phnom Da and the Ashram Maha Rosei. Only Cave G is at ground level—the other caves are midway up the northeastern peak—and it is closest in proximity to what appears to be an ancient water tank, also due east of the peak (p. 13 and map 3). The caves, like the five two-armed sculptures, are similar in size, except for the central Cave E, which is somewhat larger,[29] and they have ample space to accommodate the sculptures, except the Vishnu. The Cleveland Krishna appears to have been set up in Cave D.

Among the five grottoes, only Cave D retains its sandstone facade (fig. 8). The other caves probably once had facades and brick vestibules with superstructures as well, since sandstone architectural pieces and slate slabs are strewn on the ground in front of the caves. The earliest recorded reference to Cave D on Phnom Da seems to be the account of a French civil servant named Captain Pierre-Jules Silvestre (1841–1918).[30] Étienne Aymonier (1844–1929) wrote that Silvestre visited

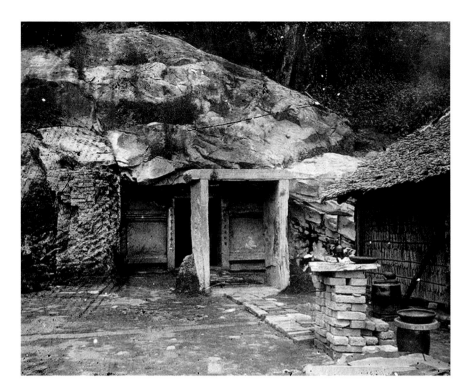

Figure 8. Cave D, Phnom Da in 1911. Southern Cambodia, Takeo Province, Phnom Da. Photo: Henri Parmentier. © EFEO

Phnom Da in 1880 and reported that he found on the slope of the hill a doorway in the rock, regularly shaped with right angles, the scree having partially filled it. He went on to say that this entry gave access to a deep cave, a refuge for thousands of bats, whose guano, mixed with the waters filtered from the ceiling, had filled this cavern bit-by-bit, effacing all memory of the "mysterious or bloody rites" of the past.[31] So, in 1880, the cave was full of debris, and no sculpture could be seen.

The next published description of Cave D is by Henri Parmentier (1871–1949) of the EFEO in the report of his visit in June 1911. He wrote that the cave had been cleaned out, apparently within the previous year, by members of a Vietnamese community who had recently settled at Phnom Da. They were renovating the cave to make it suitable for use as a Buddhist shrine, but he was unable to obtain any information about what they found in the cave during the cleaning process.[32] By the time he arrived, they had set up inside what he described as an extraordinarily beautiful statue with the unusual feature of having a raised left arm.[33] From the photograph he took at the time—which he never published—it is clear that the statue he saw was the broken body of the Phnom Penh Krishna, propped up against its broken lower stele next to a small sculpture of a Buddha with pendant legs, of the type dating to the 500s (see fig. 62).[34] The only other official reports of visits to the site between Silvestre's in 1880 and Parmentier's in

1911 are those of Aymonier in 1882 and Étienne Edmond Lunet de Lajonquière (1861–1933) in 1900. Aymonier seems not to have observed the caves, having paid attention only to the two structural temples and the sculptures of Harihara. Lunet de Lajonquière mentioned just one cave about halfway up Phnom Da, facing west—i.e., Cave B—and then only to say that the bat droppings were so voluminous the air was unbreatheable.[35] So, when Parmentier went to the site in 1911, conditions had changed. The Vietnamese immigrant community had relocated there and, undaunted by the centuries of accumulated guano, began to renovate and reuse the grottoes and sculptures they found.

From these scant clues and references, we can deduce that the Cleveland Krishna was removed from the site before Parmentier's visit in 1911; he never saw it in situ.[36] We can only guess that the sculpture was probably found in Cave D when the newly relocated Vietnamese residents cleaned it around 1910. Then, somehow, a French sailor apparently acquired it and sent it to France.[37] The sculpture had probably toppled and broken centuries prior—when all the great gods of Phnom Da were felled—perhaps by people wishing to access the consecratory treasure kept under the pedestal.[38] This initial vandalism of the site must have occurred some centuries before—long enough to cause the complete weathering of the base with feet and tenon of Vishnu, which Henri Mauger found exposed on the surface, having rolled partway down the northern slope. The site was flourishing during the 1000–1100s, as evidenced by three inscriptions and the renovation of Prasat Phnom Da, but after that, there is no evidence of devotional activity at the site until the gold paint was applied to the face of the Paris Harihara (see fig. 76), no earlier than the 1500s. It seems likely that the major damage to the sculptures took place during that interim.

The torso of the Cleveland Krishna is not as weathered as the feet and hand of Vishnu, since the left half retains most of the original polished surface, suggesting it was not as exposed to the elements. It seems likely that the torso with head and the left thigh may have remained in the cave, one side more exposed to erosion than the other, until the campaign of cleaning in 1910. The Buddhist community then set up the Phnom Penh torso—which was presumably from the neighboring Cave E, since the pedestal that fits its tenon was and is still there (see fig. 51)—in Cave D for veneration.[39] Sometime between 1911 and the next documented visit to the site in 1923 by Groslier, the new residents of Phnom Da completely severed the raised left arm, chiseled down the shoulders, and resculpted the figure using lime mortar, lacquer, and gold paint into the form of a seated Buddha (see fig. 64). Groslier noted that the Vietnamese people living there had converted three of the caves into Buddhist sanctuaries, reusing some ancient materials and transforming Hindu divinities into Buddhas by means of lime plaster and paint, but he opted not to disturb their altars.[40]

It is interesting to note that the ceiling of Cave D slopes upward from the middle to the back, enough to accommodate the full height of the monolithic sculpture of the Cleveland Krishna, including the tenon, plus a pedestal of about 60 cm. The sculpture with its monolithic tenon is too tall to fit vertically through the mouth of the cave, even before the addition of the doorway, so it would have been carried in horizontally. The ceiling in the back of the cave is high enough to allow for the sculpture to be tilted up and the tenon set into the pedestal, so the sculpture's support stele would appear built into the center of the cave.

A digital artist's restoration of how the sculpture may have looked when standing pedestal to ceiling, to scale, based on a three-dimensional laser scan of the sculpture and the cave, suggests how the Cleveland Krishna stood before it was broken and weathered: pillarlike, holding up the very mountain itself (fig. 9). In this way, Phnom Da becomes a new Mount Govardhan, and probably by extension the Mekong River becomes the holy Yamuna River, thereby ritually and visually transferring the sacred geography of Krishna's India to southern Cambodia.[41] The establishment of Krishna lifting Mount Govardhan in a grotto echoes his own words in the earliest known Sanskrit text relating the deeds of his youth, when he decides to raise the mountain to make it a shelter, a cave

Figure 9. Conjectural restoration of the Cleveland Krishna (pl. 6) as it may have appeared prior to damage and weathering, installed in Cave D, Phnom Da. Digital restoration and modeling by Dale Utt; LiDAR scans and photogrammetry by David Korzan, Konstanty Kulik, and Michał Mierzejewski

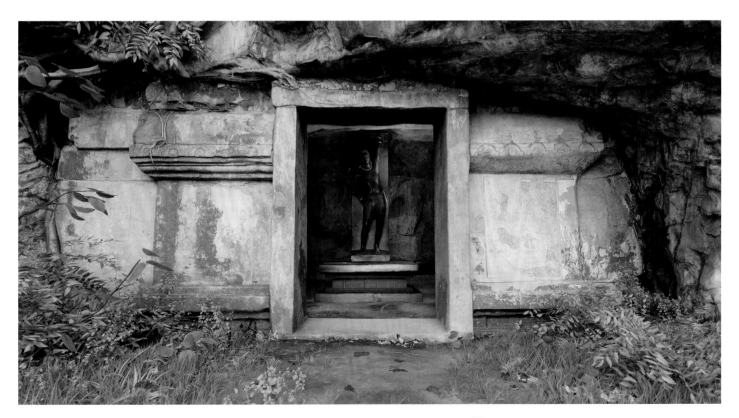

of safety, where the cows and people of his herding community are protected from the storm.[42] This same text also describes Krishna's transfiguration into the mountain itself, as the mountain god able to receive the people's offerings of food that he convinced them to divert from Indra, the old king of the gods who presides over thunderstorms and rain. André Couture has interpreted the scene as one in which Krishna becomes the mountain and people enter him to be saved from peril and subsequently are reborn into a new world, after the old order has been washed away.[43] John Stratton Hawley recognizes this moment as one in which Krishna effects a cosmic victory against an enemy, Indra, who then becomes his devotee.[44] In the process, Krishna becomes a new Indra, and a cosmic pillar (*axis mundi*) who maintains order and stability against chaos from the sky.

> Krishna's arm becomes the staff, the axis, of the mountain; visually it is as if he and it are one. Not only does it become an umbrella that celebrates his divinity (in India the umbrella is the symbol of royalty), but the two of them together form an umbrella of civilization that shelters the inhabited world.[45]

While we cannot know for certain how Krishna lifting Mount Govardhan was understood 1,500 years ago in the floodplains of the Mekong delta, the imagery denoting control of waters, protection from danger, and a boy who doubles as a mountain god all seems to cohere naturally with what would appear to be the concerns of a Cambodian population in transition.

The Cleveland Krishna is one of the five two-armed heroic figures of Phnom Da and one of two depicting his elevation of Mount Govardhan (pls. 5, 6). The main differences between the Cleveland Krishna and Phnom Penh Krishna are the hairstyle and the placement of the right hand. The Cleveland Krishna has shoulder-length ringlets and a single looped topknot secured by a ring with parallel radiating lines (frontispiece p. 6; fig. 10), while the Phnom Penh Krishna has short curly hair with the remains of three looped topknots—like the Wat Koh Krishna—each secured by a twisted ring. Gracefully lying over each ring is the tapering end of the lock of hair. The triple topknot appears to have denoted youth in early Cambodia, and the single tuft with ringlets was the hairstyle for a royal warrior. In later images, Krishna sometimes has the three tufts (see figs. 98, 105, 109–111), and sometimes he has one (see figs. 108, 113). Even in the roughly contemporaneous works from India and Thailand, his mien oscillates between youthful and regal—both aspects apparently having been appropriate for this divinity who transcends the linearity of human development.

As far as we can gather, the Cleveland Krishna had his right hand on his hip, like the Varanasi Krishna, given the angle of the bend of the elbow (pl. 6; fig. 9). The Phnom Penh Krishna (pl. 5), however, has no trace of a broken hand on the hip and instead probably held his right hand down and out, like the

Figure 10. Cleveland Krishna from above (detail, pl. 6)

Mamallapuram Krishna, according to the placement of the forearm and the broken strut on the stele behind him. It seems that the Cambodian sculptors were aware of these two possible positions for the figure's right hand.

One of the other two-armed figures from Phnom Da is clearly identifiable as Balarama, the brother of Krishna, thanks to his distinctive iconographic attribute of the plow (pl. 4). In some systems, Balarama is an avatar of Vishnu in his own right; in others, he is the incarnation of the serpent on which Vishnu sleeps on the cosmic Ocean of Milk before creating the world (see fig. 95). The figure of Balarama stands with easy confidence, his left arm holding his plow (fig. 11), which in textual accounts he uses both as a weapon and as a means of miraculously altering the course of the Yamuna River in northern India—an act that resonates with the large-scale creation of canals and waterways around Phnom Da and Angkor Borei (map 2).[46] When Mauger and his team uncovered Balarama in July 1935, the plow had broken off; most of the shaft was not recovered, and a restorative fill connects the original top portion with the base. His right arm also has broken away, but if it had remained, it may have held a long club or a lion standard, as seen on sculptures of Balarama from India;[47] only the lower section of the fluted shaft with lotus-shaped base survives. His hairstyle is like that of the Cleveland Krishna, but without the short bangs, consisting of ringlets of hair in rows radiating from the apex of the head.[48] A ring with parallel incised lines also secures the central looped topknot, now broken. The curls of

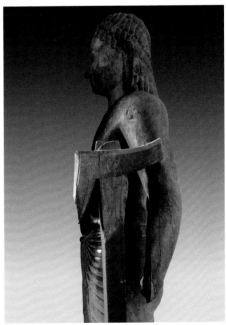

Figure 11. *Balarama* (detail, pl. 4) with plow at his left arm. Photo: Konstanty Kulik

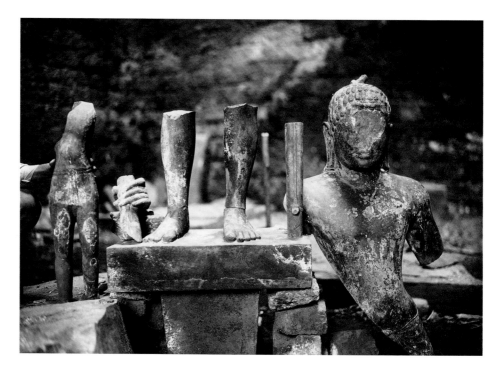

the first layer are longer than those of Krishna. His belly shines with a higher polish than any other sculpture from Phnom Da, suggesting either that it was rubbed by devotees who recognized him as a particular conveyer of good fortune or that he retains the original sheen that has worn off the others. The pleated garment described in detail by Porte and Chea fans over his hips and thighs without interrupting the elegant silhouette of his body (see fig. 48).

A fourth two-armed sculpture from Phnom Da holds a bow in the left hand, and hence has been identified as Rama (pl. 3), who is a major avatar of Vishnu and hero of the epic *Ramayana*.[49] Most of the face spalled away (fig. 12), and conservators at the National Museum have repaired it, using a mold made from the face of *Balarama* (see p. 111).

The fifth two-armed deity from Phnom Da—besides the two Krishnas, Rama, and Balarama—has not yet been satisfactorily identified (pl. 7). The figure holds an unidentified attribute in his right hand, polished on all sides except for the broken surface underneath. On the front surface is a single incised line following the rectangular shape of the object. Proposals including axe handle, manuscript, or other type of staff or standard all fall short of convincing, and his left hand lacks any attribute. His hairstyle is that of a warrior or a prince, and he has piercings for gold jewelry. Jean Boisselier first identified this figure as the avatar of Vishnu known as Parashurama,[50] but Parashurama carries an axe and should look like a forest sage. His purpose was to be the defender of Brahmans

and slayer of corrupt members of the royal or warrior castes, so he ought not be dressed as a prince.[51]

Whether Phnom Da held a level of sanctity that surpassed that of other mountain sanctuaries in the region is not certain, though in the closing essay of this volume ANG Choulean tantalizingly suggests that Phnom Da recalls the location of the Khmer origin story. Nearby Phnom Bathep has the ruins of a temple on its summit from which was recovered a massive pedestal carved with lyrically elegant ornament (fig. 13). Horizontal rows of jewels, alternating oval and rectangular, border an effervescent frieze of vegetal motifs of the type found on celebrated temple jambs and painted ceilings of central and western India from the 500s to 600s. Particularly charming is the line of geese on the underside of the spout, carrying offerings of jewels in their beaks, which are pointed in the direction of the flow of lustral fluids that were poured over the image above. The central bird under the tip of the spout, where the holy ablutions would stream out, is the only one shown en face. None of the pedestals remaining on Phnom Da have been carved with this level of care, implying that a marvel of a monolithic image matching if not surpassing those of Phnom Da may have stood on the summit of Phnom Bathep.[52] No convincing clue has yet been found to suggest the

Figure 13. *Pedestal*, c. 600. Southern Cambodia, Takeo Province, Phnom Bathep. Sandstone; 77.5 x 155.5 x 200 cm. National Museum of Cambodia, Ka.1747. Photo: Konstanty Kulik

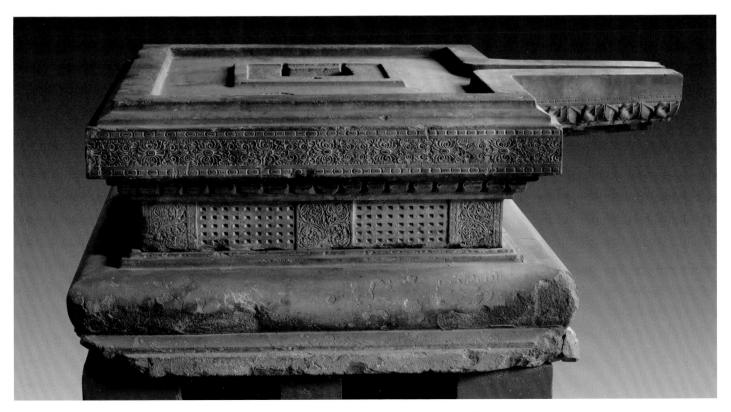

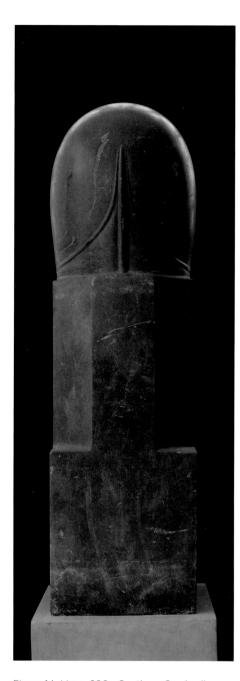

identity of the image, but it need not have been a Vishnu sculpture, since other once-spectacular mountaintop temples in the region were dedicated to Shiva, as at the site of Phnom Bayang (map 1).[53]

Lingas associated with the worship of Shiva have been found throughout the Mekong delta of southern Cambodia and Vietnam.[54] The linga is a stylized phallic form referring in an Indic Hindu context to the pre-manifest, cosmic, and eternal presence of the supreme deity, implying the potentiality for creation. At Phnom Da, Henri Parmentier noted there were three lingas of varying sizes inside Cave F.[55] George Groslier sent one of them, which is monolithic with its base and would be considered "votive" in size, to the museum in Phnom Penh in 1923.[56] The museum's records state that it was found in the ground on Phnom Da and kept in one of the caves by a Vietnamese nun. The broken base of another linga remains inside the cave, but where it and the other larger one are now is unknown. Temples dedicated to Shiva typically contain a linga in the sanctum. Votive versions by the untold thousands sprinkle the Cambodian landscape in shrines and natural sanctuaries, such as caves and streams, some dating as early as the fifth century. Many of them probably express an indigenous recognition of the divine in the fertility of the land as well as or more than the theologies of institutional Shaivism known to the priestly elite. In the precincts of the ancient royal residence in Angkor Borei at Wat Komnou (map 2), eleven pre-Angkorian monolithic lingas were excavated in 1998 when the foundations of a new school were being dug on the grounds of what is now a Buddhist monastery. The representative example (fig. 14) on view in the exhibition was found by a monk during construction of the school's new assembly hall in 2008, according to the Angkor Borei Museum records. Of precise workmanship and polished to a high sheen, the linga is divided into three segments of nearly equal height: square on the bottom, octagonal in the middle, and round on the top, with a raised borderline demarcating the anatomical shape of the head meeting at a tapered central vertical line. The remarkable workmanship of the sculptor can be appreciated in the smooth and regular form, perfect in its symmetry, inspiring confidence in its potency to generate the world in all directions. At the northern extremity of Khmer civilization along the Mekong River, at a site now called Wat Phu in Laos, a Shiva linga was designated on the apex of Lingaparvata,[57] a much larger mountain than Phnom Da, during the fifth century. Lingaparvata also has cave sanctuaries midway up, and thus resonates with the layout of the monuments of Phnom Da. Other small mountains rising out of the floodplains of southern Cambodia and across its present national border in Vietnam probably had important images on the tops as well, as attested by ruins, modern shrines built on ancient foundations, or pre-Angkorian sculptures reused and transformed to meet the needs of present-day worshippers.[58]

Figure 14. *Linga*, 600s. Southern Cambodia, Takeo Province, Angkor Borei, Wat Komnou. Sandstone; 118 x 34 x 34 cm. Angkor Borei Museum, TKA.Ka.045. Photo: Konstanty Kulik

A small stone sculpture of the four-armed warrior goddess Durga, holding a bell in her one surviving hand (fig. 15), is reported to have been found in the "easternmost cave," which would mean Cave G.[59] Though of early date,[60] her diminutive stature suggests that she was not the sole icon of this sanctuary. Nevertheless, her presence there indicates some incorporation of goddess worship at the site.

The sculptural and architectural remains at Phnom Da, though mainly fragmentary, altered, or altogether ruined, point to a thoughtfully planned site, where monumental stone icons of awe-inspiring quality were established in costly sanctuaries around AD 600, integrated into the topography of the landscape. Iconographically dominated by Vishnu and five human avatars, traces of worship dedicated to Shiva, the Buddha, and the goddess survive from the early period as well. Over the centuries, resources were continually lavished onto the site, effecting changes and renewals, until Khmer influence receded from the region in the thirteenth century.

International Peregrinations

As far as we can glean, the dismembered head-and-body section of the Cleveland Krishna was removed from Cave D of Phnom Da around 1910, certainly before Parmentier's visit in early June 1911, probably during the period of the site's renovation by the Vietnamese Buddhist community that relocated to Phnom Da sometime between 1900 and 1910. No trace of lacquer or gilding is evident on this sculpture, but the sharp breaks at the hips in opposing directions suggest that it might have been cut, rather than simply broken across a natural plane of weakness, at least on one side. Perhaps the community intended to use the Cleveland Krishna as an armature for a Buddha and seat the torso into newly fashioned crossed legs, like they later did with the Phnom Penh Krishna and the unidentified deity. Someone, however, removed the Cleveland Krishna's body with head from the site before the raised arm was fully severed.

After its removal from Phnom Da, the head-and-body section of the sculpture was transported to Marseille, and then to Paris. According to Philippe Stoclet (b. 1931), his grandfather Adolphe used to relate the anecdote that it was brought from Cambodia by a young French sailor who wanted to exchange it for a motorcycle.[61] The remaining pieces of the figure must have been left at the site, as five sections were later found there mixed with others, apparently discarded in a deposit of unused parts. Léonce Rosenberg (1879–1947), a prominent Parisian art dealer and critic famous for championing Cubism, added the piece to his extensive collection as the sole work from Cambodia.

The first publication featuring the Cleveland Krishna was in the catalogue to the second and final auction of the Rosenberg collection on June 1, 1920, as lot

Figure 15. *Durga* after restoration, c. 550. Southern Cambodia, Takeo Province, Phnom Da. Sandstone; 49 x 15 x 10 cm. National Museum of Cambodia, Ka.892. Photo: Konstanty Kulik

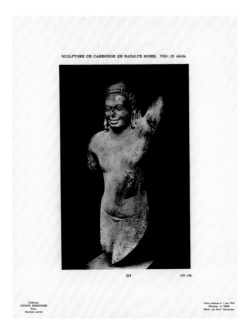

Figure 16. "Cambodian Sculpture in Black Basalt, 8th/10th century" (Cleveland Krishna, pl. 6) illustrated in Sotheby/Mak auction catalogue, Amsterdam, June 1, 1920, lot 214

214 (fig. 16).[62] Its sale price reveals the high aesthetic value placed on the work: £14,600, equivalent to approximately $850,000 in today's currency. Furthermore, it was one of the few objects in the sale to be illustrated with a full-page photograph.[63] Its buyers were Adolphe and Suzanne Stoclet of Brussels, Belgium.

The Stoclet family headed the Société General de Belgique, an internationally influential banking company that owned and operated a wide range of concerns; they also controlled the European railway CAIB. Before the death of his father, when Adolphe was obliged to return to Brussels and take over leadership of the Société General, he studied to be a civil engineer and spent the years leading up to 1904 in Vienna. His wife Suzanne was from a family of artists; her uncle Alfred Stevens (1823–1906) was among the most accomplished of the family. Adolphe's interest in industrial design and engineering, coupled with Suzanne's background in fine art, drew them to the nascent Wiener Werkstätte, a cooperative that grew out of the Vienna Secession, a group of architects and designers with a thrilling new vision of modernity, led by Josef Hoffmann (1870–1956). Excited by their ideas of incorporating artistic design into every detail of functional and quotidian objects and spaces, the Stoclets gave Hoffmann unlimited resources with which to design and build their new home, officially called Stoclet House, but better known as the Stoclet Palace. Originally conceived for Vienna, the house was instead constructed in the couple's native Brussels, where they settled after the death of Adolphe's father in 1904. Built between 1905 and 1911, the Stoclet House is one of the masterpieces of Art Nouveau architecture. Hoffmann collaborated with other luminaries of the Vienna Secession on the creation of a lavish interior that counterbalanced the geometric austerity of the exterior. Gustav Klimt (1862–1918) famously designed the golden mosaics of the dining room with the *Tree of Life*, the *Embrace*, and the *Knight*.[64] The Stoclets' extensive collection of medieval European and non-Western art complemented the modernist sensibilities of the house with a restrained eclecticism.

It was into this rarefied and artistically inspired environment that the limbless statue of the male figure with the raised arm was brought and literally placed center stage in the mansion's music hall (fig. 17).[65] The music room is a long narrow space with clerestory windows that open onto the hallway of the second floor. Hoffmann designed the chairs, covered in scarlet upholstery, that were arranged lounge style around the room. The floor is made of teak with coral wood parquet inlay, and the walls are a black marble with brass detailing.[66] In photographs taken before 1920 an organ of modern geometric design was set up at the back of the stage, but once the Stoclets acquired the Krishna torso, the sculpture stood in front, to be pulled off stage only when live performances were taking place. Philippe Stoclet remembers that the family gave the statue the affectionate moniker of the "dancing prince."

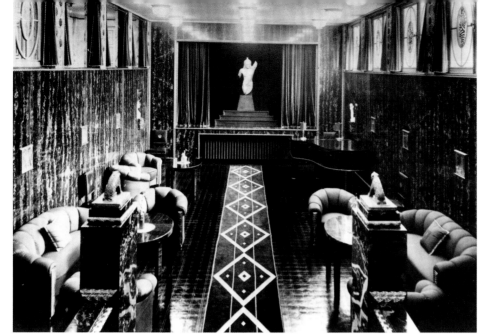

Figure 17. Music hall in Stoclet Palace with Cleveland Krishna (pl. 6) on the stage, after 1920. Brussels, Belgium. Photo courtesy Anna Geerts Stoclet and Stanislaw Czuma; photographer unknown

In several installments throughout 1937, sandstone fragments of arms and legs and pieces of support panels with feet and a hand arrived at the Stoclet Palace in Brussels.[67] Henri Mauger had found them "near the caves" halfway up Phnom Da,[68] and in December 1935 he laid a selection of the pieces out on the ground in front of Caves D, E, and F (see fig. 2) and felt that they would work with the torso in Brussels.[69] How the decision was made that the pieces should all be sent to Belgium, however, is unclear. In August 1936, Mauger wrote that the pieces of the "Stoclet Krishna" had been transported from the ground in front of the caves to the vicinity of the Vietnamese Pagoda (map 3), where they were to remain only until his director could come by boat from Takeo to visit the Ashram Maha Rosei.[70] Then in September 1936, he noted briefly that he went to Phnom Da to look for the rest of the Stoclet Krishna; those pieces were to be sent to Phnom Penh but were instead packed to be sent to Brussels.[71] According to the report on the archaeological activities of 1936, Gilberte De Coral-Rémusat indicated that the legs fit perfectly with the sculpture in the Stoclet collection and confirmed Mauger's identification of the figure as Krishna lifting Mount Govardhan.[72] She went on to equate "with certitude" the Stoclet Krishna with the limbless sculpture seen by Parmentier in 1911, even though she cited Parmentier's note in which he stated that differences between the two prevented confirming their identity as one and the same.[73] The conviction articulated in print by De Coral-Rémusat, and probably shared by others, seems to have led to the pieces having been sent to Brussels—instead of Phnom Penh as Mauger intended—and ultimately to the legs having been joined to the Krishna in Cleveland.[74]

Michel Dumoulin wrote in a biography of the Stoclet family that Paul Mallon (1884–1975), an art dealer in Paris and a friend of the Stoclets since 1912, was responsible for arranging the transport of the pieces from Cambodia to Belgium, since he already had many networks in place for exporting objects.[75] In a letter to the museum's first curator of Indian and Southeast Asian art, Stanislaw Czuma, dated January 26, 1974, Mallon wrote that Victor Goloubew (1879–1945), an art historian and archaeologist with the EFEO, orchestrated the transfer by effecting an exchange of the Phnom Da fragments for a Thai head of a Buddha from the Stoclet collection, since the members of the EFEO are forbidden from selling anything they find.[76] Mallon wrote that the Stoclets were eager to complete the statue of Krishna. Perhaps Goloubew learned of the discovery of the fragments from Mauger's reports, in which Mauger linked them to the Stoclet torso. Being a friend of the Stoclets, Goloubew may have brokered the exchange of the head for the fragments with the Stoclets, while Mallon arranged for the logistics of packing and transportation.

Paul Mallon arrived in Brussels in 1937 or 1938 at the Stoclets' invitation to advise on the reconstruction efforts. The body section of the Krishna sculpture had been laid on top of the upper stele with hand and the lower stele with feet, aligned by means of plumb lines, on the floor of the Stoclets' neighbor's villa (fig. 18). The neighbor, Marcel Wolfers (1886–1976), was a sculptor and so presumably had the means to hoist and handle the heavy stone pieces. The upper stele with hand had been broken into two parts, when compared to the photographs of Groslier and Mauger on site at Phnom Da (see figs. 2, 63); visible chisel marks in the middle of the strut and under the broken flange suggest that the slab was forcibly broken, perhaps for ease of packing or transport. A different arrangement of leg pieces than Mauger envisioned was assembled around the torso. The shin piece with bent knee and flange that Mauger considered to be a lower left leg piece (see fig. 2), it was discovered, could not work in connection with the feet and the torso; the flange was too large to allow the shin to align under the torso when the torso was set with the strut on the upper slab. Furthermore, from the point of view of body mechanics, when Krishna stretches up his left arm and leans to his right, it is the right leg that should be bent, not the left. So, Wolfers and Stoclet placed other leg fragments in the ensemble (fig. 18). Paul Mallon, who was called from Paris to assess this restoration, wrote that they all agreed that the legs did not go with the torso:

> In the Fall of 1937 (or in Spring of 1938) the Stoclets asked me to come to Brussels. With the assistance of a sculptor, they had attempted to put together the torso and the newly found legs, which from the hips down were broken in several pieces. They wanted to have my opinion in the

matter: did the legs and torso belong together or not? My initial impression was negative and a closer study confirmed it.

The difference in the quality of the sculpture in the two parts was patent. Besides there was a definit[e] lack of proportion between the torso and the hips. Furthermore, when the two parts were fitted together its throw [*sic*] the torso off balance. Mrs. Stoclet was in complete agreement with me, her husband accepted our conclusions, and the torso was left intact.[77]

Eventually, the Wolfers villa next door to the Stoclet Palace was sold to a new owner, another artist, Charles Verhasselt (1902–1993), and his wife. Wolfers's daughter Janine Schotsmans-Wolfers recalls that the fragments were still in the garden when they moved out, and Mrs. Verhasselt remembered they were there

Figure 18. Attempted reconstruction of *Krishna Lifting Mount Govardhan* (pl. 6) at the villa of Marcel Wolfers, 1937–38. Photo courtesy Paul Mallon, CMA Archives; photographer unknown

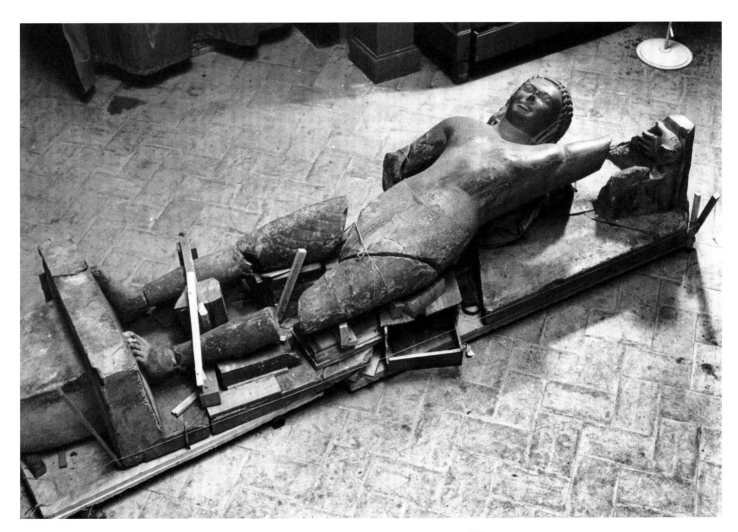

when they moved in.[78] Soon after the Verhasselts took possession of the villa, a new water cistern was installed in the backyard, and the discarded sandstone slabs and limb pieces were used for ground fill and the stabilization and support of the cistern.[79] One thigh piece was not buried and instead served to border the garden and remained partially above ground. Mallon wrote that when he saw Adolphe Stoclet after the war, the latter confirmed that the pieces had been buried in the garden, but Mallon thought he meant the Stoclets' own garden.[80] Similarly, Sherman Lee later wrote: "Paul Mallon and I discussed this sculpture on innumerable occasions beginning in 1946 with considerable discussion of whether the discarded fragments belonged with the sculpture or not and the wisdom of M. Stoclet discarding the pieces."[81] Adolphe and Suzanne Stoclet both died in 1949, and their granddaughter Michèle Leon-Stoclet (1932–1967) received the Krishna by inheritance. In 1950, she and her husband Claude Leon (1927–2004) moved to Dallas, Texas, and the Krishna apparently remained in Brussels in the Stoclet Palace, which by then had been taken over by her uncle Jacques Stoclet (1903–1961), one of the three children of Adolphe and Suzanne, and his wife Anna Geerts Stoclet (1907–2002).

In 1955 Pierre Dupont published the Phnom Penh Krishna torso with head that had been brought to the National Museum of Cambodia in 1944.[82] In the same publication, Dupont also published the 1935 photograph of Mauger's assemblage of fragments, but cropped to show only the legs and feet, and turned ninety degrees to make them appear standing, and he stated unequivocally that these legs belonged to the Leon-Stoclet Krishna.[83] As a result, even though the Phnom Penh Krishna was known by 1955, the assumption remained that the leg fragments belonged to the Cleveland Krishna. The Cleveland Krishna, however, belonged to Michèle, who was far away in Dallas, and the fragments were underground in the Verhasselts' garden, so no further attempt to connect any of the fragments with either torso was made for at least another twenty years.

In 1965, Michèle relocated to Barcelona and moved the Krishna sculpture there from Brussels. That year, she and her brother Philippe Stoclet determined that the best way to handle their grandparents' extensive art collection was to sell the works. Sherman Lee initiated negotiations for the purchase of the Krishna, claiming that he had secured right of first refusal.[84] Though the Stoclet family hired the Artemis group to find the most financially advantageous buyer for the sculpture, Lee stood firm for eight years, claiming the museum's right to purchase the sculpture. During that time, between 1965 and 1973, the dealer Paul Mallon's wife Margot kept Lee regularly abreast of the situation from Europe; the Mallons were attempting to advocate on Cleveland's behalf with the Stoclet heirs—a situation unfortunately complicated by the suicide of Michèle in

1967 and the apparent inability of her husband Claude Leon to proceed decisively. A note from Margot Mallon to Sherman Lee, dated February 2, 1973, reads:

> I am broken-hearted to have to write that I failed you in the matter of the Stoclet figure. I had been unable to contact Leon in the course of the last few weeks. His telephone did not answer and he was away from home when I called. Yesterday I had a letter informing me that the sculpture "in the interest of the minors" was not available any longer. Something about the Artemis group, trying to outbid everyone else. . . .[85]

Immediately afterward, on February 6, 1973, Lee wrote pointedly to Margot Mallon's son, Billy Girod-Mallon, in Garches, France: "I have been informed that someone else has bought the Stoclet Cambodian sculpture, but we still have the first refusal. What about it?"[86] There the paper trail ends, and it appears that Sherman Lee then turned to Eugene Thaw, a New York dealer affiliated with the Artemis group, to intervene. Lee prevailed, and the Cleveland Museum of Art finally bought the torso for the collection. The museum's Collections Committee of the Board of Trustees approved the purchase with a unanimous vote on June 7, 1973. Lee wrote to Thaw the next day: "I cannot tell you how pleased I am that after eight years of frustration we have been able to acquire this masterpiece of Asiatic sculpture which takes its place as one of the most important pieces in our collection. Your patient cooperation has been much appreciated."[87]

Published references to the existence of the fragments incited Stanislaw Czuma to find them.[88] In several articles he explained the extensive process and strokes of good fortune that led to his success.[89] In Paris in 1975 Czuma met with Albert Le Bonheur (1938–1996), curator of Southeast Asian art at the Musée Guimet, who suggested that Czuma seek out Janine Schotsmans-Wolfers (1924–1991), who, amazingly, became curator of Indian and Southeast Asian art at the Royal Museum of Art and History in Brussels. She brought Czuma to the former Wolfers villa and introduced him to Mr. and Mrs. Verhasselt, who still lived there. They granted him permission to explore the garden, where he saw the one thigh piece bordering a flower bed and instantly recognized the distinctive pleats of the Phnom Da style of lower garment (*sampot*). Then he launched a campaign of persuasion that after many vicissitudes resulted in permission to dig up the Verhasselts' beloved garden. The Stoclet gardeners accomplished the work of the excavation (fig. 19). The lower stele with feet and tenon in three sections and the upper stele with hand in two sections were the first to be found, followed by three shins, three thighs, one wrist, a forearm, an elbow, two upper arm pieces, and one other unidentified fragment. In all, they recovered seventeen separate pieces. The Cleveland Museum of Art paid for the repair and replanting of the garden,

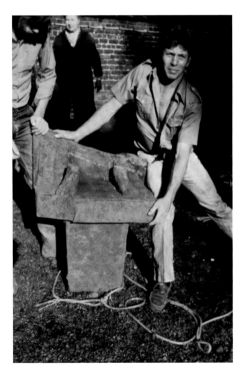

Figure 19. Stoclet gardeners with Mrs. Charles Verhasselt and the lower stele with feet and tenon of the Phnom Penh Krishna (pl. 5), Brussels, Belgium, 1977. Photo: Janine Schotsmans-Wolfers

and Mrs. Verhasselt made no ownership claim to the pieces. They were packed and shipped to Cleveland, arriving in December 1977.

At this juncture, political circumstances prevented communication between the keepers of the fragments and the torso of Krishna in Phnom Penh. The Khmer Rouge regime controlled Cambodia, then called Democratic Kampuchea, from 1975 to 1979. Phnom Penh was evacuated and international communications ceased. The National Museum was closed, and many of the employees lost their lives. At the Cleveland Museum of Art, the curator and conservators expended tremendous effort to create an elegant reconstruction that made the sculpture of Krishna as whole and as beautiful as possible, to give viewers the sense of figural unity that greatly augments the experience of the figure when compared to viewing solely the dismembered body. They accomplished their work using six of the seventeen fragments, in a process described by CMA conservators in the next chapter. Further research and recent revelations detailed by Fischer and by Porte and Chea in their subsequent essays have led to new, more accurate restorations of both the Cleveland Krishna and the Phnom Penh Krishna. While still incomplete, they are now presented differently from before, and, we believe, closer than ever to their disposition in the cave temples of Phnom Da and the vision of their creators.

1. Coomaraswamy 1927, 183.

2. "Pre-Angkorian" refers to the period preceding 802, when Angkor became the capital of the Khmer kingdom.

3. Sotheby Mak van Waay B. V. 1920.

4. For a summary of the Mount Govardhan episode in the context of the life story of Krishna, see Zéphir in this book, 153.

5. Groslier 1924, descriptive caption facing pl. XXX. Groslier was also the first to correctly identify the material as gray sandstone, though his lead was not followed for many decades.

6. Parmentier 1927, fig. 84; Cuisinier 1928, 81; Briggs 1951, 36.

7. In 1927, A. K. Coomaraswamy wrote that the sculpture is a Lokeshvara and "exhibits the Indianesque school of Funan at its highest level of achievement." See Coomaraswamy

1927, 183. Victor Goloubew responded in his review of the volume that he doubts it is Lokeshvara, but he does not offer an alternative. See Goloubew 1927, 415. Otto Fischer and Benjamin Rowland perpetuated Coomaraswamy's identification, though Rowland acknowledged the possibility that it might be Krishna. See Fischer 1928, 226, and Rowland 1954, 227, pl. 155.

8. Henri Léon Célestin Mauger was born on January 3, 1903, in Rochefort-sur-mer in western France. No records of Mauger's activities or date of death following his resignation from the EFEO in 1954 have been located. I am grateful to Christophe Pottier, Directeur des études at the EFEO, for seeking information from the database of the Institut national d'histoire de l'art and confirming Mauger's apparent disappearance after 1954.

9. Henri Mauger, EFEO Report on the work of Conservation during the months of November and December 1935; see Mauger 1935–36. Translated from the French by Molly Stevens.

10. See fig. 22 and Appendix. The upper stele with hand, right elbow, and a left thigh were from the Cleveland Krishna (pl. 6); the upper left arm, upper right arm, both legs, and the lower stele with feet were from the Phnom Penh Krishna (NMC, Ka.1641, pl. 5); a wrist and forearm section were from the unidentified deity (NMC, Ka.1608, pl. 7); and one piece remains unattributed.

11. NMC, Ka.1641. Pierre Dupont identified this figure as Krishna Govardhana in Dupont 1955, 26, pl. VIII.A, but Stanislaw Czuma considered this to be an erroneous identification and instead considered it to be a Trivikrama, seeing the angle of the break as possibly indicating a raised leg, in Czuma 2000, 130. Richard Cooler also tentatively suggested the identification of the Phnom Penh Krishna as Trivikrama in Cooler 1978, 30, fig. 4.

12. In the art of India, several different figures are regularly depicted with one raised arm, but each is consistently slightly distinct from Krishna lifting Mount Govardhan. A universal monarch (chakravartin), for example, brings a shower of coins from heaven with one arm raised, but the palm faces out (Coomaraswamy 1929, 57–61). Balarama and serpent deities known as naga sometimes are shown with one arm raised in the same royal gesture with palm out and fingers up, connoting control of rain (Srinivasan 2008, 93–104). Sometimes Shiva holds up one arm to catch the Ganges River, but always while grasping a lock of his hair (Francis, Gillet, and Schmid 2005, 600, fig. 10). The Trivikrama relief of c. 625 in the Varaha II Cave temple at Mamallapuram shows his main right hand touching the ceiling above, palm facing up in accordance with textual descriptions in the Vaikhanasa Agama (see Srinivasan 1964, 147, pl. XLIV). I thank Charlotte Schmid for sharing her recognition of this iconography. The Trivikrama identification is tempting, since the Rudravarman inscription (K.549; see note 25) found at the site mentions Trivikrama (Coedès 1942, 155–56). Nevertheless, there is no parallel for a two-armed Trivikrama in this pose, and the inscription is problematic, so it remains untenable.

13. For a list of the earliest images of Krishna lifting Mount Govardhan, see Hawley 1983, 339–41. Several scholars posit dates for small relief sculptures depicting Krishna lifting Mount Govardhan in the second century AD, but their arguments are neither cogently explained nor widely accepted. Goetz 1951, 54; Bhattacharya 1996, 28; Narayanan 2015, 132.

14. Vats 1930, 218 and pl. XLVI.d. It is now in the collection of the Bharat Kala Bhavan of the Benares Hindu University, where it is on display, complete with the addition of arms fashioned in 1940 by a well-meaning restorer. Plaster-of-paris arms were added when the sculpture was shifted from the Archaeological Museum, Sarnath, to the Bharat Kala Bhavan. The hand supporting the mountain is original. See Biswas and Jha 1985, 37 and plate IV, fig. 9; Harle 1974, 20, fig. 63.

15. The two colossal images of Vishnu's man-lion avatar Narasimha from Ramtek in Madhya Pradesh of c. AD 420 (Bakker 1997, pl. XXXIII) and the theriomorphic Varaha, or boar avatar, at the fourth- to sixth-century site of Eran in Madhya Pradesh (Cecil and Bisschop 2019, 386, fig. 12) indicate that the period leading up to the creation of the Phnom Da sculptures was a time when monumental Vaishnava sculptures were prevalent in India.

16. During my 2015 visit to Bhakaria Kund, the site of the Varanasi Krishna's discovery, local residents of the still Muslim neighborhood told me that annually a Brahman comes to perform a pūja, a devotional ritual, in honor of the Krishna that used to stand in the temple at the "power place," or tīrtha.

17. In Cave 15 of Ellora, dating to c. mid-700s, Krishna is multiarmed and his hand supports only the ceiling of the niche in which the relief has been carved.

18. Paul Lavy has recently argued against Pallava stylistic influence in pre-Angkorian Southeast Asia. See Lavy 2020, 213–49.

19. Krishna's quelling of the serpent Kaliya was nearly as prominent in India, but as yet no large-scale image has come to light. See ANG Choulean's essay in this book. See Hawley 1979.

20. See the incisive assessment of Robert L. Brown on the importance of the fifth to seventh centuries as a time when Indian art had a "sudden and profound impact" on the art of Southeast Asia. Brown 2017, 43.

21. Other pre-Angkorian sculptures found in southern Cambodia have been identified as Krishna, but they do not obviously relate to a narrative scene from his life story. They are small and static icons of a youthful god, with curly hair and the remains of triple pigtails; they otherwise seem to have little relationship with the Krishnas of Phnom Da or nearby Wat Koh (map 2). Henri Parmentier was probably correct to question their identification as Krishna. Parmentier 1927, 320; Groslier 1931, 62, pl. XVII.

22. Boisselier 1955, pls. 86–90; Guy 2014, 93–105.

23. Guy 2014, 7 and 130–31; Dalet 1940, 492–93, pl. LV.A and B. For similar sculptures from Thailand and their close connections with the sculpture of India see De Havenon 2006, 81–98, and for its identity as Vasudeva-Krishna see Lavy 2014, 158.

24. See Vickery 1998, 105, for inscription K.709 and Dowling 1999, 51–61, for arguments in favor of a later seventh-century dating.

25. A total of five inscriptions have been found at Phnom Da. The earliest, K.1216 (NMC Ka.2445), written on a sacred deposit stone, dates to c. 600 and is the only one that is likely to be contemporaneous with the sculptures of the eight gods of Phnom Da. According to the records of the NMC, it was found in a Vietnamese pagoda (modern Buddhist temple) at the foot of Phnom Da in the 1990s. Four incised symbols radiate from a central square: conch and discus, which are attributes of Vishnu, the trident of Shiva, and the thunderbolt (vajra) of Indra. The short Sanskrit inscription is legible and complete and reads namo jaimanaye stanayitnave svāhā, or "Homage to Jaimani, to Thunder, Hail!" (Griffiths et al. 2012, 246). Jaimani, or Jaimini, is the name of a sage from the Mahabharata, and is known from other inscriptions from Cambodia and Vietnam in invocations for protection from evil and in association with Vedic fire sacrifice (Soutif 2009, 338n627; Griffiths et al. 2012, 245–46). The only other pre-Angkorian inscription from Phnom Da, K.670, dated to c. 700, is too fragmentary to translate, but the Khmer word for Lord, kamratā[ṅ añ], can be discerned (Vickery 1998, 107). Inscription K.556 mentions Rajendravarman (r. 944–967) and a gift to Vishvarupa (Coedès 1942, 19–20, and Baptiste in this book, 130). K.830 was found in Prasat Phnom Da and is dated 1106 during

the reign of Jayavarman VI (r. 1080–1107); it mentions the dedication of a tract of land that had been purchased by a *tapasvin* (ascetic) and offered to Vishvarupa, Lord of the Universe (Coedès 1953, 278–79, and Baptiste in this book, 137–38). Inscription K.549 of c. 1100s mentions the last king of the Funan dynasty Rudravarman (r. 514–539) and several deities, including "Lord of Govardhan" (Coedès 1942, 155–56, and Baptiste in this book, 128–29).

26. A gold coin of Ishanavarman and an inscription (K.709) mentioning Ishanavarman were discovered in the environs of Angkor Borei. See Porte and Chea in this book, 101, and Revire 2016b, 402, fig. 2.3, for an image of the coin, and Vickery 1998, 105, for inscription K.709.

27. The attributes in the hands of the *Vishnu with Eight Arms* are not attested in any other known image of Vishnu or any surviving text. The attributes in his right hands are a flame, a baton, an antelope skin, and a mace. In his left hands are a broken pedestal, a bundle of grasses, a thunderbolt, and a ewer. See Bhattacharya 1964–65, 78, for his interpretation of their meaning with regard to the protectors of the eight directions of space. The high crown, hairstyle of a royal warrior, and lack of a third eye imply that Vishnu is the main identity of this divinity.

28. Mauger and others have noted that the ceiling level of the sanctum is too low to accommodate a sculpture of the height of either Harihara sculpture on its pedestal, even though both were found near the temple. However, the ceiling is not actually present in the temple as it stands today; only a stone ledge around the upper wall of the sanctum indicates the location of where a wooden ceiling was once inserted. The temple could have been originally designed to house a shorter icon, but after it was purportedly moved and repurposed at Phnom Da—as Mauger cogently argues (Mauger 1936, 82–83)—the level of a ceiling insert could have been adjusted accordingly; there is ample space to accommodate a sculpture of the size of either Harihara (see Parmentier 1927, t. 2, pl. LI), since the vault of the superstructure is hollow, if the level of the false ceiling were raised or a textile canopy were used instead.

29. Height at the center of each cave, just inside the notch cut in the ceiling, possibly marking the location where an image would have stood, allowing ample space for circumambulation: Cave G: 287 cm, Cave F: 292 cm, Cave E: 340.3 cm, Cave D: 294.5 cm, Cave B: 318.7 cm.

30. Louis Delaporte also notes that Silvestre, whom he calls simply "M. Pierre," director of the Saigon Botanical Garden in Vietnam, toured southern Cambodia and mentioned the existence of important grottoes. Delaporte admits that he was completely unaware of their existence when he passed through the region in 1873. Delaporte (1880) 1999, 26n1.

31. Aymonier 1900, 199.

32. Parmentier 1927, 120n2.

33. "*La grotte abrite une statue qui contre l'ordinaire est vraiment belle; chose rare, elle tenait le bras gauche levé en l'air.*" Parmentier 1913, 5.

34. Revire 2016a, 160. The current location of this Buddha is unknown, but it joins the Durga (fig. 15) and the votive linga (NMC, Ka.265) as small-scale movable stone sculptures at Phnom Da that apparently predate the eight gods of Phnom Da.

35. Lunet de Lajonquière noted the geometric shaping of the entrance and that the interior was infested with bats and the air of the cave was "irrespirable." He also documented Prasat Phnom Da and Ashram Maha Rosei. It seems he did not venture to the northern and eastern sides of Phnom Da, so he may never have seen Cave D. Lunet de Lajonquière 1902, 12.

36. He notes twice that the "Stoclet" figure was not the same as the one he saw, though they look very similar. Parmentier 1927, 121, and 266–67n1.

37. Porte 2016, 148n31.

38. Parmentier 1927, 121.

39. Ibid., and see Porte and Chea in this book, 97. Parmentier notes that the local people said the piece was found in the natural chamber that preceded the cave, which is rather vague and can refer possibly to Cave E or to the space outside the door to Cave D. "*La pièce avait été trouvée, au dire des indigène, dans la salle naturelle qui précède la grotte.*"

40. Groslier 1924, 142. Bertrand Porte first drew our attention to the transformed images in Porte 2016; see also Porte and Chea, in this book, 95

41. Elizabeth Cecil and Alexis Sanderson have discussed what they call doubles of sacred places in early Cambodia in a Shaiva context, so Phnom Da may stand as a Vaishnava example of a similar phenomenon. Cecil 2021, 344–45, and Sanderson 2003, 403–21. I wish to thank Robert L. Brown for drawing my attention to Cecil's article and this important relationship. In India, examples of the transfer of sacred geographies prior to the seventh century are only known in textual sources. The *Skanda Purana* 3.60, for example, identifies the Godavari River as the Ganges of the south during the fourth to fifth century. My thanks to Phyllis Granoff for identifying this passage and many others that show the prevalence of the ritual transfer of sacred geographies to new locations in Indian texts.

42. The *Harivamsha*, or Geneaology of Vishnu. See Couture 1991, 246, verse 28, and Brodbeck 2019, 188, verse 28.

43. Couture 2015, 206, 295, 312–13; see also Brodbeck 2019, 185, verse 18.

44. Hawley 1979, 208–9.

45. Ibid., 210–11.

46. Balarama changing the course of the Yamuna River is related in the *Vishnu Purana*, Book V, chapter 25 (see Wilson 1961, 242–43n2) and the *Harivamsha* (see Brodbeck 2019, 247–50). It is interesting to note that his dragging of the Yamuna River has been interpreted as alluding to the construction of canals for irrigation. The construction of canals in the region of a mountain echoes the landscape around Phnom Da. See Wilson 1961, 242–43nn2–3. For a thorough discussion of Balarama's association with agriculture and even Mount Govardhan itself in the Indian subcontinent, see Srinivasan 2008, 93–104.

47. Schmid 2010, 618, fig. 52.

48. These kinds of ringlets are on royal figures in Ajanta, Cave 3 and Cave 26 dating to c. 475–500. See Spink 1990, 17, and cover image. Numerous examples have also been recovered from the Gangetic plain. See Biswas and Jha 1985, 65, cat. no. 71, and pl. XIX, cat. no. 34; Pal 1978, 104. The sculptures datable to c. 500 from the north-central Indian site of Deogarh also have coiffures consisting of rows of ringlets. See fig. 86 and Harle 1974, fig. 103. Thus, this hairstyle appears to have been fairly ubiquitous during the late fifth to sixth century across the north of India.

3333

33

88

22

49. Pierre Dupont identified this figure as Lakshmana. Dupont 1955, 25, pl. VI.B.

50. Dupont credits Jean Boisselier with the identification, but without citing a publication. Dupont 1955, 24, pl. 6.

51. Small bronze figures holding an axe datable to the Angkorian period of the eleventh to twelfth century are identified as Parashurama in the collections catalogue of the National Museum of Cambodia, but this identification may be conjectural, since they appear more as guardians than a god or a Brahman (Ga.5477, Ga.5471, Ga.5459, Ga.4172, Ga.2617, Ga.2654).

52. CHEA Sambath, director of the Angkor Borei Museum, explained that Phnom Bathep appears to have been a man-made hill, constructed from the earth removed during excavation of the nearby ancient water tank (baray) p. 13; see map 2. Foundations and a black slate moonstone are visible on the surface of the overgrown mound.

53. See Porte and Chea in this book, 98. Some scholars have sugggested that the sculpture could have depicted Brahma. Email communication from Bertrand Porte, 2021.

54. A linga of exceptionally large size was found at Wat Sleng Khand of Tamlap Treang in Takeo, according to a letter from George Groslier, director of Cambodian Arts in Phnom Penh, to the director of the EFEO in Hanoi, dated June 11, 1931. Archives of the EFEO, Paris. Many inscriptions also refer to the dedication of lingas.

55. Parmentier 1927, 122.

56. Dating to the same period as the eight gods of Phnom Da, c. 600, the tiny sandstone linga measures 17.1 x 19.9 x 18.2 cm. National Museum of Cambodia, Ka.265.

57. For recent discussions of Wat Phu see Lorillard 2010–11, 187–204, and Cecil 2021, 341–83.

58. Porte 2016, 135–38.

59. Groslier 1925a, 311, and pl. 30 A, which records a pre-restoration photograph. In Groslier 1931, 68, however, he writes that this sculpture was found in the west cave of Phnom Da, which would mean Cave B.

60. John Guy dates this sculpture to the 500s, a period preceding the large-scale sculptures from Phnom Da. He suggests that this work is small and portable and may have been relocated to Phnom Da with that site's rise to prominence in the 600s, in all probability from the vicinity of Angkor Borei. Guy 2014, 137, cat. no. 63. Groslier also considers this figure to predate the large-scale Phnom Da sculptures. Groslier 1925a, 310–11.

61. Email communication from Philippe R. Stoclet to the author on February 22, 2020.

62. Sotheby Mak van Waay B. V. 1920.

63. The lot description identifies the figure as a "Personage in black basalt," which is the first misidentification of the type of stone in which the work has been carved. Several have identified it as limestone. See Visser 1948, pl. 198.

64. Thun-Hohenstein, Murr, and Franz 2012.

65. Jeanne Cuisinier described the sculpture in this setting: "And now we come to what is, in our opinion, the masterpiece of the whole collection (which includes also, as we have said, miracles of mediaeval European art), or, at any rate, the masterpiece of the Oriental works of Art. It is not necessary to describe this wonderful Pre-Khmer warrior (seventh or eighth century AD); it is enough to look at him. One thing, however, we are bound to say, and that is with what understanding of his beauty, with what a real artistic sense, his fortunate possessor has been able to show him. The mutilated warrior, rather less than four feet high, is still imposing, in spite of his broken arms and legs. He stands by himself in a rotunda upraised in a long gallery; this is kept in half-darkness, all the light being concentrated on the basalt, which absorbs and irradiates it. The effect is very striking (Plate E)." Cuisinier 1928, 81.

66. Levetus 1914, 4.

67. Dumoulin 2011, 315.

68. This wording of where the fragments were found is in the review of De Coral-Rémusat 1936, 225.

69. Mauger 1935; see Mauger 1935–36.

70. Mauger, Report on the work from the month of August 1936, unpublished.

71. Mauger, Report on the work of September 1936, unpublished.

72. De Coral-Rémusat 1936, 226.

73. Parmentier 1927, 266–67n1.

74. Stanislaw Czuma specifically refers to her publication as the one that inspired him to find the missing parts of the sculpture that may have survived. See Czuma 2000, 133.

75. Dumoulin 2011, 315.

76. Letter from Paul Mallon to Stanislaw Czuma, January 26, 1974. Courtesy CMA Archives.

77. Ibid.

78. Czuma 1979, 289.

79. Dumoulin 2011, 316. Czuma writes that the Verhasselts vaguely remembered that the fragments were there when they purchased the house and were buried shortly afterward. "The water cistern adjacent to the house was installed and, partially to give it support and partially to get rid of the useless fragments, they were buried around it. The exception was the above-mentioned fragment of a thigh, which was overlooked." See Czuma 2000, 133.

80. Letter from Paul Mallon to Stanislaw Czuma, January 26, 1974, and Czuma 1979, 289.

81. Note pendant to the acquisition of the torso, CMA Archives; Sherman Lee correspondence, dated August 6, 1973.

82. Dupont 1955. The Cleveland Krishna body with head is in pl. V.A and the Phnom Penh Krishna body with head is in pl. VIII.A.

83. Ibid., 29, 35, 37, and pl. VII.B.

84. The Stoclets may have first offered the torso to John D. Rockefeller 3rd, a collector of Asian art, who turned it down, perhaps on account of his personal rule to not collect fragmentary works, leading to Sherman Lee's then having first right of refusal, according to an agreement between Rockefeller and Lee.

85. CMA Archives.

86. CMA Archives.

87. CMA Archives.

88. De Coral-Rémusat 1936, 225–26, and Dupont 1955, 29.

89. Czuma 1979, 289–95.

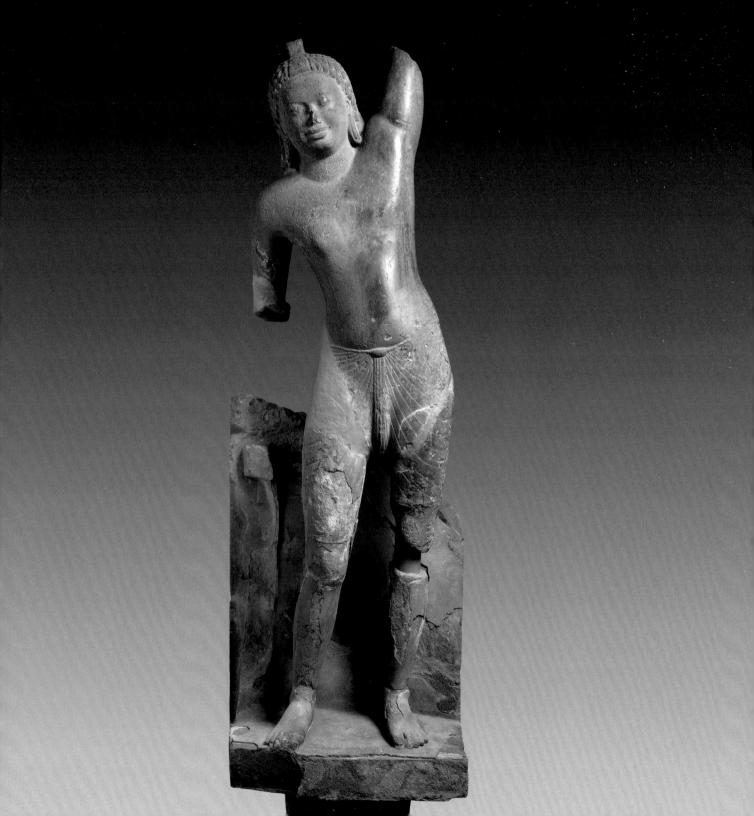

A CONSERVATION HISTORY OF THE KRISHNA AT THE CLEVELAND MUSEUM OF ART

BETH EDELSTEIN, COLLEEN SNYDER, AND AMARIS STURM

The conservation and reconstruction of *Krishna Lifting Mount Govardhan* at the Cleveland Museum of Art revisited a restoration our predecessors conducted at the museum forty years ago. Over the intervening decades, improvements in communications, technology, engineering, equipment, materials research, and developments in the conservation profession have prompted a significant reconsideration of the figure and its appearance. New tools and technologies available today not only facilitated this re-evaluation but were also crucial in the disassembly and reconstruction of the sculpture that followed. Decisions made in the current project also acknowledged the potential for future discoveries about this figure, and the certainty of continuing advancements in technology, as ours is only one chapter in the long and colorful history of this monumental sculpture.

Figure 20. *Krishna Lifting Mount Govardhan* (pl. 6) after the 1978–79 reconstruction. 202.7 (without the 43 cm tenon) x 68 x 42.5 cm

1973–79

The Krishna sculpture first entered the CMA collection in 1973 and was displayed as a single, elegantly disposed torso (fig. 21). In 1978–79, CMA conservators Frederick Hollendonner (1927–1990) and Bruce Christman (b. 1953) reconstructed a nearly complete figure of Krishna using additional stone fragments retrieved from their previous owner in Brussels by then curator Stanislaw Czuma.[1]

Figure 21. *Krishna Lifting Mount Govardhan* (pl. 6) installed in the Oriental Gallery, the Cleveland Museum of Art, 1976. Photographed for William E. Ward; image courtesy of CMA Archives, 44393B

Hollendonner's diligence in recording treatment details in text and images has been invaluable, underscoring the conservators' professionalism at a time when documentation was not always prioritized. The end result of this reconstruction was the Krishna as displayed in the museum's Southeast Asian galleries until 2017: a standing figure placed against a wall, with fully assembled legs and feet, his left arm truncated but lifted aloft in the recognizable gesture of Krishna lifting a mountain overhead (fig. 20).

The challenges of reconstructing a complete figure with the seventeen parts brought from Brussels were daunting. To begin with, there were too many pieces for a single figure, including fragments of three legs and various arms (fig. 22). Fitting the heavy, unwieldy stone pieces together in different configurations to determine the right arrangement was physically difficult; the torso alone weighs nearly five hundred pounds. The conservators attempted various permutations, assembling the sculpture both lying down and suspended upright (fig. 23). Czuma, Hollendonner, and then museum director Sherman Lee conferred endlessly about the proper assembly. With only the fragments at hand to use, the reconstruction may have been driven at least in part by a desire to create a coherent standing figure that conveyed the monumentality and elegance of the important group of sculptures from Phnom Da.

Figure 22. The 17 sculptural sandstone pieces and associated surface fragments from Phnom Da, recovered in Brussels, upon arrival in Cleveland, December 1977. Image courtesy of CMA Archives, 46009

The reconstruction materials and techniques used were standard for the conservation field in the late 1970s and effectively secured the heavy stone fragments in alignment for the foreseeable future. The fragments chosen for inclusion in the reconstruction were joined with three-quarter- and half-inch-diameter steel rods, set with epoxy into newly drilled holes in the stone fragments. The entire figure was bolted to a large aluminum plate using additional steel rods set into the stone to support its weight and unify the object for easier handling. Missing sections of the legs were filled in with bulked epoxy putty and/or metal casings. These fills were painted to be visible upon close examination yet allow for a unified impression of the complete original form (fig. 20).

The fragment comprising the upper stele with left hand was a significant area of discussion at the time. A horizontal strut of stone present on both the torso and upper stele sections suggests that the two were once joined (see fig. 10); however, in his 1970s report, Hollendonner noted that when the broken strut of the torso interlocked with the corresponding part of the upper stele, the left upper arm did not seem to align well with the hand. Furthermore, the distance between the break at the raised arm and the wrist appeared too short to accommodate an elbow and a forearm. To clarify this question, core samples were taken from each side of the adjoining strut between the upper stele and torso, and from the right thigh (see fig. 39). An analysis by Philip Banks, a Case Western Reserve University (CWRU) geologist, noted that "no criteria sufficient to prove or disprove a match were found. Two cores taken from the stone on either side of the presumed surface of juncture are more similar to each other than to a single core taken elsewhere in the sculpture, but this is not adequate proof of a match without further statistical validation."[2]

Without additional samples of stone from other Phnom Da sculptures, or other studies of similar sculptures, there was insufficient evidence to prove the relationship between the samples. Banks's report concluded that "reconstruction of the sculpture must depend on the probable artistic validity of the result rather than the intrinsic parameters of the stone itself." Between the uncertain fit and the inconclusive analysis, the ensuing reconstruction prioritized the leg and base fragments; the Krishna was reassembled with a complete lower half, but without his upper stele and hand. Eight pieces in all were attached to Cleveland's torso: three comprising the lower stele, two shins, two thighs, and one elbow. The nine remaining pieces, consisting of two joined parts of the upper stele with hand, one shin, one thigh, one wrist, one forearm, two arm pieces, and an unidentified fragment, were retained until 2005, when Czuma was finally able, after sixteen years of unsuccessful attempts,[3] to contact colleagues in Cambodia and arrange for their return.

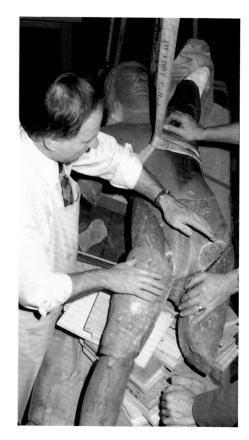

Figure 23. CMA objects conservator Fred Hollendonner examines the alignment of the pieces, shown here with a temporary fill connecting left arm to hand, Cleveland Museum of Art, 1978.

Building on the foundation of goodwill laid by Czuma's return in 2005 of the nine fragments to Cambodia, his successor, Sonya Rhie Mace, was able to establish a collaborative relationship with colleagues in Phnom Penh. This allowed for an ongoing exchange of information and photographs that was impossible during the late 1970s, when the National Museum of Cambodia was closed during the time of the Khmer Rouge regime. The NMC holds six of the eight monumental pre-Angkorian Phnom Da sculptures (pls. 1, 3–5, 7, 8), including a second figure with an upraised arm also identified as Krishna Lifting Mount Govardhan. Most of the fragments returned by the CMA in 2005 were used by conservators at the NMC in new restorations of this group of figures, as Bertrand Porte and CHEA Socheat describe in their essay in this book.[4] Two of the fragments, the upper stele with hand and a lower leg, were reversibly assembled with the Phnom Penh Krishna (see fig. 74), though lingering uncertainties remained about the upper stele fragment in particular. In January 2014, Porte, in charge of the sculpture conservation partnership between the EFEO and the NMC, noted to Mace that the broken strut on the back of the Cleveland torso was almost certainly the clear counterpart of that on the upper stele, reopening the decades-old question of this fragment's attribution.

When the Phnom Penh Krishna traveled to the United States for the first time for an exhibition at the Metropolitan Museum of Art in the summer of 2014, CMA conservators and Mace secured permission from the NMC director and the Ministry of Culture and Fine Arts of the Kingdom of Cambodia to laser scan the upper stele section.[5] With the help of Sears think[box] at CWRU, the Cleveland Krishna was scanned in the CMA galleries so that the two sections could be digitally combined.[6] Three-dimensional digital modeling of the two sculptures enabled a reassessment of the alignment with which Hollendonner and his team had struggled, revealing that the join between the torso and upper stele fit nearly perfectly, and that the hand and upper arm could be properly aligned with sufficient spacing when viewed vertically and from a lower vantage point. Christian Fischer, a conservation scientist and geochemist with the UCLA/Getty Conservation program, provided the in-depth analysis and comparative studies that were missing in 1979, as described in the following chapter. Fischer re-examined the stone samples taken at that time, now with the context of recent studies of Cambodian sandstone types, and in comparison with additional samples from the six Phnom Da sculptures at the NMC.[7] With this information, Fischer could definitively interpret the samples as supporting the fragments' relationship to each other.[8]

The digital models and physical three-dimensional prints of the fragments illustrated the consequences of this conclusion: if the upper stele were reattached

to the torso in its current state, the stele would be at an incorrect angle to the sculpture overall. The torso would have to be turned and moved forward, requiring a complete reversal of the 1978–79 reconstruction (fig. 24). In an unprecedented decision following negotiations with the Ministry of Culture and Fine Arts of the Kingdom of Cambodia, the upper stele with hand was returned to the CMA in September 2015.[9] After securing funding and outfitting the museum's objects lab with a custom-built bridge crane and hoist for vertical assembly, a large-scale conservation project began in 2017 to disassemble the sculpture and reassemble it with the upper stele fragment.

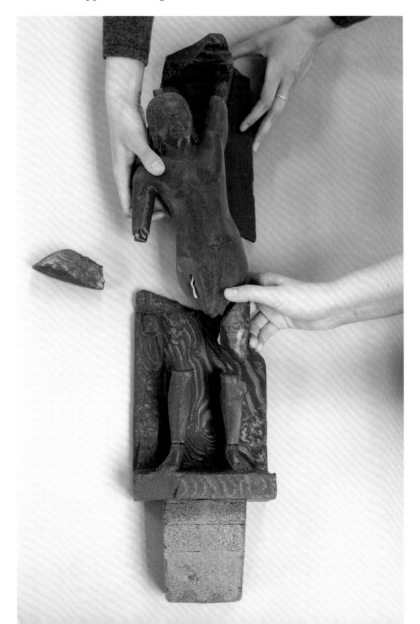

Figure 24. 3-D prints (both full-scale and miniature, seen here) were produced from laser scans with assistance from colleagues at Sears think[box] at Case Western Reserve University, and they convincingly demonstrated that the upper stele with hand section fits well with the Cleveland torso, but that the position of all the leg fragments, besides the proper left thigh, would have to change.

2017–20

In November 2017, the sculpture was de-installed from the galleries and arrived in the conservation lab. Deconstructing the figure presented several challenges: the materials used in 1979, including epoxies and polyester resins, are considered irreversible when applied to a porous material like sandstone. The removal of these materials could cause damage to the original stone surface if done in haste or without proper methods.

The primary goal of deconstruction was to remove all added materials and return the stone, to the furthest extent possible, to its originally excavated state. The figure's right hip and left knee presented the most accessible points with which to begin, as both had large fills of epoxy and metal that could be cut through with minimal risk of damage to the stone (figs. 25, 26). Once these two connections were severed, the upper and lower halves of the body were removed from the aluminum plate. The extremely close-fitting joins at both ankles, right knee, and left hip, as well as the four- to ten-inch-long threaded steel rods inserted at every join with permanent adhesives, required nearly two years of careful work to separate and remove. The variety of tools and methods attempted and abandoned in this effort could fill its own chapter; equally long would be the list of colleagues who thoughtfully and helpfully contributed invaluable ideas and experiences.[10]

Figure 25. Co-author and conservator Beth Edelstein cuts through the aluminum tube and steel pin at the left knee, Cleveland, 2018.

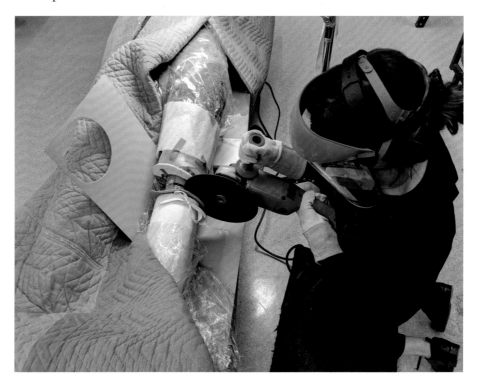

As described by Mace in the previous chapter, the fragments of the legs and upper and lower stelae had been discarded by the Stoclets in their neighbor's garden in Brussels and had remained buried outdoors for decades before they were excavated and retrieved by Czuma. As a result, they showed extensive contour scaling, a type of deterioration resulting from water penetration and evaporation during cycles of wet and dry and warm and cold environments. Losses to the surface along the contours of the object, subsurface voids, and networks of fine surface cracks are characteristic consequences, and loss of additional stone during the often forceful methods of deconstruction remained a risk. Previous stabilization efforts in 1978–79 and later had resulted in a network of fine dark lines along the cracks, particularly noticeable in Krishna's calves, where adhesives had saturated the sandstone. To prevent further darkening while treating the still-unstable surfaces, CMA conservators employed a recently developed method of pre-saturating the porous stone with a slow-evaporating and immiscible solvent before introducing an adhesive (fig. 27).[11] A combination of well-established and newer methods and materials, including the use of the CMA's Nd-YAG laser, proved successful in reducing the many types of staining on the sculpture, and in stabilizing the delaminating surfaces without visible alteration.[12]

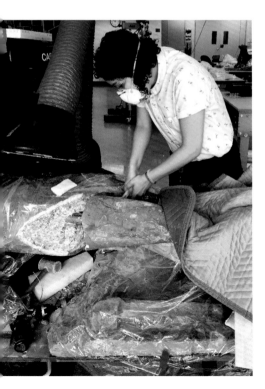

Figure 26. Conservation assistant Margalit Schindler removes epoxy from the filled-in area at the figure's right hip, Cleveland, 2018.

Figure 27. Co-author and conservator Amaris Sturm consolidates flaking stone on the back of the upper stele, Cleveland, 2018.

Figure 28. Using digital models produced by photogrammetry, a section of the Phnom Penh Krishna (lighter gray) was digitally fitted to the model of the right thigh in Cleveland (darker gray), confirming the close fit between them. Photogrammetry models courtesy Nicholas Josso and the Cleveland Museum of Art, digital pairing by Marcus Brathwaite of Sears think[box], 2019

As this work progressed, the conservation team was also planning the reassembly of the fragments. Rather than construct a monolithic wall-mounted figure again, Mace and the conservation team envisioned a modular assemblage of the figure's three major sections—upper stele with hand, torso with attached thighs, and feet with attached shins—each supported separately on a freestanding structure. A steel mount with wide base and vertical columns was designed that would enable these sections to be displayed in proper relationship to each other, without being permanently attached.[13] This concept aligns with current ethics in the conservation profession that promote reversible or re-treatable approaches, prioritizing the integrity of the object while ensuring its safety and longevity. The three primary goals were to enable the sculpture to be more readily moved and potentially loaned to other institutions, to allow for the sculpture to be viewed in the round as it would have been in its original cave temple location, and to leave room for additional discoveries about the disposition and provenance of the fragments.

This last goal proved even more prescient than originally intended. In November 2018, Porte and SOK Soda, head of stone conservation at the NMC, were reconsidering the installation of the Phnom Penh Krishna after the upper stele section had been transferred to Cleveland. Previously, when looking at images of the Cleveland Krishna they had noted that the hem of the *sampot* (the garment Krishna wears) did not fall at the same level across both thighs, and they questioned the large gap at the upper right hip (see fig. 20). Once the epoxy fill was removed, exposing the upper break plane of the right thigh for the first time since 1978, they confirmed that it closely resembled the contour of the break at the Phnom Penh Krishna's right hip. Again utilizing photogrammetry modeling to share details of the two sculptures across the world, the two pieces were digitally joined with a convincing result (fig. 28).[14] From there, the rest of the right leg and even the lower stele with feet were called into question, as the right knee and ankle looked well aligned. If the entire right leg belonged to the Phnom Penh Krishna and not the Cleveland Krishna, then the feet and base, as well as the left shin, would most likely follow suit.

Over the following year, as the fragments were slowly separated, additional examination of the joins, new digital models, and consultations with Mace, Fischer, Porte, and Sok contributed to a clearer understanding of the proper placement of the fragments. The study of Cambodian sandstones has advanced significantly since the last reconstruction, and CMA conservators consulted colleagues specializing in this area (see note 2). Though their experiences confirmed that petrographic analysis or surface elemental analyses would probably not provide clear answers, a suggestion that computed tomography (CT) scanning could reveal patterns of density variation in the stone eventually

Figure 29a, b. The right leg, when still joined at the knee by a steel rod (appearing as a white disk in cross-section), was imaged with computed tomography (CT) at the Cleveland Clinic, Cleveland, 2019. The upper image (a) shows a double crack in the thigh section that continues into the shin section in the lower image (b). The continuous cracks demonstrate that the two fragments were once a single piece of stone. Photos: Anthony Mangelli, Cleveland Clinic

pointed us to the needed information. Once the right leg was detached from the feet at the ankle, CMA conservators took the fragments to the Cleveland Clinic for imaging.[15] Though typical sandstone bedding planes were not visible due to interference from the metal rods still present in the fragments, two hairline cracks through the center of the stone clearly continued across the knee join, from thigh to shin (fig. 29). This evidence supported the validity of the knee join and thus determined that the entire right leg belonged to the Phnom Penh Krishna. Later, after removal of the rods, a second scan of the left shin and right leg fragments provided a clearer picture of the bedding planes inherent in the

stone and supplied additional evidence to include the left shin in the reattribution to the Phnom Penh Krishna.

The lower stele section that includes the sculpture's feet, however, is too large to be examined with the same method. Industrial CT scanning for an object weighing more than six hundred pounds is not yet readily accessible. The relationship of this lower stele and the upper one had always been an open question, though, as the back plates differ in thickness by nearly one inch, with the lower one thinner than the upper. Furthermore, when the lower stele is aligned with the upper stele and torso, the position of the feet lies behind the centerline of the torso, requiring the legs to bend in a manner inconsistent with the existing knee and ankle joins. Finally, a third existing lower leg fragment, among the nine sent back to Cambodia in 2005, is the most likely replacement for the misattributed right shin and cannot fit with the lower stele.[16] All this evidence brought consensus to the decision to return the lower stele to Cambodia as well.

Sending most of the lower half of the sculpture to Cambodia spurred significant changes to the mount design in late 2019. The planned columns could be replaced by a structural support that mimicked the missing stele, both supporting and visually completing the sculpture (fig. 30), much like the one previously made for the Phnom Penh Krishna (see fig. 74). This new design also enabled a more streamlined torso mount, utilizing the two one-inch-diameter holes that had been drilled into the back when the sculpture was in Brussels. It also allowed for the placement of the lower right leg fragment that had been displayed with the Phnom Penh Krishna. The right lower leg arrived in Cleveland in October 2020. Since there is no point of contact with any remaining sculptural piece, a three-dimensional conjectural reconstruction, developed by Mace and Dale Utt of True Edge Archive, in which missing sections were digitally filled, served as the model for the placement in the assemblage (fig. 31; see also fig. 9). They based the length of the legs on the figure of Rama (pl. 3), whose head and body proportions are nearly identical to those of the Cleveland Krishna. The placement of the feet was drawn from the Phnom Penh Krishna (pl. 5), while locating the right hand on the hip followed from the orientation of the surviving elbow and comparisons with other sculptures, such as the Wat Koh Krishna (fig. 5), Varanasi Krishna (fig. 3), and later bas-reliefs (figs. 108, 109).

While the current mounting system represents a change from the 1978–79 reconstruction in many philosophical ways, the technology for attaching a metal support to a heavy stone fragment has not fundamentally changed. Load-bearing epoxy adhesives and structural steel components are still the most reliable materials. However, the conservation field has moved forward in mitigating the irreversible nature of this type of bond. Recent research has shown that adding an intervening barrier layer of Paraloid® B-72, an acrylic adhesive often used in

Figure 30. The new mount supports the torso, upper stele, and lower leg (clockwise from upper left) independently in the correct alignment to each other. Drawing by Carlo Maggiora

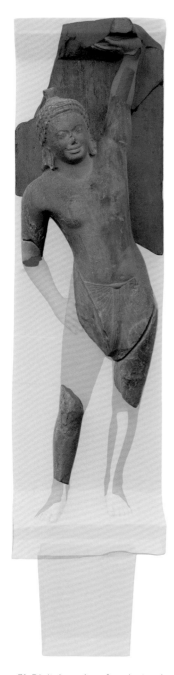

conservation, between the stone and the epoxy causes no reduction in strength but does facilitate later removal of the epoxy if needed.[17] In another small but important change, rather than permanently embedding steel rods into the torso as before, the holes now hold threaded anchors, so that the metal external mount can be bolted on and easily removed. As this part of the support suspends the torso on a cantilever arm nearly six feet above the floor, the security of the planned anchor and rod assembly was tested with the civil engineering department at CWRU.[18] Overall, the planning and fabrication of the mount was a collaborative effort among many museum staff members and independent engineers to create a structure that is as adaptable as currently possible, while still allowing for potential changes or any future discoveries.[19]

The newly reconstructed Krishna once again effortlessly holds up his mountain as originally intended (pl. 6). Though less grounded by his former heavy stone feet, the figure continues to convey a sense of monumental beauty and grace. As the current caretakers of this sculpture, the CMA conservators have been honored to partner with the National Museum of Cambodia in furthering our understanding of this important work of Khmer art, and we look forward to what will undoubtedly be the continuing story of Krishna and the sculptures of Phnom Da.

Figure 31. Digital overlay of conjectural reconstruction of *Krishna Lifting Mount Govardhan* (pl. 6) with 3-D models of the sandstone pieces, 2021. Image rendering: Dale Utt; scans and photogrammetry: Konstanty Kulik and Michał Mierzejewski

1. See Mace in this book, 55; Czuma 1974 and Czuma 1979.

2. Banks 1979.

3. In 1989, before the US had reestablished diplomatic relations with Cambodia, Czuma, as a member of the Committee for the Restoration of Angkor, traveled by way of his native Poland via Moscow to Phnom Penh to evaluate restoration work carried out by the Polish Conservation of Monuments and an Indian conservation team led by B. S. Naylal (Hubbard 1991). He was welcomed by CHEY Sophea, vice minister of culture; ING Sarin, director of the Royal Palace; OUK Chea, head of conservation at the NMC; OUK Sun Heng, director of the NMC; and PICH Keo, assistant director of the NMC. Czuma brought photographs and measurements of the unused sandstone fragments from Phnom Da in an effort to restitute them. However, still recovering from its extended closure, evacuation of Phnom Penh, and loss of staff under the Khmer Rouge regime, the officials were not in a position to manage an international transfer.

4. Five fragments were used in the reconstruction of the Phnom Penh Krishna: three arm fragments, the upper stele with hand, and a lower leg (see figs. 71, 72). The wrist and forearm pieces found their place with the as yet unidentified deity (pl. 7), also at the National Museum of Cambodia (Ka.1608).

5. Scanning and digital modeling in 2014 were facilitated thanks to Larry Becker, John Guy, Lisa Pilosi, Deborah Schorsch, and Ronald Street at the Metropolitan Museum of Art, and CMA conservator Samantha Springer.

6. Marcus Brathwaite, Ian Charnas, and Ben Guengerich from Sears think[box] performed the scans and created the digital models of Krishna in the CMA galleries in December 2014.

7. Carò and Douglas 2014; Carò 2009; Carò 2000; Carò and Im 2012; Douglas, Carò, and Fischer 2008.

8. Christian Fischer, via email correspondence to Samantha Springer, Bertrand Porte, and Sonya Rhie Mace, March 14, 2014: "Regarding the petrography of the sandstone, there is nothing much to add to the excellent report of P. Banks which clearly shows that the sandstone lithology, in particular the grain size, is very similar to the cores taken from the opposite struts on the backing plate and the sculpture. While he was correct in stating that this similarity does not provide a definitive 'proof' because of the grain size variability within the sandstone block used to carve the sculpture, to me it represents, however, a key supporting argument. In addition, based on my results on five samples from the Krishna in Phnom Penh, it is clear that the sandstone type is the same and probably from the same quarry, but more importantly, all these samples have a fine-grained particle size (closer to sample CL-1/CL-2), including the one from the backing plate with the hand (which indicates that both fine- and coarse-grained layers are also present in this fragment). Therefore, considering both the petrography data and the remarkable fit of the two struts that can be seen on the pictures, there is little doubt that the backing plate belongs in fact to your Krishna and that the apparent (but still possible . . .) 'inconsistency' mentioned by the conservators while trying to reconstruct the original sculpture might need to be reassessed."

9. Litt 2015.

10. Our gratitude goes to Adam Jenkins, Carlo Maggiora, Carolyn Riccardelli, Erik Risser, William Shelley, Norman Weiss, and George Wheeler for their invaluable assistance in meeting these challenges.

11. Recent developments in conservation, notably at the Winterthur/University of Delaware Program in Art Conservation, have explored the use of cyclomethicone silicone solvents, the material used for this treatment step. More commonly known as D4 or D5, these colorless, odorless, and moderately volatile solvents have proved successful in cleaning painted and other water-sensitive surfaces, and their possible uses within objects and stone conservation continue to be investigated. Before using it on the Krishna, CMA conservators tested D4 and D5 on stone samples, examining the solvents' ability to saturate stone surfaces, determining miscibility with potential solvents used to deliver the chosen adhesive, and assessing visual results after evaporation of the solvents.

12. Although poultices are not new to the field of conservation, the materials available to conservators have grown. Alongside cotton pads, Evolon® fabric was tested and used as one of the poultice materials for adhesive stain removal. This super-microfilament spun-bound fabric is highly absorbent and has been used for varnish and stain removal. Due to its high absorbency, pliability, and lack of solubility in the chosen solvents, it was an ideal material to be used as a solvent poultice on areas with adhesive staining. Laser cleaning with a Lynton Lasers Ltd. Phoenix laser (Nd-YAG 1064 nm) was the most effective method to remove remnants of gallery paint along the edges of the lower stele and surface grime and iron staining on the upper stele. Our thanks to Bob Simon and the Simon Family Foundation, a supporting foundation of the Jewish Federation of Cleveland, and to Albert Leonetti and Ruth Anna Carlson, for enabling the purchase of this equipment.

13. Mount concept, design, and drawings provided by Carlo Maggiora LLC.

14. Marcus Brathwaite of Sears think[box] paired the digital model of the NMC torso, created by Nicolas Josso, with the model of the CMA thigh, provided by Howard Agriesti.

15. CT imaging provided thanks to the generosity of Anthony Magnelli, MS, medical physicist at the Cleveland Clinic.

16. Joel Hauerwas and Marcus Brathwaite at Sears think[box] generated multiple combinations of the three thighs, three shins, and two stelae fragments with the two Krishna torsos to aid in assessing possibilities.

17. Podany et al. 2001; see also Riccardelli et al. 2014.

18. Modeling and strength testing designed and conducted by Luke Traverso, undergraduate research assistant, and Michael Pollino, associate professor of civil engineering, CWRU, Cleveland.

19. Engineering consultations provided by Emily Garrison and Christopher Ruiz, Silman Engineering, New York, and by Jon Leuthaeuser, Barber & Hoffman Inc., Cleveland. Mount fabrication services and problem-solving by Randy Gross and staff at VME LLC, Cleveland, CMA mountmaker Philip Brutz, and Carlo Maggiora LLC. X-radiography services thanks to Curt Gulley, Mark Behal, and staff at XRI Testing, Cleveland.

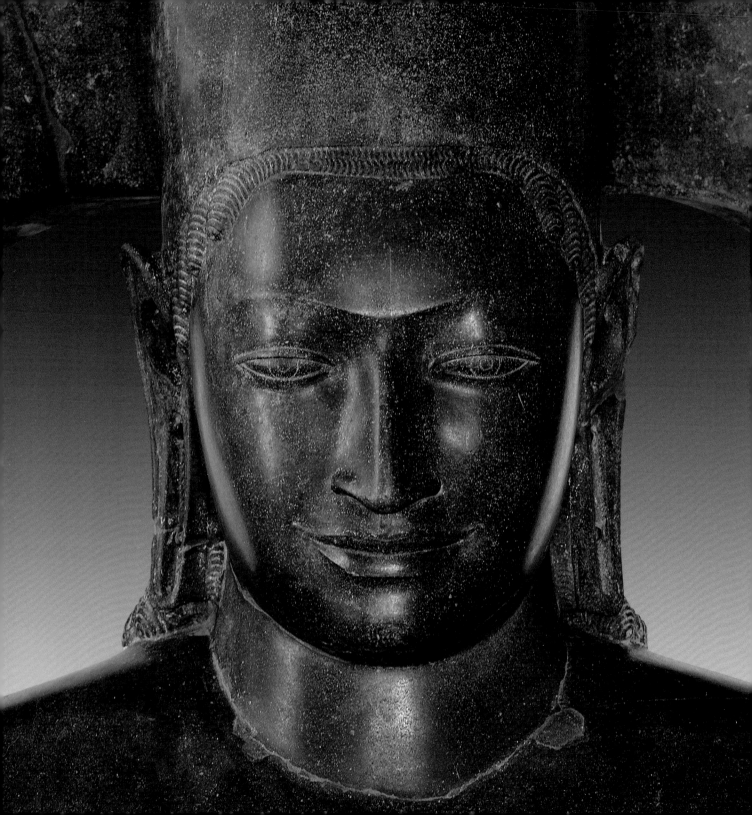

STONE MATERIAL CULTURE AT PHNOM DA: NEW INSIGHTS FROM RECENT SCIENTIFIC INVESTIGATIONS

CHRISTIAN FISCHER

In the course of several visits and archaeological missions led by French schol-ars from the end of the nineteenth century to the 1940s, eight original stone statues carved partially in the round were discovered at Phnom Da, the "Stone Mountain," located a few kilometers south of Angkor Borei, the purported pre-Angkorian ancient capital.[1] The iconography and sculptural style of this unique corpus, primarily from the Vaishnava pantheon, was extensively studied and discussed in the seminal work on pre-Angkorian statuary by Pierre Dupont, who grouped the sculptures under two main "Phnom Da" styles.[2] Based on epigraphic evidence,[3] most Phnom Da statuary production started with King Rudravarman (r. 514–539) and spanned more than one hundred years until the emergence of the Sambor Prei Kuk style under the reign of Ishanavarman (r. 617–637). However, this chronology was challenged with a later date attribution contempo-raneous with the Sambor Prei Kuk style,[4] though recently an early sixth-century date has been favored again on grounds of stylistic Indian influence and other considerations.[5]

Among these eight statues, the so-called triad, comprising the large-scale eight-armed Vishnu and two of his avatars, Rama and Balarama, is probably the most impressive and iconic rep-resentation of the Phnom Da style (fig. 33). The three sculptures were found under the brick rubble inside the Prasat Phnom Da, a large eleventh-century sanctuary built on the remains of an ancient pre-Angkorian brick structure (frontispiece pp. 2–3; fig. 34a).[6] Despite pronounced alterations caused by environmental, biological, and anthropogenic factors, their dark surfaces still show a remarkable luster, bearing witness to the high degree of finishing achieved by the artist(s). This visual aspect explains why the stone was often described as schist,[7] reflecting a causal-ity between this lithotype and its polishing potential that was indirectly referred to in an earlier work.[8] In fact, all Phnom Da sculptures are carved from a type of sandstone—also highly

Figure 32. *Vishnu with Eight Arms* (detail, pl. 1). Photo: Konstanty Kulik

Figure 33. The Phnom Da "triad" with the colossal eight-armed Vishnu (center, h. 288.5 cm) and his two avatars, Rama (left, h. 189 cm), and Balarama (right, h. 185.5 cm) in the galleries of the National Museum of Cambodia, October 2019. Photo: Sonya Rhie Mace

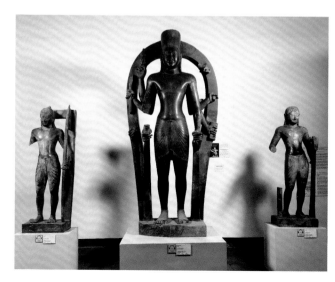

polishable—and this short essay aims to provide some insight on the characteristics and variations of the sandstones used for these images.[9]

Geological Context

Phnom Da is a rocky eminence composed of two main peaks (fig. 34b, d) and a third hill called Phnom Ngnel, or "Bald Mountain,"[10] that rise above the Mekong floodplain in the shadow of the larger and higher Phnom Borei (~164 m elevation), situated less than two kilometers farther southwest (fig. 34e). Both geomorphic features belong to a network of residual hills scattered in the south Cambodian plain; they are associated with the strongly folded Triassic sandstone formation of the Srang mountain range and the major syn- and post-tectonic granitic intrusions of the Kchol and Knong Ay massifs (fig. 35), located northwest and

Figure 34. Prasat Phnom Da: east blind door (a); aerial view of two main peaks of Phnom Da (b); Ashram Maha Rosei sanctuary (c); view of the two main peaks of Phnom Da from Phnom Ngnel (d); view of Phnom Borei from the southwestern peak of Phnom Da (e). Photos: Christian Fischer (a, c, e); Konstanty Kulik (b); Bertrand Porte (d)

west of Phnom Penh. The latter consist of monzonitic[11] biotite-granite rocks with younger aplite[12] and microgranite veins and dikes of early Jurassic-Cretaceous age.[13] The petrology and structure of these geologic formations are closely linked to the last deformation phase of the Indosinian orogeny, dated to the end of the Triassic period.[14]

At Phnom Borei, a felsic[15] mass intrudes beds of Triassic sandstone that are metamorphized into hornfels[16] in the contact zone (fig. 35). At Phnom Da, the igneous material found on the two connected hills is a microgranite or aplite[17] primarily composed of quartz, potassium feldspar, plagioclase, and muscovite,[18] while the rock of the third hill (Phnom Ngnel) is a metamorphized sandstone intersected by numerous large veins of milky quartz formed during intense

Figure 35. Topographic map (Google Earth) with overlaid relevant geological formations (data from https://date.opendevelopmentcambodia.net, modified after Dottin 1972)

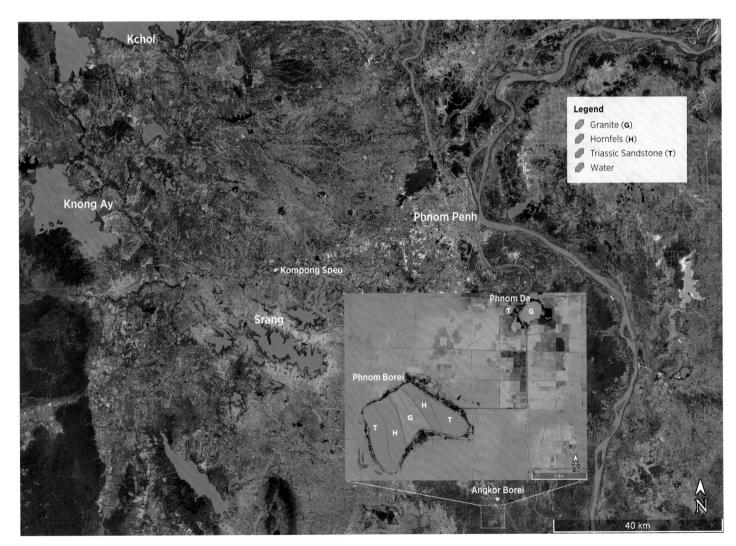

Figure 36. Thin section photomicrographs under plane-polarized (PL) and cross-polarized light (XPL) showing the texture and mineralogical assemblage of the Phnom Da rocks: microgranite/ aplite from Phnom Prasat (XPL: a, b) with details of a muscovite-rich area (PL: c; XPL: d), metamorphized Triassic sandstone from Phnom Ngnel with neoformed amphibole (e), and epidote/ prehnite-rich microveins (f)

Abbreviations: Am: amphibole, Bt: biotite, Chl: chlorite, Ep: epidote, F: feldspars, Lv and Lm: volcanic and metamorphic rock fragments, Ms: muscovite, Pl: plagioclase, Prh: prehnite, Q: quartz; Ttn: titanite

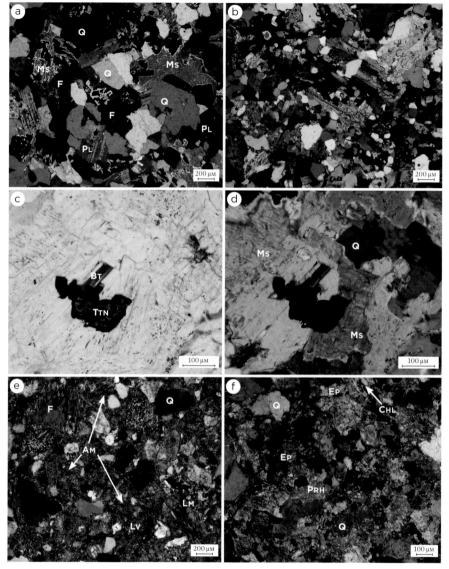

deformation and metasomatic events (fig. 36). Triassic sandstones are particularly relevant here, as they were the material par excellence for statuary during pre-Angkorian times.[19] Based on current knowledge, the Phnom Da sculptures were carved with sandstones belonging to this formation as well, though not from the nearby sources of Phnom Ngnel and/or Phnom Borei. Moreover, the analysis of the sandstone from pre-Angkorian sculptures and natural outcrops has revealed the existence of numerous subtypes with minute but significant variations, representing a real challenge for both lithotype-based grouping and identification of potential sources.

78

Triassic Sandstone and Phnom Da Sculptures:
Lithology, Typology, and Specificities

Triassic sandstones in Cambodia are usually compact, fine to coarse grained, sometimes with a microconglomeratic texture, and show colors that vary from grayish-green to bluish-dark gray. They can be very crystalline and relatively hard, as the whole sedimentary formation was affected to various degrees by tectonic deformation and regional low-grade metamorphism as well as specific intrusion-related contact metamorphism. The sandstones have a "graywacke"[20] typology and are classified under the feldspathic-lithic arenites in a quartz-feldspar-lithic (QFL) ternary (fig. 37). Their framework grains are composed of mainly sodic feldspar, lithic fragments from volcanic, metamorphic, and sedimentary sources in variable proportions, and quartz, sometimes in lesser amounts. A few micas and a range of accessory minerals such as epidote, titanite, garnet, tourmaline, and zircon complete the mineralogical assemblage. The matrix is rich in chlorite, and secondary calcite is common. While Triassic sandstones form a rather homogeneous group of rocks, variations in particle size, relative proportions of framework grains, and other characteristics are frequent. Regarding the sandstone of the Phnom Da sculptures, a fine-grained texture and relatively high—and variable—amounts of calcite are two main distinguishing features that are detailed below, alongside more subtle differences.

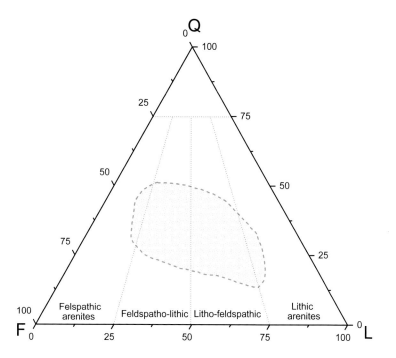

Figure 37. Quartz-feldspar-lithics (QFL) ternary plot delineating the compositional area of the Triassic sandstone types

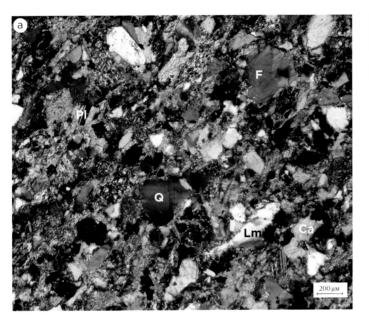
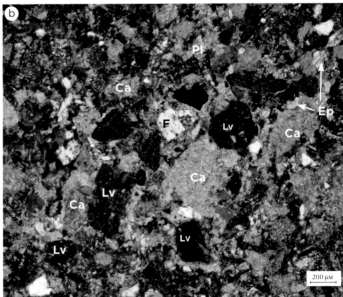

Figure 38a, b. Thin section photomicrographs under XPL showing the texture and mineralogy differences between the eight-armed Vishnu (a) and Rama (b) sandstones

The Phnom Da "Triad"

Although the three sculptures look like they are carved from the same sandstone, macroscopic and petrographic observations show that the Vishnu sandstone has a lighter color and contains more quartz, fewer volcanic rock fragments, and less calcite compared to the sandstone of the other two sculptures (fig. 38a, b). It is also slightly silicified and, more importantly, enriched in authigenic small mica-like flakes scattered throughout the matrix and some altered micaceous phases, which alignment enhances a weakly developed schistosity (fig. 38c). This difference can be detected in spectral profile obtained with fiber optics reflectance spectroscopy (FORS) where the aluminum-hydroxide (Al-OH) absorption of white mica, usually around 2200 nm, is shifted to longer wavelengths (~2218 nm), indicating that the sandstone used for the eight-armed Vishnu underwent mineralogical transformations induced by the circulation of hydrothermal fluids (fig. 38d, e).[21] The FORS spectral signature is therefore a sort of fingerprint that clearly distinguishes the two sandstone subtypes.

The Krishna Sculptures from the National Museum of Cambodia and the Cleveland Museum of Art

The analyses conducted on the two sculptures and their numerous fragments, discovered in or near the man-made caves on the northern slopes of the northeast peak of Phnom Da, indicate that they are made from a similar, if not the same, fine-grained carbonate-rich Triassic sandstone. On the Cleveland Krishna,

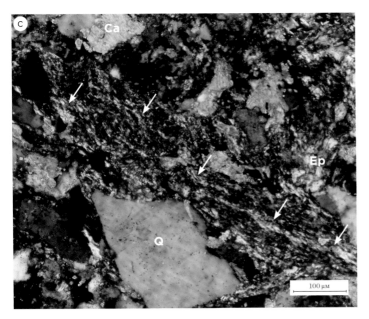

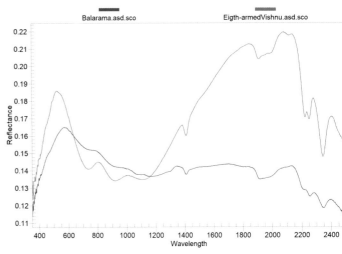

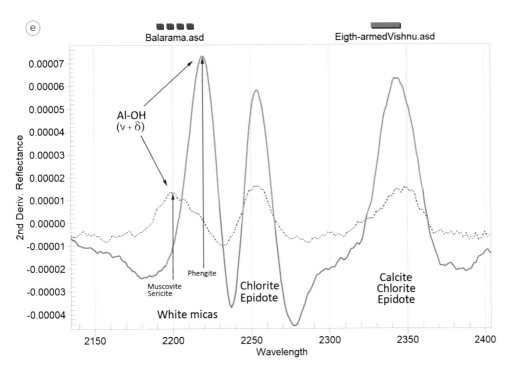

Figure 38c–e. Detailed view of the oriented mica flakes (phengite-type, white arrows) in the Vishnu sandstone with general FORS and second derivative spectra highlighting the main absorption features (positive peaks) in the fingerprint region, notably the Al-OH vibrational combination mode $\nu + \delta$ (c). Ca: calcite

81

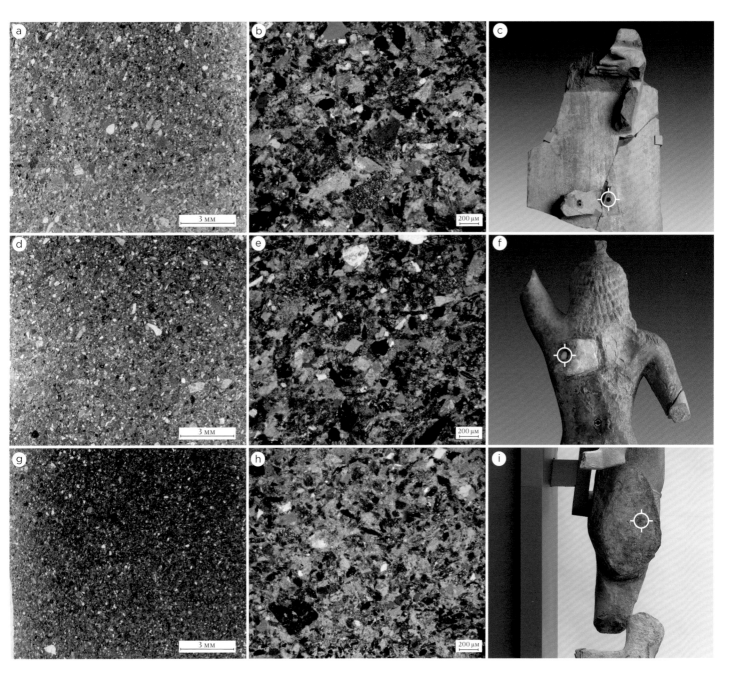

Figure 39. Thin section scans and photomicrographs under XPL of the Cleveland Krishna (details, pl. 6) sandstone: broken strut samples from the backplate (a–c) and the rear of the torso (d–f), and sample from the thigh (g–i)

82

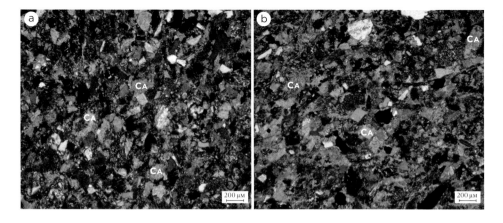

Figure 40. Thin section photomicrographs of the fine-grained sandstone from the Paris Harihara (a) and the Cleveland Krishna (b). Noticeable is the larger amount of calcite (Ca) in the Krishna sandstone.

two cores were sampled in the 1970s from the broken strut on the back and from the backplate with the hand to validate their connection during the restoration of the sculpture. In adequation with the results of an earlier petrographic study, the two sandstone samples have indeed the same texture and composition, confirming an already evident match at the strut between these two parts (fig. 39a–f).[22] Interestingly, another sample taken from the thigh has an even finer texture and also contains more calcite (fig. 39g, h).[23] This heterogeneity reveals that layers corresponding to sedimentary beds with different granulometry and mineralogy coexist in the same sandstone block.[24] Such a feature is not unique to the Cleveland Krishna and can be observed on other pre-Angkorian sculptures, such as the Kalkin at the National Museum of Cambodia (NMC, Ka.1642) on which a sharp transition from a fine-grained to a coarser bed can be seen on the chest.[25]

While stone analysis of the two fragmentary Krishna sculptures has definitely contributed to deciphering some of the restitution conundrums that arose from their entangled stories, the similarities and heterogeneity of the sandstone material left many questions unanswered.[26] Several critical attribution issues for a correct reconstruction of the two images could only be resolved through careful observations of the breaks and contacts between the fragments as well as of the common surface and structural defects.

The Two Harihara Sculptures

The sandstone petrography of the Paris Harihara sculpture (pl. 2)[27] found next to the Ashram Maha Rosei sanctuary[28] is similar to that of the two Krishna sculptures (fig. 40). Minor differences are found in the amounts of secondary calcite, which is less abundant for the Harihara, as shown by the calcium levels measured with portable X-ray fluorescence (pXRF) (~8% compared to ~11%). These three sculptures are therefore also close to Balarama and Rama in terms of

sandstone typology, which could suggest a common source. On the other hand, the Phnom Penh Harihara (pl. 8) classified under the later Phnom Da "Style B" by Dupont[29] was carved from the same sandstone as the eight-armed Vishnu. The textures and mineral compositions are similar, and the FORS spectrum shows the characteristic shift of the Al-OH absorption to ~2218 nm.

Other Sculptures and Artifacts

The body of a heavily damaged statue, probably a depiction of Vishnu, was brought back to the NMC in 1944.[30] Associated with the Phnom Da Style B, the sculpture was carved from a fine-grained carbonate-rich (calcium ~15%) Triassic sandstone comparable to the Cleveland Krishna. Another small statue representing the goddess Durga was found in Cave G (see fig. 15).[31] She does not stylistically belong to the Phnom Da corpus and is probably of an earlier date;[32] the sandstone shows a Triassic typology, though without obvious similarities to the Phnom Da group.[33]

On the other hand, the monumental pedestal inside Prasat Phnom Da was carved with a fine-grained carbonate-rich (calcium ~10%) Triassic sandstone different from the one of the eight-armed Vishnu that supposedly stood on it, but comparable to the sandstone from other sculptures of the corpus, in particular Balarama, Rama, and the two Krishnas (fig. 41a, b). Furthermore, there are a few dressed blocks near the entrance of Cave G on the right,[34] and the analysis of the one closest to the cave opening confirmed that the sandstone is also of a similar type (fig. 41c, d). Finally, the same inference can be made about the stone elements used for the partial closing of Cave D based on the analysis of a sample from the right doorjamb (frontispiece pp. 4–5; fig. 42).

Conclusion

The scientific study of the stone material culture from Phnom Da sheds some light on the characteristics of the sandstones used for the statuary and other carved elements. While they all show a broadly defined graywacke typology associated with Triassic sedimentary formations, they can be grouped under two main subtypes. The first is a very fine to fine-grained carbonate-rich sandstone and was employed for the representation of the gods as well as for building elements and the monumental pedestal found in the Prasat Phnom Da sanctuary. The sandstone contains relatively high and variable amounts of calcite (calcium ~8% to 17%) to the extent that this subtype could also be described as a calcareous sandstone. From the sculptor's perspective, it might have been deliberately chosen for its lower hardness and better workability compared to the highly crystalline siliceous and "carbonate-poor" variety far more common in the Triassic sandstone sequence. Additionally, if the separate stylistic attributions indicate a

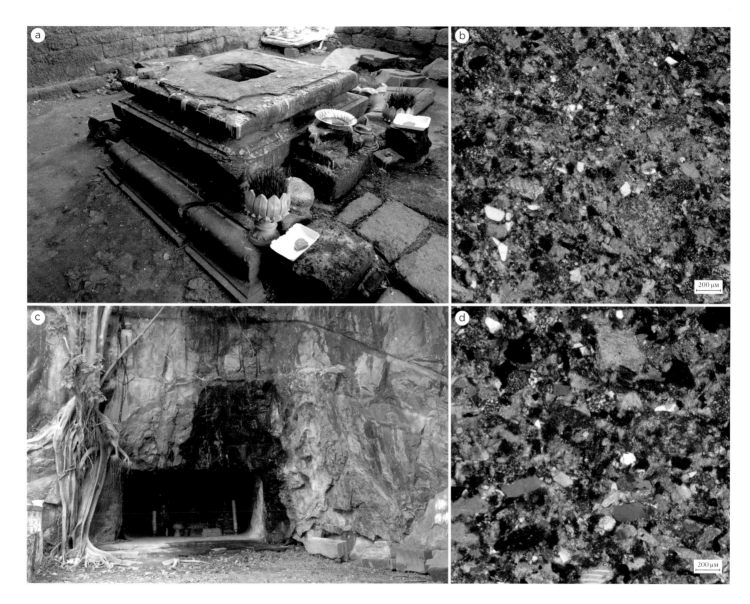

Figure 41. Monumental sandstone pedestal inside Prasat Phnom Da (a) and sandstone blocks outside Cave G (c) with corresponding thin section photomicrographs under XPL (b, d). Photos: Christian Fischer

difference in the date of carving, then the sandstone similarity suggests that the same source was exploited over a certain period of time.

The second subtype that includes the eight-armed Vishnu and the Phnom Penh Harihara bears a mineralogical signature reflecting a particular geological context. Importantly, this specific Triassic sandstone was also used for the Tuol Dai Buon Vishnu,[35] as well as other pre-Angkorian sculptures discovered more recently in the Kompong Speu region. Moreover, none of the sculptures in the Sambor Prei Kuk style analyzed so far is carved with this sandstone, and if the two styles are indeed contemporaneous, these results support both the view that there was a regional style for the Phnom Da corpus[36] and the likelihood of a local procurement for the sandstone. On the other hand, an earlier date would reinforce a royal connection that better reflects the uniqueness and originality of the corpus while the sourcing area could still be the same. However, though some results point to the hills of the Srang massif west and south of Kompong Speu as a potential source,[37] clear field-based evidence is lacking, and the outcrops or quarries from which these rather large blocks[38] of Triassic sandstone were extracted have yet to be discovered.

Figure 42. Entrance to Cave D, right doorjamb, showing location of stone sample. Southern Cambodia, Takeo Province, Phnom Da. Sandstone. Photo: Christian Fischer

1. Aymonier 1900, 199–200; Lunet de Lajonquière 1902, 12–15; Parmentier 1913, 4–5; Groslier 1924, 141–46; Parmentier 1927, 119–26; Mauger 1935, 490; Dupont 1955, 25.

2. Dupont 1955. Style "A," first subgroup: *Vishnu with Eight Arms* (NMC, Ka.1639), *Balarama* (NMC, Ka.1640), and *Rama* (NMC, Ka.1638) as well as the Phnom Penh *Krishna Lifting Mount Govardhan* (NMC, Ka.1641); Style "A," second subgroup: Paris *Harihara* (MG 14910), the unidentified deity, formerly designated as Parashurama (NMC, Ka.1608), and the Cleveland *Krishna Lifting Mount Govardhan* (CMA, 1973.106); Style "B": Phnom Penh *Harihara* (NMC, Ka.1614).

3. Coedès 1942, 155–56.

4. Dowling 1999; see also Woodward 2014, 124.

5. Baptiste and Zéphir 2008, 53; Baptiste in this book, 123.

6. Mauger 1935, 490–91.

7. Boisselier 1955, 150; Boisselier 1966, 228; Cooler 1978, 34. Referring to Phnom Da sculptures, the stone was even described as a gray-bluish volcanic rock (Delvert 1963, 465) and Parmentier mentions a small statue found there as well made of a gray-blue stone (Parmentier 1927, 122).

8. Groslier 1925a, 26.

9. The sandstone material was studied directly on the sculptures and/or on samples (when available) using various scientific techniques ranging from traditional optical microscopy on thin sections for petrographic analysis to noninvasive spectroscopy for elemental and molecular composition such as portable X-ray fluorescence (pXRF) and fiber optics reflectance spectroscopy (FORS).

10. The northeastern peak of Phnom Da (elevation ~40 m) is sometimes called Phnom Prasat (Temple Mountain). It is connected to the somewhat lower southwestern peak, sometimes called Phnom Khieu (Blue Mountain) or Phnom Bakheng, with the basalt-built Ashram Maha Rosei sanctuary nestled on its northwestern slope. The lone Phnom Ngnel (Bald Mountain), also previously known as Phnom Bakong (~10 m), is located more to the west (Porte 2016, 126–27).

11. Monzonitic granite is composed of roughly equal parts of alkali feldspars and plagioclase, with less quartz than a granite *sensu stricto*.

12. Aplite is a medium- to fine-grained granitic rock (average grain size usually 1.0 mm or less) with a characteristic equigranular, sugary (saccharoidal) texture (Bishop 1989).

13. Dottin 1972; Workman 1977, 29.

14. Fromaget 1941.

15. The term *felsic* refers to silicate minerals, magmas, and rocks enriched in light elements such as silicon, oxygen, and alkali metals (Na, K). Granite is a typical felsic rock.

16. Hornfels refers to a group of rocks, often sedimentary (sandstone, mudstone, shale, etc.), that were modified by the heat of intrusive igneous masses through a process of contact metamorphism.

17. Some rhyolitic material might also be present.

18. The microgranite/aplite underwent mineralogical transformations of metasomatic origin. Muscovite is probably secondary and formed at the expense of biotite and potassic feldspars during a pervasive phyllitic alteration induced by hydrothermal fluids.

19. Douglas, Carò, and Fischer 2008; Carò and Douglas 2014.

20. Although the definition and use of the term has engendered much controversy among sedimentary petrologists, graywacke is a kind of immature sandstone and corresponds to a fairly homogeneous group of rocks. Their essential characteristics are a dark, fine-grained, often chloritic matrix in which the quartz grains, rock fragments, and other minerals are set; a continuum in the particle size distribution from coarse to fine; the dominance of sodic plagioclase over K-feldspars; and a marked induration (Pettijohn, Potter, and Siever 1987, 163–75).

21. In this case, a transformation of the muscovite/sericite-type white micas into phengite, a series name for the muscovite-celadonite solid solutions.

22. Banks 1979.

23. Calcium ~17% compared to ~11% for the other two samples from the strut.

24. Heterogeneity also raises the issue of sample representativity, since such sculptures are often sampled in only one location.

25. For a photograph, see Guy 2014, 150.

26. Porte 2016; Mace 2018, 58–62. See also Edelstein, Snyder, and Sturm in this book.

27. The sandstone was incorrectly identified as belonging to the "Terrain Rouge" series (Douglas, Carò, and Fischer 2008) due to a sample mislabeling. Analysis herein was done on the corresponding base with the feet (Porte 2016, 142).

28. Aymonier 1900, 200.

29. Dupont 1955, 43–46, pl. VIII B.

30. NMC, Ka.142; Dupont 1955, 48.

31. NMC, Ka.892; Groslier 1925b, 311, pl. 30, A; Parmentier 1927, 122.

32. Dupont 1955, 64–66, pl. XVII A; Guy 2014, 136.

33. Characterization was limited, as the available sample was tiny and weathered.

34. The blocks might correspond to the pedestal fragments mentioned by Parmentier (1927, 122) or to a pre-existing built structure in front of the cave, though this would need to be confirmed.

35. NMC, Ka.1597; Dupont 1955, 46, Style B.

36. Woodward 2014, 124

37. These results were based on the analysis of about twenty samples collected during field surveys in this area..

38. The *Vishnu with Eight Arms* (pl. 1) required a sandstone monolith of at least 3.5 x 1.5 x 0.6 meters, implying a weight not far from ten metric tons.

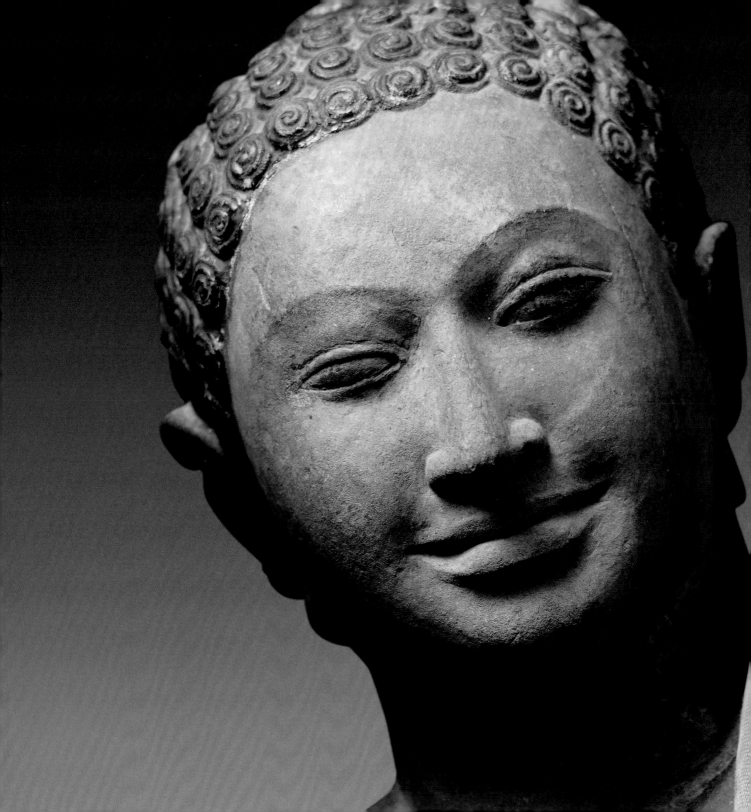

THE PHNOM DA SCULPTOR
BIRTH AND CONSERVATION OF A STATUARY

BERTRAND PORTE AND CHEA SOCHEAT

A few more delicate taps with the chisel in the crevice of the join, perhaps a gentle injection of water. . . . We thought we would need additional patient steps in the process when all of a sudden the mask detached itself. With a big smile on his face, THLANG Sakhoeun took it in his hands (fig. 44).

Since that mask had been secured by bits of mortar and a small iron pin, we were not even sure it would be possible to remove it; holding it was like a miracle. It was akin to the moment when a head we are holding in our hands quietly "clicks" to fit with its shoulders, having been separated by unforeseen events in history.

This was in July 1998, when the sculpture conservation workshop at the National Museum of Cambodia (NMC)—in partnership with the EFEO for the last twenty-four years—was undertaking the "de-restoration" of the torso and head section of the *Krishna Govardhana* statue from Phnom Da.

It had been on view along with five other sculptures from the same site in the then poorly lit gallery junction of the southeast wing of the NMC.[1] At the time, the entirely limbless body was set with mortar into a concrete base placed

Figure 43. *Krishna Lifting Mount Govardhan* ("Phnom Penh Krishna," detail, pl. 5). Photo: Konstanty Kulik

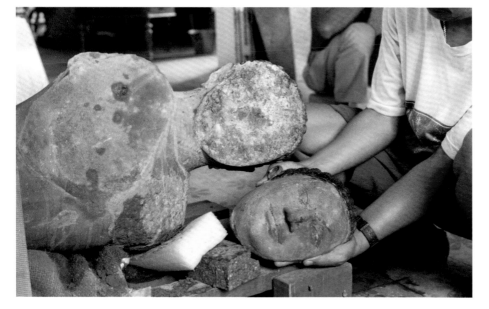

Figure 44. Face of Phnom Penh Krishna (pl. 5) detached, July 1998. © EFEO-NMC

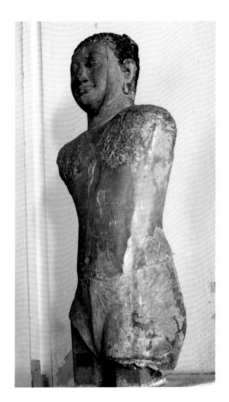

Figure 45. Phnom Penh Krishna (pl. 5) in 1997. © EFEO-NMC

against a wall. Visitors were presented with a strange image: a round head with curly, painted hair and a black gash across the left cheek, connected by way of a wide neck to an arching torso (fig. 45).

The first intervention to update the old restorations of the Phnom Da sculptures was prompted by having read Pierre Dupont and coming to understand the condition and appearance of the piece, which led to discussions with the NMC's then director KHUN Samen.[2] Of the six in the group, Krishna was the most accessible. The goal was to find a lighter support for it and to rework the thick and ungainly repairs on the right breast and on the face.

Since then, the conservation and restoration of the Phnom Da statues have continued to nourish our work and research, while also giving rise to many questions and surprises. The undertaking has also led us to work on many other pieces from the same region, especially Angkor Borei, but also Tuol Kuhea and Phnom Bathep, as well as pieces from sites in Vietnam housed at the Museum of Vietnamese History in Ho Chi Minh City.

New restorations and reconstructions of the six Phnom Da sculptures in the NMC (pls. 1, 3–5, 7, 8) were conducted between 2000 and 2006. In 2005 the Cleveland Museum of Art (CMA) sent a group of nine fragments from Phnom Da, unidentified at the time, to the NMC.

Often accompanied by students, colleagues, and friends specializing in epigraphy, history, geology, and archaeology, we returned regularly by boat to survey the hills of Phnom Da and the surrounding areas in order to collect evidence and take stock of recent discoveries (see fig. 115).

During the dry season, the three hills that overlook the green plains are stripped of their thick foliage and further reveal the rock and fallen ancient bricks strewn across their slopes. During the rainy season, they are nothing more than bushy islets emerging from the high waters. Rebuilt in the eleventh century, the impressive tower atop the northeastern hill (frontispiece pp. 2–3), its peak at the horizon, is set among flame trees, also known as royal poinciana (*delonix regia*).

Below, only the gaping black hollows of the five cave sanctuaries remain, inside and around which elements of pedestals and doorjambs still stand, where offerings, prayer trees, and incense are regularly placed (frontispiece pp. 4–5; see also fig. 41c).

Of the other sanctuaries built above, only pillaged ruins remain (see fig. 7), except for the restored structural stone temple called the Ashram Maha Rosei (see fig. 34c). Another was recently found, entirely leveled, at the top of Phnom Ngnel (map 3).

Between the end of the nineteenth century and the mid-twentieth century, the first evidence of fragmented and dispersed statues emerged—some still venerated—in the caves or modest buildings. These were gradually removed from the sanctuaries to become parts of collections.

And so began an imbroglio of Krishna sculpture fragments that would last until 2019. We recount the main developments here.

Our conservation and restoration work, begun in 1998 on the sculptures of Phnom Da and the surrounding region, has allowed us to more fully appreciate their originality. In the following pages, we also aim to understand the artist who sculpted the face of *Krishna Govardhana* (the Phnom Penh Krishna), who appears to have profoundly influenced the history of Khmer statuary.

The Face of Krishna: Affirmation of a Style and the Hand of an Artist

At the time of our first intervention, we were removing an old repair that reattached the face of Krishna to the head, like a mask. The face had previously been detached along a plane of weakness inherent in the rock.[3] That perfectly flat plane crosses the left side along the eyebrow and continues through the ear on the right.

The proportions of the features are striking. The nose is long and slightly aquiline, and the philtrum (*l'empreinte de l'ange*, or angel's stamp),[4] marked in deep relief above the lip, announces a smile; the chin is prominent, the cheekbones high, and the forehead wide (see fig. 43). The expression gives the impression of great kindness and of youthfulness that is a touch mischievous. The face is so

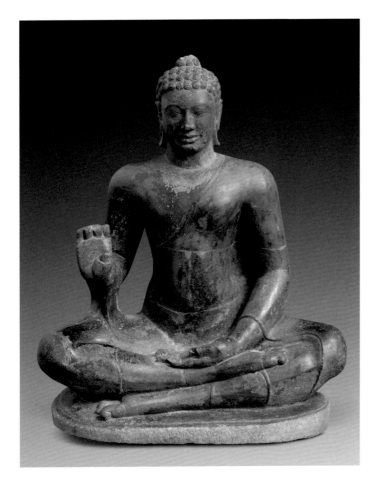
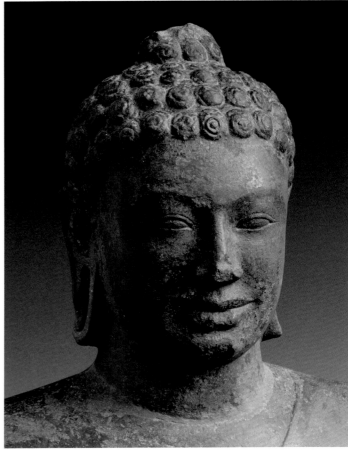

Figure 46a, b. *Seated Buddha*, c. 600. Southern Cambodia, Takeo Province, Angkor Borei, Wat Kompong Luong. Sandstone with traces of lacquer and gilding; 120 x 60 x 54.5 cm. National Museum of Cambodia, Ka.1731. Photos: Konstanty Kulik

full, so natural and pure, that it seems to be the very essence of the Khmer face from which emerged a school of sculpture. It could just as well be the face of the Buddha. We actually find these same traits on the face of the recently restored Buddha from Wat Kompong Luong in the nearby city of Angkor Borei (fig. 46a, b) and on a smaller Buddha head discovered in the abandoned Wat Kdei Ta Ngnuoy (northwest Angkor Borei; map 2) and brought to the NMC in 1923 (fig. 47). These features are the work of a sculptor with many years of experience, a master filled with creative vitality and undeniable genius.

The Sculptor and the Context: Who He Was and How He Worked
Stone inscriptions often mention the ceremonies to establish images of the gods and the offerings made to them, but they never name the sculptor or refer to the process of producing the sculpture. In addition, the corpus of ancient inscriptions from Phnom Da is fragmentary or much later in date (see p. 57n25). Chinese records speak only of "spirits from the skies."[5] How many generations of

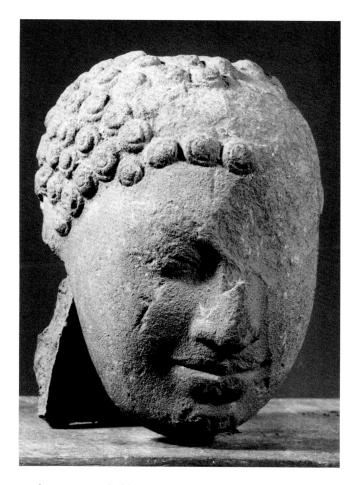

Figure 47. *Head of a Buddha*, c. 600. Southern Cambodia, Takeo Province, Angkor Borei, Wat Kdei Ta Ngnuoy. Sandstone; 16.5 x 12.5 x 10 cm. National Museum of Cambodia, Ka.1067. © EFEO-NMC

sculptors preceded him? How did he acquire his art? And above all, how did he keep it alive, knowing that "Indianized" images had existed in the Mekong delta for several generations?

We are at the end of the so-called kingdom of Funan, near the city of Angkor Borei, an important center, perhaps even a capital, in a prosperous state that traded with India, China, and Champa (map 1). This is a region that has been inhabited for a long time, where mountain cults and earth spirits are influential, and where Buddhism, Shaivism, and Vaishnavism had been adopted.

To bring this artist to life, we must speculate. We imagine that he expressed himself in a Khmer language quite different from today's Khmer. He may have been illiterate.

We see him creating these images from themes assimilated from textual sources describing the representations of gods that a scholar, a Brahman, would have dictated to him in response to a commission for a major holy site by a powerful patron whose status and privileges are still not well defined.

Figure 48. *Balarama* (detail, pl. 4). Photo: Bertrand Porte. © EFEO

In this way, he was able to shape entirely original images in the round. There must have been visual references, but his work clearly shows that he studied from nature and observed his environment. Morphology is respected, even though it is subtly stylized—the signature of an innovative, distinctive, and immediately identifiable approach.

In addition to the features of the face, we consider another characteristic element of the early Phnom Da sculptures to be the draping cloth knotted around the waist and faithfully transcribed into the sandstone (fig. 48).

The clothing consists of two stoles. The first, a *chong kboen sampot*, is a rectangular cloth wrapped around the lower body toward the front, then coiled, folded, and knotted at the belt. The second stole, which is shorter, lighter, and purely decorative, is layered over the first, to which it is knotted, often in what is called an "olive" knot. In front it creates layered folds that float and extend to the sides. To finish the wrap, part of the first chong kboen sampot threads between the legs and is slipped behind the waist, thereby tightening the two garments.[6] Once on, the folds resemble silk, but their heft is more like cotton. One can easily imagine the couturier Madame Grès drawing inspiration from this garment for her designs.[7] Far from falling out of fashion, the chong kboen, in its short form, is worn by dancers portraying the *yeak*, the roles of mythical monkeys and guardians in Cambodia's royal ballet. Men continue to wear them today to bathe in rivers at the end of the day.

The drapery, like the entire statue, was given a polish that has been well preserved on the surface of the sculptures of Rama, Balarama, and the large Vishnu, protected by having been buried. The hardness of the Triassic sandstone lends itself well to a rendering of the surface in this way. It is nevertheless still difficult to determine the polishing process used. Furthermore, we are unable to say if the almost black luster of the three statues is from a particular technique, from their condition, from environmental circumstances, or—and this is less likely—from the residue of incense, ghee (clarified butter) lamps used in rituals, or a fire.

Color and Ornament

It is not certain if color was applied to the surface. It is quite possible that the polish would in and of itself have functioned as the surface finish. And the harmony of material and rendering, notably between the statues and their pedestals, was undoubtedly part of the intended aesthetic.

The lacquer and gilding remaining on the face of the Paris Harihara date from a significantly later period, after the 1400s (see note 37 and fig. 76). Similarly, the color on the heads of the Phnom Penh Krishna (fig. 43) and the unidentified deity (fig. 49) date from the beginning of the twentieth century,

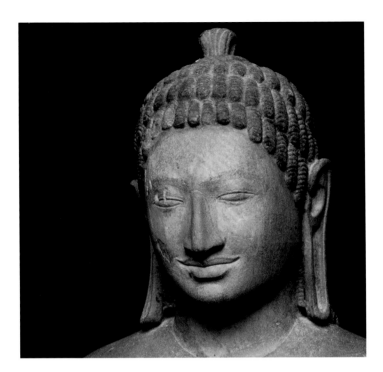

Figure 49. *Deity* (detail, pl. 7). Photo: Konstanty Kulik

when they were transformed into Vietnamese sitting Buddhas. Layers of gilding and varnish appear underneath and attest to older applications, perhaps even to previous transformations.[8] When they were applied is yet to be determined.

It is clear, however, that the statues were bejeweled. The long earlobes of the deities from Phnom Da, which are double pierced (see figs. 1, 11, 12, 32, 49, 76, 89)—triple in the case of the large Vishnu—were adorned with pendants or hoops. A ring was likely inserted into the discreet hole behind the right little finger of the unidentified deity.[9] For the sculpture of Krishna from Wat Koh (see fig. 5), perforations at the back of the wrists and shoulders, as well as through the stele on each side of the waist, must have accommodated bracelets, armlets, and cloths or belts.

Observations on the Execution of the Principal Sculptures and Their Pedestals

A system was established to transport blocks of sandstone appropriate for sculpting from the quarry, since that kind of rock was not available in the immediate area.[10] It is difficult to imagine the large Vishnu monolith being carved from a block large enough to accommodate eight arms. Hoisted to the top of the hill, it is very likely that its form was rendered nearby or perhaps even inside its original vast brick temple.

Similar in facture, the sculptures of *Vishnu with Eight Arms*, *Rama*, *Balarama*, the unidentified deity, the Paris Harihara, and the Cleveland Krishna were not necessarily all made by "our sculptor," but they certainly came out of his workshop or circle. The technique is never fully in the round, and each sculpture has its unique qualities. Special attention was paid to the front, but the finish in back was rendered with equal care.

Arched Supports, Bridges, Steles, and Other Support Elements
Arched supports or frames, reminiscent of the stelae on the back of Indian divinities' sculptures in high relief, are used around the figures with more than two arms in order to stabilize and reinforce the outspread limbs and attributes.[11] Stone bridges or solid props—under the lower left arm of the Paris Harihara (pl. 2), for example—also contribute to the stability, as do elements like the club or handle of an attribute held in the lower hands, extending downward to the base as supports. Because they contribute to the three-dimensional rendering, the support devices never visually interfere. Close attention was paid to the contour of these mechanisms; for example, on the large arch encircling the sculpture of Vishnu, the top segment behind the head is shaped like an inverted bracket (fig. 50). Dark recessions—hollow spaces meant to accentuate the relief—are subtly included, like the cavity under the wrist of the right hand holding a baton leaning against the arched support.[12] The play between empty and solid would have allowed the statues to appear embodied when seen in dark inner sanctuaries or caves, enlivened by the merest ray of sunlight or glow from a lamp.

The two figures of Krishna are special in that they stand in front of a stele to which they are connected by stone bridges or struts (pls. 5, 6; see also fig. 10). It seems that such a device, as an alternative to a more fragile arched support, was necessitated by their raised left arms. For the Cleveland Krishna, it suggests the base of the mountain the figure is raising (see fig. 9).

Bases and Pedestals
The bases of the sculptures are rectangular and similar in proportion, save for the base of the Paris Harihara, which is chamfered in front (see fig. 85). Note the length of the feet, which are endowed with particularly prominent heels. Such a protrusion does not lend to the stability of the piece.[13] These bases extend underneath into anchoring tenons shaped like symmetrical trapezoids. These would fit into the mortises bored into the center of each pedestal.

The deities stood on slate or sandstone pedestals that were particularly elaborate, formed by two and sometimes three units fitting one atop the other. The pedestal bases are girdled by a thick bullnose molding, followed by a

Figure 50. *Vishnu with Eight Arms* (rear view, detail, pl. 1). Photo: Konstanty Kulik

receding dado supporting the entablature of a wide, shallow basin that would catch ceremonial ablutions.

Certain parallels can be established between the base units of the sculptures and some of the now dispersed pedestal fragments, although reconstituting a complete pedestal among the remaining known slabs is not possible. It would be instructive, however, to draw up a detailed inventory of the scattered pedestal elements.

A shallow slate basin, rather wide and having a relatively deep entablature formed by three tiers, and its dado stand in Cave E, covered by bat guano (fig. 51).[14] They probably correspond to the Phnom Penh Krishna since the tenon fits snugly into its mortise. In the middle of Cave B, there remains the base of a slate pedestal with its dado whose corresponding statue is currently unknown.

Inside Prasat Phnom Da, the tower crowning the summit of the northeastern peak, there still are remains of the impressive sandstone pedestal belonging to the large Vishnu, the levels of which were made from several elements assembled in very elaborate ways (see fig. 41a). Seven fragments of the plinth's bullnose molding lie beneath the central stack of slabs, and next to it a portion of the inset block is partially buried and filled with dirt. All these pieces have a handsome greenish patina and are marvelously polished.

In addition, when the inside of the tower was cleared out, the EFEO architect Henri Mauger observed a large cavity in the form of an inverted pyramid carved into the rock in the middle of the cella. This was undoubtedly a cache for consecration materials inside the foundation.[15]

One rare example of a complete pedestal was found at the top of Phnom Bathep. It was brought to the NMC by KAM Doum in 1944 (see fig. 13).

Other Pieces and Recent Discoveries

Phnom Da undeniably summoned the best artists. The statuary and many other pieces discovered even recently in the region attest to the rich exchange and artistic sophistication achieved there at the end of the Funan era.

In Stone

Since its arrival at the NMC in 1936, a remarkable round shallow basin for ablutions, made of slate, was thought to be from Phnom Da, but it in fact comes from Wat Leu situated at the foot of Phnom Bayang, about fifty kilometers southwest of Phnom Da (map 2).[16] Perhaps its handsome, dark luster, similar to that of the statues found at the top of Phnom Da, caused the confusion. The circular body extends into a spout resembling a buffalo head, sculpted flat on the top and outlined on the sides (fig. 52a, b). In the center of the well-rounded basin is a wide conical hole that must have perfectly held a linga. However, it is surprising to see

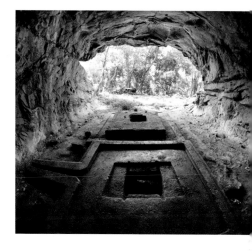

Figure 51. Spouted pedestal with dado slabs, Cave E, c. 600. Southern Cambodia, Takeo Province, Phnom Da. Photo: Konstanty Kulik

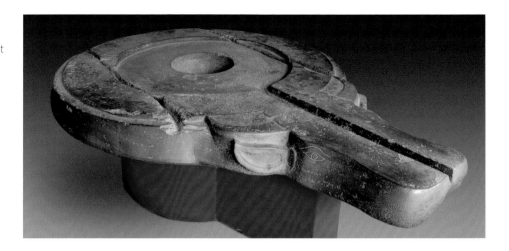

a buffalo head paired with a linga. One might expect an image of Durga, the goddess who slayed the buffalo demon, standing on a buffalo head, but we do not see how the base of a figural sculpture could have fit in the center of the basin. The question of the initial composition remains open.

Regardless of its function, it is every bit the work of a genius the caliber of "our sculptor." The buffalo eyes are simply and subtly drawn with dotted incisions into the eyebrow arch and by themselves reveal, practically by surprise, the inhabitant of this stone (fig. 52b). This is an often-used process characteristic of Khmer statuary.[17]

In Bronze

A statue's larger-than-life bronze feet (fig. 53)[18] were also brought from the top of the Bayang mountain ("Phnom Bayang Kor" formerly called Shivapura, "City of Shiva"),[19] where the temple is perched, by Henri Mauger at the same time as the shallow basin with the buffalo head. Long and endowed with prominent

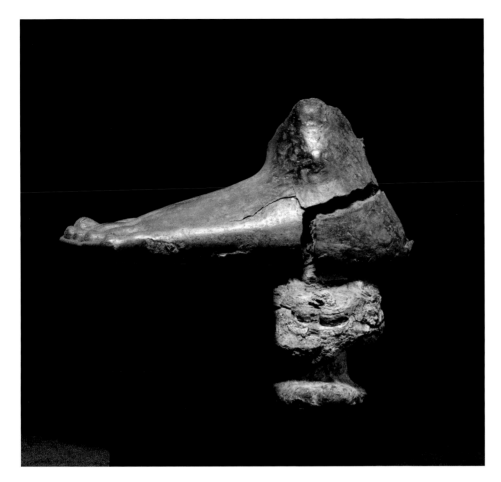

Figure 53. *Left Foot*, c. 600. Southern Cambodia, Takeo Province, Phnom Bayang. Bronze with clay core and lead; 31 x 11.5 x 25.5 cm. National Museum of Cambodia, Ga.5449. Photo: Konstanty Kulik

heels, they resemble the feet of Phnom Da statues. The shape and spacing of the toes, with their nails carved inward, is also very similar.[20] It seems likely that they belonged to a standing statue of Shiva.[21] These feet were found sealed to a sandstone base with rounded corners without an anchoring tenon.[22]

Another bronze sculpture inevitably draws our attention. It is the exceptional sculpture of Shiva's bull in silver-plated bronze fortuitously discovered by CHEA Tum in 1983 on the site of Tuol Kuhea approximately seven kilometers northeast of Phnom Da (map 2).[23] Preah Ko (the sacred bull) is housed today in Phnom Penh in the Silver Pagoda where it now incarnates a myth in which it is the main idol and where it watches over holy texts (fig. 54).[24]

In Tuol Kuhea, slate pedestal elements similar to the ones from Phnom Da and Phnom Bathep remain. Basalt elements have also been found there. Both this bull and the feet described above attest to a remarkable mastery of lost-wax casting.[25]

Figure 54. *Bull of Shiva*, c. 600. Southern Cambodia, Takeo Province, Tuol Kuhea. Silver-plated bronze; 78 x 74 x 145 cm. Silver Pagoda, Royal Palace, Phnom Penh. © NMC-EFEO

Stone Inscriptions

A few stone inscriptions—and hardly any were found at Phnom Da—inform us about the life of deities and the rituals devoted to them. A sandstone grindstone, used to prepare offerings to a god and inscribed on its base, was discovered in 2005 by TIN Mao in his rice field to the east of Wat Komnou.[26] Grindstones are commonly found near ancient foundations, but no other is known to this day that has an inscription. Moreover, on the northeast perimeter of Wat Komnou, Henri Mauger found an impressive inscribed "cube" as early as 1935. It is a base or a pedestal, but its use is unknown. Its engraved sides mention names of attendants, dancers, and courtesans in the service of a deity.[27]

Sculpted Decoration

The wealth and variety of the sculpted decoration adorning the sanctuaries is practically unimaginable today. A few heads in high relief with prominent and expressive features, rendered in lime mortar on brick, were found in 1923 north of Wat Komnou, which was abandoned at that time (see fig. 79). Likely part of a building, those relief remains are reminiscent of the stucco figures at Wat Pathon Chedi in the heart of the city of Nakhon Pathom, north of Bangkok.

More recently, terracotta tiles were recovered.[28] They bear carved plant scrolls from which emerge fantastical animals, musicians, and perhaps even a singer (fig. 55). In 2015, during excavation work at Tuol Thmor, a few sculpted fragments in terracotta, likely part of a group, were salvaged in extremis, thanks

to CHEA Sambath, director of the Angkor Borei Museum.[29] The findings include the toes of a right foot that must have been close to forty centimeters long (fig. 56). Clearly, some of "our" sculptors were also accomplished at modeling in clay. Unfortunately, most of the work, if not all, has been lost.

Coins

An important discovery was made in August 2012, when a gold coin inscribed with the name of King Ishanavarman (reigned 616–637) was found at a stall in the Russian market in Phnom Penh.[30] An investigation quickly pointed to its having come from a *tuol* (mound) between Angkor Borei and Phnom Da, in a village called Phum Angkor where fiber-optic cables were being laid underground (map 2). Research also revealed the existence of an actual coin hoard at a place known as Kunlah Lan, along the same route near the southern entrance of the old city; it consisted of several jars containing silver coins of the so-called rising sun type (fig. 57). Almost everything was quickly sold or recast.[31]

Figure 55. *Architectural Tile Relief*, c. 600. Southern Cambodia, Takeo Province, Wat Komnou. Terracotta; 40 x 40 x 12 cm. Collection of Michel Tranet. © NMC-EFEO

Figure 56. *Toes of a Right Foot*. Southern Cambodia, Takeo Province, Angkor Borei, Tuol Thmor. Terracotta; 12 x 20 x 22. Angkor Borei Museum, TKA.Ka.0118. © NMC-EFEO

Figure 57. "Rising Sun" coins, c. 600. Southern Cambodia, Takeo Province, Angkor Borei, Kunlah Lan. Silver and silver alloy. Preah Srey Icanavarman Museum, Phnom Penh, Inventory in progress. © NMC-EFEO

Figure 58. *Ring with Ram*, c. 600. Southern Cambodia, Takeo Province, Angkor Borei. Gold. Recovered by a resident of Angkor Borei during work on the main road in 2012; current whereabouts unknown. © NMC-EFEO

Figure 59. *Ring with Bull*, c. 600. Southern Cambodia, Takeo Province, Angkor Borei. Gold. Recovered by a resident of Angkor Borei during work on the main road in 2012; current whereabouts unknown. © NMC-EFEO

Figure 60. Gold beads, c. 600. Southern Cambodia, Takeo Province, Angkor Borei. Collected by a resident of Angkor Borei from a vendor at the Angkor Borei market in 2012; current whereabouts unknown. © NMC-EFEO

The city of Angkor Borei has yielded an abundance of ceramics, jewelry, and beads (figs. 58–60). Every low-water season, the river that crosses the old city reveals its harvest. In the best cases, the finds stay with residents and are sometimes worn as ornaments, but most are sold and dispersed.

Feet and Other Elements

Fragments, especially of feet, were found in recent years in the storage rooms of the NMC. Such is the case with the right heel of the large *Vishnu with Eight Arms*[32] collected in the area around Phnom Da and housed at the museum since the early 1990s. Forgotten since 1945, the forearm of the Phnom Penh Krishna[33]

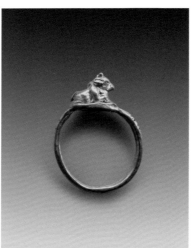

was also found there in 2005, along with the feet and base—in three pieces—of the Paris Harihara in 2014.[34] Very recently, a sandstone toe from a left foot surfaced,[35] just a bit smaller than life-size (fig. 61).

From the Twelfth to the Sixteenth Century and Until the Twentieth Century: The Rediscovery of Sculptures and Their Departure

It is difficult to know the initial location and to retrace the movement of the images found except for the large Vishnu. In the twelfth century, Phnom Da experienced a revival, and some of the sculptures may have been moved.[36] Rama and Balarama may then have been brought to join the large Vishnu in the entirely restored Prasat Phnom Da, which was lined with laterite inside and out. But nothing has been clearly established. The two statues' workmanship and state of conservation are quite similar (pls. 3, 4).

There are too few clues to tell us about what happened to the statues in the centuries that followed. Analysis of the gilding on the face of the Paris Harihara statue suggests that it could not have been applied prior to the sixteenth century (see fig. 76).[37] Some of the sculptures continued to be venerated or were venerated anew, but we do not know under what circumstances.

Today we cannot ascertain the date of the collapse of the Prasat's brick roof that buried the Vishnu, Rama, and Balarama; we are not even certain that plunderers seeking riches hidden in the foundation had not already toppled them before the collapse. The base of the statue of Vishnu was discovered on the mountain slope, along with one of the hands (pl. 1), before the inside of the sanctuary was cleared out. They have lost their polish and must have been outside for a long time.

The first written records, which date to the end of the nineteenth century, point to the dispersal of sculpted fragments inside and around caves.[38] Starting in 1882, Étienne Aymonier sent the remarkable Paris Harihara as well as the head of the Phnom Penh Harihara to France.

At the time of his first visit in 1911 the indefatigable Henri Parmentier photographed the bust of the Phnom Penh Krishna "resting on a pile of bricks" at the back of Cave D (fig. 62).[39] Against the light, Krishna presents his right profile. His raised left arm[40] can just barely be perceived behind the cloth[41] across his left shoulder. The bamboo poles that can be seen in the image likely held a *pidan*[42] above the statue; on the side, the front of the lower part of its broken stele is easily seen. In the 1911 photo, the torso does not have all the current damage, and the contours of the neck and right shoulder have not yet been chiseled down. The mask of the face does not seem to have been detached yet. Many years later, when writing *L'Art Khmer Primitif*, Parmentier would remember that he recognized this as another statue with its arm raised, different from the one acquired by Adolphe

Figure 61. *Toes of a Left Foot*, c. 600. Southern Cambodia, Takeo Province, Phnom Da. Sandstone; 16.3 x 21.9 x 15 cm. National Museum of Cambodia, Ka.215. © NMC

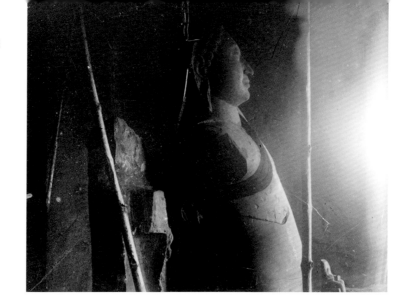

Figure 62. Phnom Penh Krishna (pl. 5) at the back of Cave D, Phnom Da in 1911. Photo: Henri Parmentier © EFEO

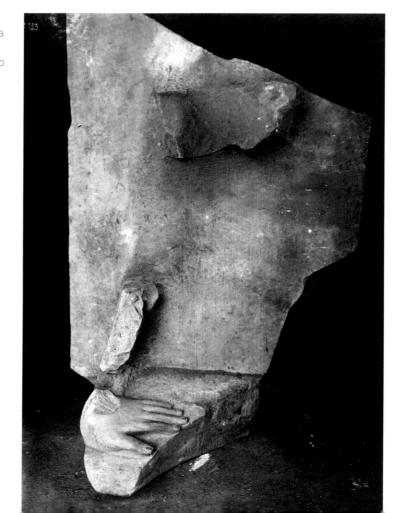

Figure 63. Upper stele with hand of the Cleveland Krishna (pl. 6) in a cave on Phnom Da in 1923. Southern Cambodia, Takeo Province, Phnom Da. Sandstone; 104 x 68 x 11.9 cm. Photo by George Groslier (C-183). Musée national des arts asiatiques-Guimet, Paris. © RMN-Grand Palais / Art Resource, NY

Stoclet that ultimately made its way to Cleveland. It was therefore certainly before his visit that the latter, now the "Cleveland Krishna," was said to have been salvaged by a French sailor who brought it all the way to Marseille.[43] Stoclet then acquired it in 1920 from the collection of the Paris dealer Léonce Rosenberg.

In 1923, George Groslier would then take note of statues recently transformed into Buddhas by the local Vietnamese community without recognizing the Krishna whose raised arm had been removed. He wrote that he photographed "the fragment of a large stone stele with a section at right angle on which remains a hand pressing flat against it" (fig. 63).[44] For the new Phnom Penh museum Groslier brought back the two lower hands of the Phnom Penh Harihara, as well as a female statuette (see fig. 15) and a small linga from Phnom Da.[45]

And so began a game of hide-and-seek with the transformed statues.

Between 1934 and 1936, Henri Mauger, in charge of the conservation of historic monuments in the Cochinchina-Cambodia sector, launched several projects and explorations in the region. At Phnom Da, his main mission was to restore the Ashram Maha Rosei through anastylosis. During that time, he took the opportunity to inspect the caves, searching in particular for that "raised hand" and for the other figure with a raised arm that Parmentier had photographed a few years before. He became more enthusiastic about his prospection when he located another statue of Krishna Govardhana, set in a termite mound at Wat Koh, about fifteen kilometers north of Angkor Borei (see fig. 5; map 2). He ultimately ignored the Phnom Penh Krishna in Cave D, which had been transformed into a Buddha (fig. 64) and which he confused with the statue of the unidentified deity at NMC; it too was transformed into a Buddha in Cave B (fig. 65). He also noted in his reports the presence of a four-armed torso (certainly the body of the Phnom Penh Harihara, pl. 8) decked with a "grotesque" head that had recently been installed in a small shrine located to the west, between the two main hills.[46]

Mauger's major discovery was the large *Vishnu with Eight Arms* and the statues of Balarama and Rama, found in pieces under the collapsed brick roof of Prasat Phnom Da. These were transferred to the Phnom Penh museum in 1936. He also managed to find the raised hand, as well as other limbs and a base—a total of some fourteen elements—that he gathered together (see fig. 2). Mauger associated these with the Stoclets' Krishna Govardhana statue and sent them to Brussels the following year.[47] The imbroglio around the fragments belonging to the Phnom Penh Krishna and those belonging to the Cleveland Krishna had begun in earnest.

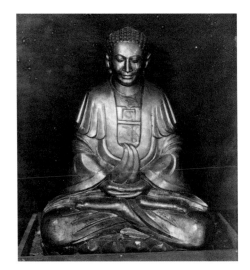

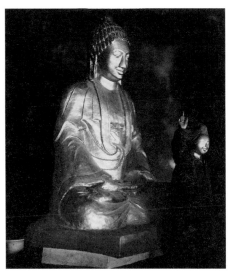

Figure 64. Phnom Penh Krishna (pl. 5) transformed, upon arrival at NMC, being prepared for or just after plaster casting, after September 1944. © NMC

Figure 65. *Deity* (pl. 7) transformed, on an altar in Cave B, Phnom Da, around 1930. © EFEO-NMC

1944: Pierre Dupont and KAM Doum's Mission

At the end of 1944 Pierre Dupont, director of the NMC from 1944 to 1945, also collected a large number of pieces from Phnom Da and Angkor Borei for the museum.[48] The circumstances of this significant relocation are known through a report written by KAM Doum (1905–?), a member of the Buddhist Institute in Phnom Penh and an employee of the NMC.[49] In a 1945 issue of *Kampuchea Soriya*, he recounts how sculptures that were still being venerated in pagodas at Phnom Da and Angkor Borei were brought to the museum in Phnom Penh.[50]

The very detailed account of the mission begins in Takeo Province on September 4, 1944, during the rainy season. Water levels were high. KAM Doum, his colleagues, and a team of rowers set out at night with equipment and headed for Phnom Da, about twelve miles to the east, across the entirely inundated plain. At daybreak, the water extended into the distance. On the horizon were a few dark masses, indicating villages and the outlines of mounds. In the early afternoon, through layers of water hyacinths, they reached Phnom Da, but with difficulty.[51] They were greeted at the Vietnamese pagoda Chua Thap Son[52] (across from Cave B), where they had to negotiate with the monks in order to proceed with the removal of the sculptures. Torn between the distress and consternation of the Vietnamese community upon seeing its statues being taken away and his instructions from the Phnom Penh authorities, KAM Doum did his best to convince residents that the government was acting out of concern for the conservation of these images. The community asked for a few days' postponement so that the surrounding communities (all the way to the Chau Doc River) might come to pay homage to the images one last time before their departure. KAM Doum was very upset, because he was not able to grant the stay: Pierre Dupont and both the provincial and Phnom Penh authorities had planned a ceremony on September 12 at Angkor Borei to celebrate the collection of all the sculptures for the NMC.

Without waiting, the team proceeded on the morning of September 6 to take down a statue of what they thought was Vishnu from the neighboring temple Chua ong Dai Vuong;[53] in fact this sculpture was the body of the Phnom Penh Harihara (pl. 8, the head of which had been taken to Paris in 1882) (see fig. 89). In the afternoon, a statue of the Buddha was removed from the "first cave," identified as Cave B. It covered a standing figure, its legs concealed within the altar: it was the NMC's unidentified deity.[54]

KAM Doum mentioned that the original hands of the sculpture were repurposed to build a base beneath the crossed legs of the Buddha and therefore were well protected beneath the piece. The next morning, another image of the Buddha was in turn removed from the "second cave," which we understand to be Cave D. It contained the dismembered body of the Phnom Penh Krishna (see fig. 64).

A procession with musicians accompanied the removal of each statue to the boat on which they were loaded. The mission then set out for Phnom Bathep. KAM Doum noted that a Caodaist[55] temple had been built there but was no longer in use. At great risk—he was almost crushed by it when it fell off the rails that were laid for its removal—he brought down an impressive and very handsome pedestal from the summit (see fig. 13).[56] On September 11, the mission proceeded to Angkor Borei, in particular Wat Kompong Luong, where many pieces were retrieved, including the remarkable seated Buddha from the sixth century (see fig. 46), still concealed under numerous layers of pious restorations (see fig. 6).[57] Water celebrations and ceremonies were organized at Wat Kompong Luong and at Wat Chruoy.[58] Pierre Dupont came from Phnom Penh with a delegation. Gifts were offered to the monastic communities, and elders were given medals, as was

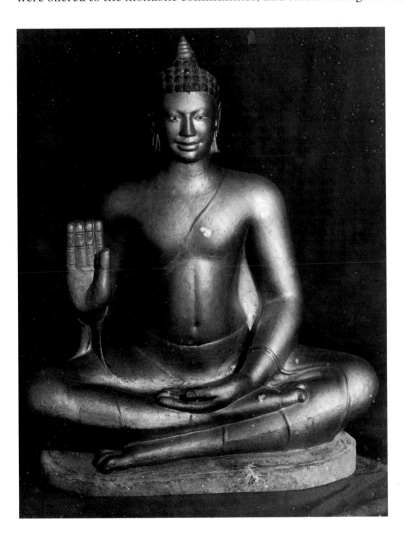

Figure 66. *Seated Buddha* from Wat Kompong Luong (see fig. 46) remodeled with many layers of lacquer and gilding, on display at the NMC, May 1948. © NMC

the chief of the Angkor Borei village. A solemn request was addressed to the venerable KHY Nut, chief of the pagoda, to obtain his permission to remove the statue of the Buddha from Wat Kompong Luong. It is very clear in KAM Doum's account that the members of the community were unwilling but kept their displeasure in check in front of the authorities. KAM Doum and his colleagues had to wait until after Pchum Ben (the Celebration of the Dead) on September 17 to charter a boat capable of transporting the heavy load of "sensitive" sculptures. Finally, under pressure from the governor of Takeo, a Chinese boatman agreed to carry out the transfer to the Chau Doc River and then continue on the Bassac River to Phnom Penh, where the barge drew up alongside the Sinhek market on the night of September 25.[59]

Casts of the Krishna and of the unidentified deity transformed into a seated Buddha were installed later in the Cave B and Cave D sanctuaries. Madeleine Giteau photographed them in 1960: the Krishna substitute, with painted eyes, bears a sad expression (fig. 67). These casts disappeared during the Khmer Rouge regime, when Cave B was used as a dungeon (fig. 68), according to accounts from OUK Bean (fig. 69) and PEACH Vat, both born in the region. They were interviewed at Wat Phnom Da.

Figure 67. Plaster cast copy of the transformed Phnom Penh Krishna in Cave D, Phnom Da in 1960. Photo: Madeleine Giteau © EFEO

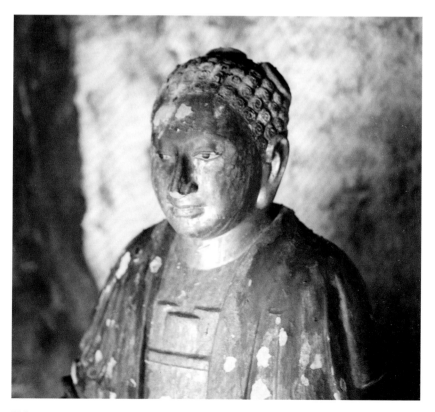

Interventions of the Sculpture Conservation Department at the National Museum of Cambodia: 1998–2019

As these statues entered the museum in 1944—some whole, some in fragments—they were restored and prepared for exhibition in the middle of the NMC's south wing. Set into concrete bases, some were also secured with metal mounts for support.

In the late 1990s, the presentation of the six Phnom Da sculptures was considered far from satisfactory. The department of sculpture conservation and restoration at the museum intervened in important ways between 2000 and 2007. The projects mostly consisted of "de-restorations," as previous restorations were deemed, for the most part, to be excessive and not always sound. The pieces were then reassembled in accordance with current conservation principles, and some missing parts, which had been identified, added to most sculptures. Their installation was also able to be reviewed.

The De-Restoration of the Wat Kompong Luong Buddha
Saved from destruction by the Khmer Rouge when it was transferred to the NMC a few decades earlier by KAM Doum,[60] the Wat Kompong Luong Buddha did not look like it does today when it was installed at the monastery temple altar. The different layers of lacquer and gilding applied over the centuries and identified during the restoration attest to the continuity of the sculpture's veneration, at least between the fifteenth century up to its transfer to the museum. It is tempting to conclude that it has been an object of worship since its creation.

Its last renewal, probably dating back to the nineteenth century, considerably modified its appearance, notably by raising the neck and reworking several other areas (see fig. 66). Pierre Dupont had undoubtedly recognized the still visible sandstone around the base and especially the curls of the hair when he identified the antiquity of the statue and the interest it would hold for the museum. Neither Dupont nor KAM Doum reported that the statue, during transport, was broken in two across the abdomen along a cleavage plane in the sandstone. One can imagine how difficult it must have been for Dupont when he had to give up on removing the thick overpainting, and when, contrary to his initial plan, he even had to entirely repaint the statue in gold to hide the repair and idealize its presentation.

In the early 2000s, when this very tarnished paint was peeling, we were puzzled by the religious reasons that supposedly stopped Dupont from completing the removal of the overpainting, as stated in his writings. We undertook a long and delicate "de-restoration" based on a stratigraphic study and many

Figure 68. Comrade UNG Sem, district official, pointing to the entrance of Cave B, Phnom Da, during the investigation of Khmer Rouge crime sites organized by MAI Lam with the Tuol Sleng Genocide Museum around 1982–83. Tuol Sleng Genocide Museum, Collection of TSGM-40/27

Figure 69. OUK Bean of Angkor Borei, at Wat Phnom Da in 2019, recalls the use of Cave B as a dungeon by the Khmer Rouge. © EFEO-NMC

Figure 70. *Seated Buddha* from Wat Kompong Luong (fig. (figs. 46a,b and 66), during the process of cleaning the face, 1999. © EFEO-NMC

Figure 71. Removal of Vishnu's head, supported by co-author CHEA Socheat for the complete restoration of the statue, Phnom Penh, September 2004. Photo: John Vink

surveys (fig. 70). That operation aimed to retain only the remains of the black and red layers with minute gilding dating from the fifteenth century, which had not modified the original sculpted form.

Other Significant Interventions at the National Museum of Cambodia
The sculpture of the unidentified deity brought from Cave B on Phnom Da was in turn "de-restored" in 2001 (pl. 7; fig. 65). The props and renovations done in concrete during the first restoration were removed. A gypsum "Band-Aid" on the right cheek as well as the tuft were also taken away, alterations meant to raise the head dating from when the piece was transformed into a statue of the Buddha.

The three statues discovered by Mauger in the rubble of Prasat Phnom Da's roof in 1935 were restored one by one between 2002 and 2005. The large statue of *Vishnu with Eight Arms* supported by metal brackets tended to fall backward. The seventeen elements were taken apart (fig. 71) and were then carefully reassembled (fig. 72). It became necessary to reconstruct missing parts of the supporting arch structure and the base in order to create better visual and structural coherence (pl. 1). Reversible gudgeon mechanisms were, as is now standard practice, installed between the various broken parts.

The statues of *Rama* and *Balarama* underwent similar intervention processes. The visitor paying close attention will notice that, for aesthetic reasons,

Rama's face, largely gone (see fig. 12), was reconstructed with a cast "graft" from Balarama's face using an entirely reversible procedure.

In 2005, the "triad" was reinstalled in the middle of the cross-shaped south gallery junction (see fig. 33). Two bays were reopened. The statues today overlook the garden. With any gleam of sunlight, they become bathed in a ruddy glow reflected off the exterior walls of the museum.

Work on the Phnom Penh Harihara began in 1999; George Groslier had brought back its lower hands and Pierre Dupont, its body. The body and the base of the neck were still completely stained with varnish drips and mortar dating from the transformations Mauger had observed ("a grotesque head" as previously mentioned). The head brought back to France by Étienne Aymonier (see fig. 89) was reunited with its shoulders in 2016, thanks to an exchange of loans between the Musée Guimet and the NMC (pl. 8).

The Ongoing Imbroglio of the Two Krishnas and Its Conclusion

In 2005, the Cleveland Museum of Art had the good idea to send to the NMC nine fragments collected by Mauger that they had not utilized in the restoration of the Cleveland Krishna. They had been sent to Brussels and were later shipped to

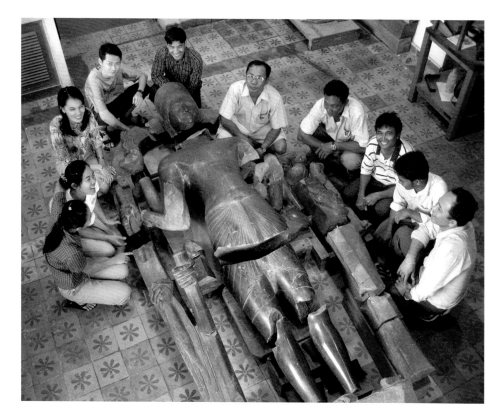

Figure 72. Conservation team around the main fragments of *Vishnu with Eight Arms* (pl. 1) in the NMC sculpture conservation workshop, December 2004. © EFEO-NMC

the CMA in 1977, following the torso, which was sent in 1973. The nine unused fragments were unattributed. When they arrived in Phnom Penh, we found that a right forearm and a left wrist completed the arms of the unidentified deity (pl. 7), while a left thigh, an upper left arm, and an upper right arm fit with the Phnom Penh Krishna. The upper stele with hand—the one Mauger was so eager to find—was also sent to the NMC, having had no luck in Cleveland. Although we did not find a match for the torn-away stone around the shoulder blades of the Phnom Penh Krishna, we attempted to graft that piece on Krishna's back by default, observing that the position levels and the proportions fit relatively well (fig. 73).[61] Doubts remained, but at least the Krishna raising Mount Govardhan found its pose (fig. 74), and its parts were assembled in a way that could be easily disassembled.[62]

But the graft did not hold. In early 2014 we understood through photographs that the broken strut of the upper stele and its hand in fact belonged to the Cleveland Krishna. In October 2015, the stele and hand were sent back to the CMA, but it was not until November 2018 that this muddle was finally resolved. The previous owner of this piece, Adolphe Stoclet, did not want to trouble himself with fragmentary restorations that were difficult to undertake. He therefore

Figure 73. Installation for reassembling tests of the Phnom Penh Krishna (pl. 5) at the entrance of the NMC sculpture conservation workshop, July 2005. © EFEO-NMC

Figure 74. Phnom Penh Krishna presentation at NMC just before removing the upper stele with hand to be returned to the CMA, May 2015. © EFEO-NMC

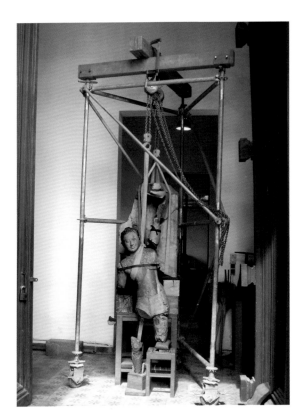

preferred to try to get rid of the fragments collected by Mauger and only present the bust with a raised arm without its hand. When the CMA acquired the statue in 1973 and found the fragments again, that hand and stele were set aside, clearly because of how difficult it was to align the lower part of the stele with the upper part. The installation of this lower part with the feet had been favored, so that the statue could be exhibited standing. After the upper stele with hand returned to the CMA, a full new restoration of the Cleveland Krishna began in 2017.[63]

Now, without the upper stele with hand, there were no reference points for how to reset the position of the Phnom Penh Krishna, with only its two arms and one thigh. So the statue and its limbs were stored away.

In November 2018, while adjusting the presentation and tilt based on photographs of the Cleveland Krishna, we realized that the right thigh of the latter belonged to the Phnom Penh Krishna. The CMA carefully verified each piece of the sculpture as it was being disassembled. It was then confirmed that the lower right leg, the lower stele with base and feet, and by extension the lower left leg also belonged to the Phnom Penh Krishna. The Phnom Penh Krishna of the NMC could stand on its own two feet again (pl. 5).[64] And so an imbroglio that started in the early twentieth century in Phnom Da came to an end.

The two statues of Krishna found their pose, one through its base unit, and the other through its raised hand. But their few limbs—retrieved, stripped, and washed—still leave much unanswered about the history of these sculptures. We have attempted to find records of any and all visitors to Phnom Da. Among them, KAM Doum's account is little known, but is nevertheless detailed and sensitive, and sheds precious light on the lives of these works and their role within the Khmer and Vietnamese communities, whether they were relocated or transformed. Paradoxically, while the French Protectorate's removal of these objects and their incorporation into collections was at times drastic, their actions also saved the works from later destruction. Today, the region abounds with ruins and traces of the ancient past (fig. 75).

At the foot of the former Wat Chruoy and the small Angkor Borei Museum, when the catch comes in, women can be seen at the market wearing stones, the luster of which dates back to the time when our sculptor was working.[65] Did our sculptor live in the city of Angkor Borei or was he only there temporarily? Presumably, he attended the consecration ceremony for his statue of Krishna fifteen centuries ago. At that carefully chosen auspicious moment, the eyes of the statue were "opened," and the deity came to inhabit it. We like to imagine his features on Krishna's face.

Figure 75. Angkor Borei River during the dry season, crossing the ancient city with Wat Kompong Luong in the distance, 2007. Photo: Bertrand Porte

We thank Michel Antelme, Olivier de Bernon, CHAM Vicheth, CHEA Sambath, CHUCH Phoeurn, Vasundhara and Pierre-Sylvain Filliozat, Christian Fischer, Dominic Goodall, Mathieu Guérin, Mr. Horn (the custodian of Prasat Phnom Da), Nicolas Josso, Sylvain Lim, OUK Bean, PEACH Vat, Anne-Laure Porée, Charlotte Schmid, Dominique Soutif, Michelle Vachon, Brice Vincent, LIM Yi, and Thierry Zéphir.

Thanks to Pierre Gillette for his review of the French version.

Translated from the French by Molly Stevens.

1. Besides *Krishna Lifting Mount Govardhan* (pl. 5, NMC, Ka.1641), the other related works from Phnom Da are the unidentified standing male figure with two arms (pl. 7, NMC, Ka.1608, formerly, and probably untenably, identified as Parashurama), the large *Vishnu with Eight Arms* (pl. 1, NMC, Ka.1639), *Balarama* (pl. 4, NMC, Ka.1640), *Rama* (pl. 3, NMC, Ka.1638), and *Harihara* (pl. 8, NMC, Ka.1614).

2. Dupont 1955.

3. This cleavage plane of sandstone crossing the source rock opened at an undetermined date, following shock or stress. Intrinsic to the sandstone, such cleavage planes are common in Khmer statuary. The statue of Krishna Govardhana from Si Thep (Bangkok National Museum, see fig. 101) lost its face in this way. The statue of Rama from Phnom Da presents a similar fracture plane that crosses its body diagonally (see fig. 12).

4. Dimple between the nasal septum and the upper lip.

5. Dupont 1955, 13.

6. The unidentified figure (pl. 7), as well as the Vishnu side of the Paris Harihara in the Musée Guimet (pl. 2), dons a unique *chong kboen*. One side wraps through the legs and the other is folded into an accordion that falls in front between the legs and serves as a support.

7. Germaine Émilie Krebs (French, 1903–1993) adopted the moniker Madame Grès, which means "sandstone" in French. Her signature styles reflected her interest in the draped garments of ancient sculpture.

8. See conservation report (NMC-EFEO), 1997.

9. There are also two perforations on either side of the ewer (*kendi*) held in the lower left hand of the large Vishnu.

10. A kind of sandstone from the Triassic age (see Fischer in this book, 78).

11. Baptiste and Zéphir 2008, 53.

12. This hole could also be used to pass a bracelet.

13. Perhaps one must see it as a characteristic of a Buddha or deity.

14. Parmentier 1927, 122, fig. 39.

15. Parmentier also noticed a cavity in the rock in the middle of Cave D.

16. The massif of Phnom Bayang is located about thirty miles southwest of Phnom Da. The EFEO architect Henri Mauger led projects both there and at Phnom Da in 1935 and 1936.

17. For example, this process is found on the third eye of Harihara (see figs. 76, 89), stone inscription K.1216 (NMC Ka.2445, see Mace in this book, 57n25), the outlines on the statues' breasts (pls. 1–8), decorations on the Phnom Bathep pedestal (see fig. 13), and to varying degrees on the feline skin covering the right side of the Paris Harihara (pl. 2) as well as the antelope skin held in the second lower right hand of the large Phnom Penh Vishnu (pl. 1).

18. NMC, Ga.5449 and Ga.5450.

19. Mauger, 1937, 258. Inscription K.14 is currently in the Musée Guimet.

20. The left toes are connected by the remains of conduits or channels used in the casting process.

21. Two bronze fingers were also discovered.

22. Mauger 1937, 256–58. There are important tenons in bronze under the heels, crossed by an iron armature and surrounded by corroded lead. The remains of the sandstone base have unfortunately not survived. Did the installation come at a later date? Were they a kind of *shivapada*, a type of icon consistent with a representation of Shiva's feet or footprints? This remains very hypothetical; Phnom Bayang also experienced a tumultuous history marked by numerous shifts in religious affiliation.

23. Porte and Chea 2008.

24. Ang 1997.

25. Two ancient inscriptions, K.913 and K.421, mention the production of wax and honey from the region of the Mekong delta. Coedès 1953, 270–72.

26. Inscription K.1215. The grindstone was offered to the king in 2005 and known through photographs by Michel Tranet. Soutif and Estève, forthcoming.

27. Inscription inventoried under the number K.600. The pedestal is today housed at the NMC.

28. Collection M. Tranet. The precise provenance at Angkor Borei is not yet known.

29. In recent years, with projects and development on the rise, many *tuols* were opened or even demolished along with the remains they concealed.

30. Ishanavarman was a ruler of the Zhenla dynasty based in Sambor Prei Kuk, about 300 kilometers north of Phnom Da and Angkor Borei (map 1). The coin with Sanskrit legends on both sides has the Indian goddess of wealth Lakshmi seated on a lotus on the obverse and Nandi, the bull mount of Shiva, crouching on the reverse.

31. Epinal and Gardere 2013. Some of these coins are today housed at the Ishanavarman Museum (coin and economy museum) in Phnom Penh.

32. NMC, Ka.268.

33. NMC, Ka.535.

34. NMC, Ka.230, Ka.302, Ka.242.

35. NMC, Ka.215.

36. Baptiste in this book, 133–38.

37. Analysis conducted by the Centre for Research and Restoration of the Museums of France (C2RMF) in 2000. See also Baptiste and Zéphir 2008, 56, cat. 14.

38. Delaporte (1880) 1999, 26; Lunet de Lajonquière 1902, 12–14; Aymonier 1990, 199–200.

39. A date mistake was found in Parmentier 1927, 121. Parmentier actually visited the site for the first time in 1911 according to the 1911 "Chronique" section of the *Bulletin de l'École française d'Extrême-Orient*, 249–50.

40. This arm would later be collected by Mauger before being shipped to Brussels. There would be many adventures.

41. Stole worn across the shoulder as a mark of respect for the divinity, like the monastic *ansak*.

42. A square or rectangular piece of cloth secured above a statue of the Buddha.

43. Information passed on by Philippe Stoclet.

44. Groslier 1924, 142.

45. NMC, Ka.265.

46. Mauger 1935–36.

47. Through art historian Victor Goloubew, member of the EFEO, and through Paris art dealer Paul Mallon (see Mace in this book, 52).

48. The king of Cambodia was Norodom Sihanouk (1922–2012). Political power, however, belonged to the colonial administration under the authority of Admiral Jean Decoux (1884–1963), who got his orders from the French government based in Vichy until the spring of 1944 and the Liberation of Paris. The colonial administration was constantly under the surveillance of the Imperial Japanese Army that was occupying the country.

49. We do not have any information about his death, which likely occurred during the Khmer Rouge regime.

50. Kam 1945.

51. Today it takes forty-five minutes in a motorboat. The landscape has not changed.

52. This was likely the name in Vietnamese, which means "Pagoda of the Mountain with the Tower." The pagoda stood near the first cave (B). See Porte 2016, 152n53; and map 3 in this book.

53. Can be translated as "Pagoda of the Great King." See Porte 2016, 153n55.

54. See Porte 2016, 132, fig. 12b.

55. The new religious movement emerged in 1926 in southern Vietnam and advocated for a reconciliation of the great religious universal traditions.

56. NMC, Ka.1747.

57. Porte 2002 and Guy 2014, 93, cat. 43. See also the conservation report NMC-EFEO, Ka.1731.

58. The Wat Chruoy is no longer in use; its location along the banks of the Angkor Borei River is where Angkor Borei's district museum stands today. *Chruoy* means peninsula in Khmer.

59. This market no longer exists. Its location was nearly right across from the NMC.

60. The Wat Kompong Luong was entirely destroyed.

61. The sandstone's being the same and the rarity of this kind of representation in the round encouraged us to attempt this pairing.

62. Porte 2006.

63. See Edelstein, Snyder, and Sturm in this book, 66–72.

64. We can conclude that the unattached right lower leg, which was for a time presented with the Phnom Penh statue, likely belongs to the Cleveland Krishna.

65. The fishermen for the most part belong to the Cham, Chvea or Jva (Muslim communities from Java), and Vietnamese communities.

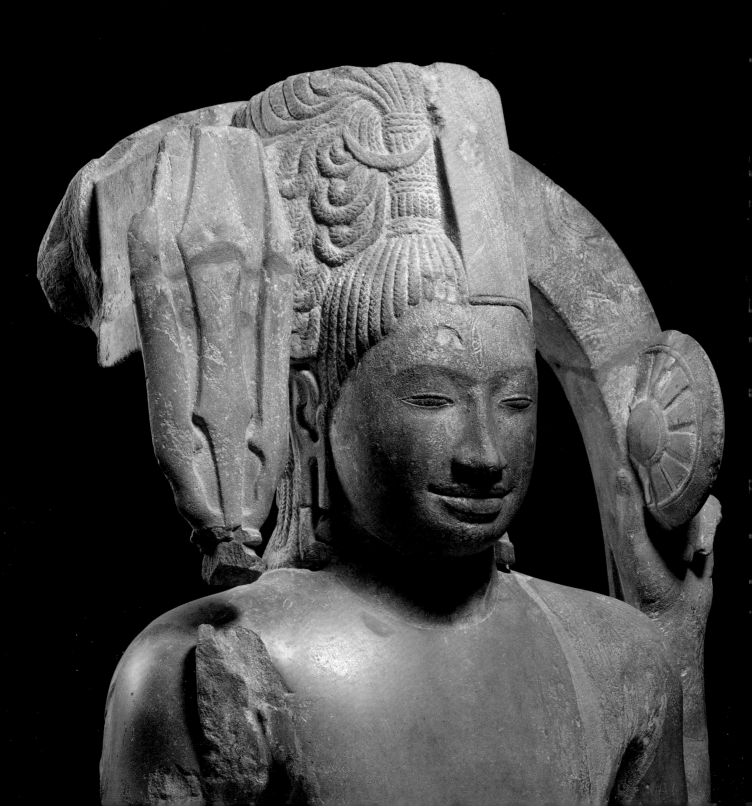

EXPRESSING ROYAL MAGNIFICENCE: THE CITY OF ANGKOR BOREI AND THE SACRED SITE OF PHNOM DA

PIERRE BAPTISTE

More than seventy kilometers as the crow flies south of Phnom Penh is a small town of about six thousand inhabitants nestled in an intricate network of canals and rivers (map 2). Most of the year, this vast plain is flooded by the impressive overflows of the Mekong River and one of its arms, the Bassac River. Peaceful and unpretentious, the town nevertheless retains part of its ancient prestige in the name of Angkor Borei, which can be translated as "capital city," "royal city," or "city of cities," according to Khmer toponymy.[1] Historians and researchers of ancient Cambodia agree that this small locality and the region surrounding it were the center of intense economic, political, and religious activity in the first centuries of our era. Its apogee seems to be at the end of the sixth century. Naturally turned toward the sea by the network of rivers that compose the meandering, immense Mekong delta and that were, over the centuries, reinforced by the digging of numerous drainage canals, this region was in early contact with the merchants who participated in the maritime trade connecting India to China. Brahmans in search of patrons, Indian merchants, and traveling Buddhist monks contributed to the diffusion of the foundations of Indianity: Hindu and Buddhist religions, Sanskrit language, script, a certain conception of the world, sciences, and the arts. This slow process of peaceful and gradual acculturation led the elites of the various regions of continental Southeast Asia and of Java to adopt these characteristics and set them up as a political, social, and religious system.[2] One of the places in Cambodia where the effects of these changes were most spectacular in early times is Angkor Borei and its region.

Angkor Borei occupies the southeast end of a small strip of land sinking into the western branches of the Mekong delta. Surrounded by lowlands connected to the delta, it is submerged most of the year with the notable exception of the northwest side where the city is connected with the north of the country thanks to a strip of land protected from the floods,[3] which places the city in contact with Prei Kabbas, Phnom Chisor, and the rest of Cambodia.

Even today, the northern core of the town of Angkor Borei is almost surrounded by arms of the river of the same name and a moat dug along the western and northern sides. This quadrangle stretches about nine hundred meters east to west by four hundred and fifty meters north to south; it is crossed by a grid of streets having perhaps preserved the city's genuine structure. The city

Figure 76. *Harihara* (detail, pl. 2). Photo © RMN-Grand Palais / Art Resource, NY / Thierry Ollivier

also includes an extension to the south bank of the Angkor Borei River, vaguely triangular in shape and occupying a space of about fifteen square meters east to west and north to south.[4] Étienne Aymonier's explorations of the site led him—as early as the late nineteenth century—to observe the vestiges of the surrounding wall and, perhaps, of "quays along the river." The archaeological work carried out under the supervision of the Lower Mekong Archaeological Project (LOMAP) since 1996—initiated in 1994–95 at the instigation of H. E. CHUCH Phoeurn and directed by Miriam T. Stark of the University of Hawai'i—would then confirm the richness of a site dating back to the middle of the first millennium BC and occupied at least until the sixth to seventh century.[5] During the archaeological campaign of 1995–96, a defensive structure was discovered that consists of a thick brick wall more than six kilometers long, bordered at least partly, inside and out, by parallel moats.[6] Together with the remains of brick structures found inside this enclosure, they enabled Stark to show that the site had been continuously occupied from the middle of the first millennium BC to the middle of the first millennium AD, making it contemporary with other urban centers in Burma (Myanmar), Thailand, and Vietnam. The actual layout of the city, harmoniously inscribed in the natural setting of the meanders of the river, parallels those of some contemporary cities of central Thailand related to the so-called Dvaravati period, such as U Thong, Nakhon Pathom, or Khu Bua.[7]

The inscriptions found in the Mekong delta regions of southern Cambodia and Vietnam bear witness to the importance of Indianization. They confirm a remarkable religious activity during this early period (sixth and seventh centuries), even if they are not always explicit.[8] They include names of Hindu deities Vishvarupa (Vishnu), Shri Tribhuvananjaya (Vishnu), and Ganapati (Ganesh) and lists of workers assigned to the temple. In 2014 the publication by Dominic Goodall and Gerdi Gerschheimer of an inscription written on a doorjamb stele found in Angkor Borei came to complement this rather limited corpus[9] by shedding light on the importance of the cult of Vishnu, once again called Tribuvananjaya (Conqueror of the Three Worlds), and his multiple manifestations (*prādurbhāva*), among which are Hayagriva, Varaha, Narasimha, and Vamana.[10] Their relevance in the context of Angkor Borei and Phnom Da is discussed later.

Early Political History of the Mekong Delta

For this early period up to the seventh century, some of the most precise records can be found in the Chinese dynastic annals, listing in a report of vassalage the contacts the Chinese empire established with its more or less distant neighbors. Paul Pelliot has clearly shown the importance of a kingdom called Funan by the Chinese, probably corresponding to the Mekong delta and present-day southern Cambodia, whose name could have originated from the Khmer word *phnom* or

"mountain," referring to the natural eminences where the gods live—in particular Shiva, but not exclusively—and where the Khmers erected many sanctuaries over the centuries.[11] This name of Funan, replaced in the seventh-century Chinese chronicles by the name of Zhenla, has long led historians to believe in a hiatus in the history of ancient Cambodia, one kingdom supplanting another. More recently, some researchers, particularly Michael Vickery (1931–2017), have shown that a certain dynastic continuity could apparently exist between these two entities, one simply more northerly than the first.[12]

As early as 1931, the progress of aerial photography enabled Pierre Paris (1859–1931), colonial administrator of civil services, to highlight the presence of old canals connecting Angkor Borei to several places, including Phnom Ba The and the site of Oc Eo, about eighty kilometers south-southeast (map 1).[13] The archaeological work conducted in early 1944 by Louis Malleret (1901–1970) in Oc Eo (An Giang Province, Vietnam) confirmed the richness of a major site in the Mekong delta—which would soon give its name to a whole culture characterized by maritime commerce, Indianization, a rational management of the delta, and construction of an urban center in which Hindu and Buddhist temples were associated.[14] In 1975, after the Vietnam War, Vietnamese archaeologists took over and highlighted the complexity of what is now called the Oc Eo culture.[15]

The problem with conceptualizing a coherent ancient political entity in the Mekong delta, as suggested by Miriam Stark,[16] is that on the Cambodian side of the border archaeological research could never be as intense, because of the crushing effects of the genocide and the aftermath of civil war. Furthermore, while restoration of monuments was occupying the time of all the scientific teams in Angkor and in the great temples of the periphery, extensive looting developed in the southern regions in the early 1990s. Therefore, it is difficult to apprehend a region formerly united on both sides of the border between Vietnam and Cambodia.

Finally, there has been a tendency to question the traditional vision of a civilization enriched by a process of Indianization linked to the development of maritime trade that exerted influence on relatively passive populations, as George Coedès believed. Some researchers, such as Miriam Stark and Charles Higham, strove to convincingly show that this Indianization was much more the consequence of a slow process that went further back in time.[17] Similarly, various historians sought to minimize the share of Indian influence as it had been conceived, described, and analyzed by French researchers in a particular colonial context.[18] In Éric Bourdonneau's recent relevant analysis of the historiography of this site, he reestablished Oc Eo and its relationship to the city of Angkor Borei in the process of a reaffirmed strong Indianization, but at the same time redefining and clarifying the meaning. According to his analysis, this was neither a massive

Indian contribution received by rather passive locals nor a superficial varnish adopted by people otherwise independent in mindset. The reality is somewhere between the two, but the importance of Indianization cannot be minimized.[19]

Colonial Discoveries

Étienne Aymonier was the first to recognize the prestigious origin of the small town of Angkor Borei. This self-taught soldier, whose career led him to Indochina in the colonial context, would devote his life to studying the Khmer language and to teaching at a time when everything in this area was yet to be well understood. In charge of "native affairs," he was first working in Tra Vinh province in Vietnam, where he was in close contact with the Khmer community of the Mekong delta beginning in 1871 (map 1).[20] Aymonier began to travel through Cambodia in 1876, but it was particularly between 1879 and 1881, when he was acting as the representative of the French Protectorate of Cambodia, that he intensified his archaeological explorations throughout the protectorate. The records of old inscriptions that he brought back to France in 1881 soon allowed Auguste Barth (1834–1916), Émile Sénart (1847–1928), and Abel Bergaigne (1838–1888) to produce the first translations.[21] Bergaigne also attempted to create the earliest chronology of the Khmer kings.[22] In order to complete the documentation of the inscriptions, Aymonier returned to Cambodia in 1881 to make more precise rubbings, employing the so-called Lottin de Laval process of using laminated paper that rendered more complete and accurate transfers from the original carved stone. Between March 20 and April 26, 1882, he explored southern Cambodia and the Angkor Borei region. His knowledge of the Khmer language was helpful. The particular name of the small town of Angkor Borei guided his steps in that direction. Unfortunately, it was not until two decades later that he published the accounts of this interesting mission, in the first volume of his work *Le Cambodge*. Yet, he reveals all the finesse of his judgment when he writes, concerning the province of "Prei Krabas" (present-day Takeo Province where Angkor Borei and Phnom Da are located): "[T]he archaeological and epigraphic vestiges are very important in this province where one of the oldest capitals of Cambodia was raised."[23] It was indeed not easy to imagine, in the 1880s, all the importance that this apparently remote region had played in the history of ancient Cambodia.

Sculptures of Angkor Borei

Some sculptures from the late sixth to seventh century and often of great plastic quality have been found in the city or its immediate surroundings. They bear witness to this prestigious past. Found by Aymonier, some of these works reached France in 1889, where they were exhibited in Paris in the outdoor gallery of the

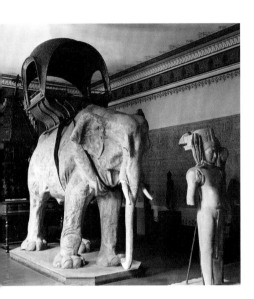

Figure 77. *Harihara* (pl. 2) exhibited in the original Indochinese gallery of the Musée Guimet around 1900–1910. Musée national des arts asiatiques–Guimet, Paris

Palais du Trocadéro during the Paris Universal Exhibition, shortly before being transferred to the Musée Guimet (now known as the Musée national des arts asiatiques–Guimet, Paris), which had just opened that year (fig. 77).[24]

In 1882 Aymonier brought to light "under the trees outside the southern gate of the city" of Angkor Borei a tall pillar surmounted by a bull (vṛṣastambha), which has been kept since 1889 in the Musée Guimet with other pieces from the same source (fig. 78a).[25] Quite enigmatic and without equivalent in Cambodia, this large slate pillar is almost entirely without decoration, except the beveled edges nearly the entire height of the piece, but not at the lower and upper parts.

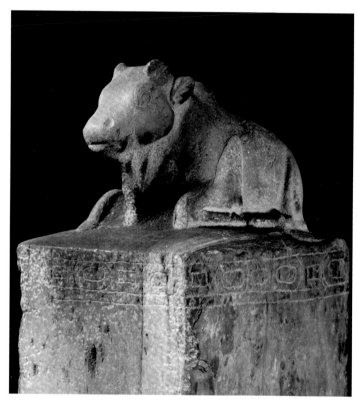

Figure 78a, b. *Pillar with Nandin (Vṛṣastambha)*, 500s–600s. Southern Cambodia, Takeo Province, Angkor Borei. Slate; 253 x 27 x 33.5 cm. Musée national des arts asiatiques–Guimet, MG 14930. Photos © RMN-Grand Palais / Art Resource, NY / Thierry Ollivier

The top is underlined by a frieze roughly incised in the stone with alternating ovals and rectangles (fig. 78b), according to a decorative principle characteristic of Khmer architectural ornament of the seventh and eighth centuries, evoking a "frieze of large gems encased in a metal frame, a bezel which sets and unites them."[26] This is what art historian Mireille Bénisti called "the bezel band."[27] The rustic treatment perhaps indicates an even greater antiquity (possibly during the sixth century). Even today, the fragment of a stone slab decorated with the same ornament is found in the modern pagoda of Wat Kompong Luong, in the center of Angkor Borei.[28] The animal lies atop the pillar, its legs folded under its body

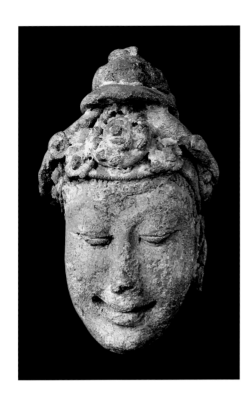

Figure 79. *Head*, c. 500s–600s. Southern Cambodia, Takeo Province, Angkor Borei, Wat Komnou. Stucco; 24.4 x 15.2 x 10.1 cm. National Museum of Cambodia, Kha.1706. Photo: Sonya Rhie Mace

with the exception of the right foreleg extended forward; the animal is treated with great sobriety. No doubt the hardness of the stone—a slate found in the region, especially used for the inscribed stelae and door frames of Buddhist and Hindu monuments of the period—did not allow for a more elaborate sculpture. Convinced that this pillar was nevertheless a kind of emblem posted close to the city gate, Aymonier mentioned that another example was to be found at the north gate. It is unclear whether he was referring to a simple figure of the sacred bull calf Nandin, another example of which was found in Angkor Borei, or to a real pillar that, according to him, "was removed and transported to Oudong by order of King Ang Duong, therefore around 1850" of which there is no longer any trace.[29] Another image of Nandin, but of a much more prestigious level, made in bronze, was found in 1983 in the remains of a temple in Tuol Kuhea (Kandal province, Cambodia), seven kilometers east of Angkor Borei (see fig. 54).[30]

Such a pillar was likely originally part of a temple complex dedicated to Shiva, since the bull is his mount, and it may have been erected in front of the sanctuary long before being moved to its place of discovery in the nineteenth century. Miriam Stark's archaeological surveys within the city have highlighted the remains of several brick terraces, some of which are probably linked to temples.[31] Recall that in 1923 George Groslier found some interesting vestiges of architectural design on "a mound located along the dike of Angkor Borei where a pagoda was formerly located."[32] These few heads in high relief (e.g., fig. 79), made of stucco, or more precisely lime mortar, were formerly fixed to a brick masonry, some fragments of which are still partially visible on the back. Although heavily eroded and difficult to properly visualize, they nonetheless bear witness to the high quality of the architectural sculpture of the time (probably sixth to seventh century). The plastic treatment of the faces shows varied expressions and sophisticated hairstyles reminiscent of similar works unearthed in the contemporaneous cities of central Thailand and that are today grouped under the convenient designation of Dvaravati art.[33] It can thus be affirmed that brick temples existed in Angkor Borei, and some of them were decorated with reliefs of stucco of an elaborate nature, as seen in Thailand and in Sambor Prei Kuk (seventh century).

It is not known whether it was within Angkor Borei or on the slopes of the neighboring hill of Phnom Da that Aymonier discovered the remarkably preserved, charming little sculpture possibly representing Agni, the god of fire and guardian of the southheast, now in the Musée Guimet (fig. 80). This directional deity (*dikpāla*) was once confused with a representation of Shiva on Nandin.[34] The character's stocky proportions, the abundance of hair falling on his shoulders, and the absence of a third eye are, however, incompatible with this identification. Furthermore, the mount has nothing to do with a Nandin bull. Aymonier, followed by Coedès, formerly identified the animal as a pig, but the sort of "saddle

cloth" that covers his back is probably the misunderstood translation of the armor of the rhinoceros: Agni's attested mount.[35] Belonging to the art of the neighboring Champa people, a comparable example appears on an interesting offering pedestal (*balipītha*) showing the eight directional deities[36] and a similar version of the rhinoceros, treated in such an uncertain way. In the case of our sculpture, this statuette could have been accompanied by seven other directional deities, surrounding, for instance, a representation of Shiva. This original small work bears witness to the particular context to which it relates. The general treatment of the sculpture, the smiling face with its large expressive eyes, and the stylization of the costume are all elements showing links with the art of Champa. But the robust musculature, the stocky proportions of the chest, and the plump arms tie this work well to the creations of the Mekong delta related to the Oc Eo culture, while the face follows the style of the sculptures discovered in or near Phnom Da, some examples of which are in this book. These influences reflect the particular dimension occupied by Angkor Borei within the Indochinese peninsula: as an outpost of the Khmer country turned toward the Mekong delta, which does not stop unrolling its meanders toward the sea. It is a bastion of an entity linked by the Angkor Borei River and the canals to the "trading post" that was the city excavated on the site of Oc Eo by Louis Malleret.

North of Angkor Borei, seven kilometers from the northern wall of the city in what is now Phum Ta Ei, along the northern route (map 2), a large modern Buddhist temple known as Wat Koh, the "Temple of the Island," can be recognized precisely by the presence of a large pond in the middle of which is a square peninsula with what appears to be an ancient layout. This is where in 1935 Henri Mauger uncovered the fragments of a beautiful sandstone sculpture depicting Krishna raising Mount Govardhan (see fig. 5), which has stylistic characteristics allowing it to be linked probably to the seventh century and to other statues in the area.

Remains other than those of Hindu affiliation have been found in Angkor Borei and the surrounding region. Pre-Angkorian Buddhist sculptures were unearthed in 1923 at Wat Romlok, a modern Buddhist sanctuary about nine kilometers north of the city along the road connecting Angkor Borei to northern Cambodia via Prei Kabbas (map 2).[37] The sculptures still evince a strong Indian influence; some can be dated from the end of the fifth to early sixth century, and others to the sixth and seventh centuries.[38] Perhaps they are related to a Buddhist inscription found about fifty kilometers north at Ta Prohm of Tonle Bati (map 1).[39] As for the sculptures of Wat Romlok, kept at the National Museum of Cambodia in Phnom Penh,[40] they are representative of the crossroads of influences that characterize this region. They are inspired by Indian models of various origins—Andhra Pradesh of the fourth century in southeastern India

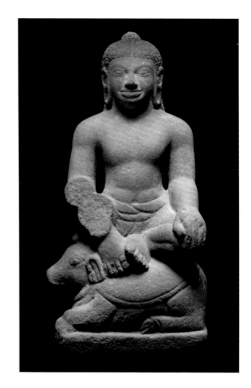

Figure 80. *Agni*, 500s–600s. Southern Cambodia, Takeo Province, Angkor Borei or Phnom Da. Sandstone; 38 x 19 x 13 cm. Musée national des arts asiatiques–Guimet, MG 14947. Photo © RMN-Grand Palais / Art Resource, NY / Thierry Ollivier

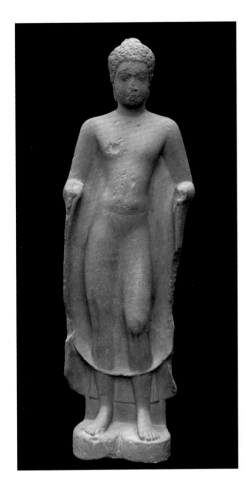

Figure 81. *Buddha*, c. 650. Southern Cambodia, Takeo Province, Wat Romlok. Sandstone; 95.5 x 32.3 x 17 cm. National Museum of Cambodia, Ka.1595. Photo: Pierre Baptiste

under the Ikshvaku dynasty, Uttar Pradesh and Madhya Pradesh of the fourth to sixth century in northern and central India during the so-called Gupta and post-Gupta periods, and western India under the Vakatakas—but they are reconceived in such an original manner that they cannot be mistaken as copies. If the famous Buddha head[41] is rightly considered one of the examples most faithfully reflecting these Indian contributions and shows many stylistic links with the Krishna of Wat Koh (see fig. 5), then the beautiful standing Buddha with slender proportions[42] seems to testify to the evolution of this influence in a more specifically Khmer spirit that could be dated to the middle of the seventh century (fig. 81).

In 1923 George Groslier was able to unearth the bust of an interesting sculpture, possibly representing a bodhisattva, in the eastern section of the rampart of Angkor Borei, at a place where there was a shrine called Kdei Ta Nguoy (fig. 82).[43] Unfortunately heavily eroded, the statue nevertheless has many preserved details that make it a particularly wonderful work. The male deity wears a large diadem with a flat band including three florets with an ovoid heart, enriched by a halo with radiating stripes. Adorned with heavy ear pendants and a pectoral necklace, he wears large shoulder-length curls. In the most recent analysis devoted to this sculpture, John Guy compared it to the famous Lokeshvara of Tan Long (Rach Giá province, Vietnam), a masterpiece in the Musée Guimet that was brought to light much farther south, in the Mekong delta, in 1919.[44] Noted elsewhere, this outstanding work has links with the arts of India and of the Malay peninsula,[45] additional proof of the multiplicity of influences on these works produced in areas in contact with the sea and naturally turned toward the cultural and commercial exchanges that it permitted.

The same could be said about the extraordinary monumental but quite eroded *yaksha* to which little attention is paid today, with the notable exception of John Guy.[46] Pierre Dupont found it "at the edge of the *stung*, in the northern sector of the city" and brought it to the National Museum of Cambodia in 1944 (information kindly provided by Bertrand Porte). Like the bodhisattva bust, it is characterized by a sculptural treatment of great force and testifies to the local adaptation of the yaksha cult in a Buddhist context, following an Indian precedent.

But it is in the heart of the city, inside the modern Buddhist sanctuary of Wat Kompong Luong, where the most fascinating Buddhist image of the period was found (see fig. 46). It is probably no coincidence that it was once part of an important Buddhist temple, located along the Angkor Borei River at the southwest corner of the intersection of the two main streets of the northern district of the city (map 2). Some fragments of sculptures, still remaining on-site, bear witness to that importance, including the aforementioned slate slab, as well as an incomplete inscription presenting a list of workers attached to the service

of a foundation of which nothing else is known, but that can be dated paleo-graphically to the sixth to seventh century.[47] Lacquered, gilded, and completed with modern additions to harmonize it with the cult statues that surrounded it in the modern sanctuary of Wat Kompong Luong (see fig. 66). this powerful representation of a seated Buddha was placed in 1944 at the National Museum of Cambodia, where an important successful restoration was recently directed by Bertrand Porte.[48] Carved from dense, high-quality sandstone, the impressive work has a powerful, sophisticated aesthetic—a very fine example of the Phnom Da style translated into a Buddhist context, as defined by Pierre Dupont.[49]

Harihara Sculptures and the Pre-Angkorian Art and Monuments of Phnom Da

Phnom Da has indeed given its name to a style—the first great style of pre-Angkorian statuary, surprising if one considers the mastery with which the characteristic works were carved and the sophistication of the finest details. This small natural hill consisting of two main peaks, the taller of which culminates at barely forty-four meters above sea level, two kilometers southeast of the city, is part of several rocky hills and mounds, the highest of which is Phnom Borei (one hundred sixty-four meters above sea level), located three and six-tenths kilometers south of the southern city wall (map 2). As early as 1882, Étienne Aymonier had glimpsed the importance of these hills and hummocks, "which, according to some natives, present vestiges of burials of the ancient kings."[50] Local tradition often considered the remains of ancient temples as the "burials of kings." George Coedès was interested in this possible funerary dimension of the temples, at least some of them.[51] Abandoned afterward, or minimized, this hypothesis was taken up more recently and convincingly by Éric Bourdonneau.[52] Nevertheless, Bertrand Porte recently confirmed the presence of architectural remains (fragments of bricks) on most of these mounts and mounds, such as Phnom Borei, Phnom Ngnel, and, of course, the two main peaks of Phnom Da.[53] The most spectacular and best preserved have been known for a long time. Built in laterite and brick and visible from afar (frontispiece pp. 2–3), the main tower is a later and original monument, to be discussed herein.

The second monument is a sanctuary of a type no less extraordinary, first by its materials, then by its structure, and finally by its type of superstructure. The Ashram Maha Rosei or "Hermitage of the Great Ascetic" is indeed a build-ing that has caused a lot of ink to flow (fig. 83a; see also fig. 34c). The small temple was built entirely in stone (a basalt with a microlithic structure)[54] at a time when stone was usually only used for a few parts of a brick monument. A narrow corridor surrounds the cella, pierced with small windows opening in the external wall (fig. 83b). The architectural composition of the whole and its

Figure 82. *Bodhisattva*, 600s. Southern Cambodia, Takeo Province, Wat Kdei Ta Nguoy. Sandstone; 68 x 53 x 28.5 cm. National Museum of Cambodia, Ka.1590. Photo: Konstanty Kulik

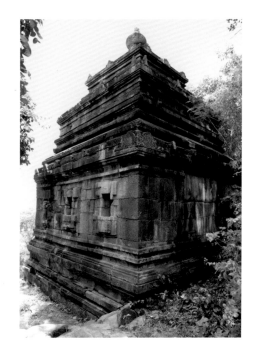

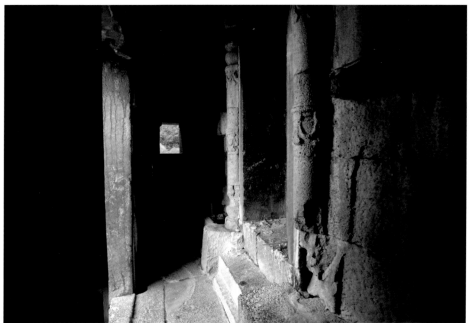

Figure 83a, b. Ashram Maha Rosei, view from southwest corner (a); circumambulatory passage with door to sanctum (b), c. 600. Basalt. Photos: Konstanty Kulik

ornamentation—as brilliantly shown by Henri Mauger, who knew the building perfectly from having it dismantled stone by stone and then reassembled during the restoration of 1935—show how much this monument is inscribed in the direct heritage of Indian architecture and precedes, in many respects, the better-known pre-Angkorian Khmer architecture of the seventh and eighth centuries. On the other hand, it remains to be answered if Mauger is correct when he asserts that the temple was built in another place, probably more northerly (in the basaltic zone of Cambodia), before having been dismantled and moved south to Phnom Da.

Whatever the truth about the construction of the Ashram Maha Rosei, in the immediate vicinity of this small monument Aymonier discovered a sculpture "almost intact" in 1874. However, it was reportedly shattered in 1880 "by a fierce and lonely elephant that remained the terror of the region for a long time."[55] The fragments of the sculpture were sent to France with the pieces already noted and some other works that will be discussed further. The sculpture was restored in Paris and kept upright by heavy metal stands (fig. 84). This work is the beautiful representation of Harihara, which is today among the masterpieces in the Musée Guimet (pl. 2). Since the work of Henri Mauger in 1935, it has been known that the Ashram Maha Rosei could not receive this far too large statue with its wooden ceiling in place, which it should have been. However, there is nothing to confirm where this work was originally worshiped. If believing a note of October 12, 1950, written by the curator of Angkor at the time, the Harihara would

actually come from "one of the five caves of Phnom Da"[56] where a fragmentary base preserving the feet of the statue was found, now kept at the National Museum of Cambodia (fig. 85). Considering the size of this statue that had a long tenon to strongly secure the sculpture to the pedestal, and taking into account the necessary height needed to properly lift the statue on its pedestal, such an image can be believed to have been worshipped in a brick tower, now destroyed. No doubt the statue was put close to Ashram Maha Rosei at a later date. Perhaps it was found in the remains of the large brick structure, the unexcavated remains of which can be seen behind the Ashram Maha Rosei (map 3; fig. 7). The presence of gilding on lacquer, covering the partly eroded face (fig. 76), highlights the clearly later cults of which this Hindu deity was the object, requiring its displacement, probably at a time when the iconography of this venerable image had long been forgotten. Bertrand Porte already showed the extent of the modifications to many statues from this site.[57]

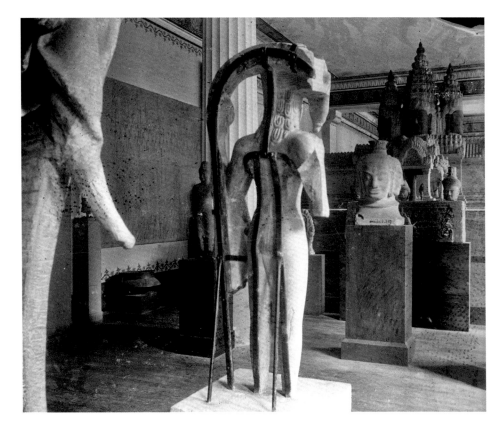

Figure 84. *Harihara* (pl. 2) exhibited in the original Indochinese gallery of the Musée Guimet, around 1900–1910. Musée national des arts asiatiques–Guimet, Paris

Figure 85. Feet with base and tenon of the Paris Harihara (pl. 2), c. 600. Southern Cambodia, Takeo Province, Phnom Da. Sandstone; 73.2 × 41.2 × 21.7 cm. National Museum of Cambodia, Ka.230, Ka.242, and Ka.302. Rendering from 3-D photogrammetry and LIDAR scan by David Korzan and Michał Mierzejewski, courtesy Konstanty Kulik

What is certain, however, is that this Harihara image shows close connections with the sculptures found in 1935, during the clearing of rubble carried out by Henri Mauger's team inside the cella of Prasat Phnom Da. Three statues of exceptional quality were found in fragments: a colossal image of *Vishnu with Eight Arms* (pl. 1)—a major representation that appears to be the most imposing and the most elaborate of all pre-Angkorian sculptures preserved from this date—and two aspects of this god: *Rama* holding his bow (pl. 3); and *Balarama* (pl. 4), who can be recognized by his plow. Today preserved in the National Museum of Cambodia, these sculptures present, with Harihara, homogeneous and, after all, original aesthetic characteristics, to the extent that these images seem to be the most impregnated with Gupta and post-Gupta Indian traditions. Among them are the general proportions of the body—broad shoulders and a thin waist, with sensitive muscles under supple flesh—the hips wrapped with a tight loincloth marked with symmetrical radiating folds sculpted in the round, the noble and almost haughty face with an aquiline nose and almond-shaped eyes, and an imperial smile, proud and distant. On the Harihara, the ascetic's high knotted hairstyle that crowns the part depicting Shiva seems to be a faithful echo, beyond the seas, of the heavy coiffures with sophisticated plaits worn by the Indian Buddhist and Hindu deities worshiped in the excavated shrines of Maharashtra made under the Vakataka dynasty of western India. The rows of heavy ringlets on the regal images in plates 1–4 and 6–8 recall sculptures on the temples of the kingdom of Magadha in the Gangetic plains (fig. 86).

Pierre Dupont brilliantly showed this Indian influence that his successors, notably Jean Boisselier, tended to downplay, contending that such sophisticated art could only see the light of day around the eighth century.[58] Even now, the dating of these major works is far from unanimous. The doubts mentioned by Boisselier and the proposition of Nancy Dowling to date these works to the seventh century—in connection with this attempt to show a Funan dynasty country less steeped in Indianness than previously thought, compared to the Zhenla—have led many researchers to reject Coedès's hypothesis of linking the early sculptures and temples of Phnom Da to the patronage of the last king of the Funan dynasty, Rudravarman (515–539). Admittedly, the indices offered by Coedès are fragile. They are given by an inscription written on a slab in slate, alas fragmentary, in a rather late script, which cannot be "very posterior to the twelfth century."[59] This text in Sanskrit and in Khmer mentions a certain king "Rodravarmma," associated with several Vaishnava foundations, who was considered by Coedès to be the aforementioned Rudravarman. In the text, apparently too fragmentary to be properly translated, in the Sanskrit part are various names of Vishnu—Keshava, Govardhanasvami, Narayana, Hari, and Trivikramapada—and in the Khmer part, it is specified in the first line: "after

the ceremony of installation of Hari Kambujendra in the cave, a royal order enjoined. . . ." These varied and explicit Vaishnava iconographies correspond to several images found on the site.

Considering the question of the king's name, John Guy's claim "that the author of this twelfth-century inscription mistakenly associated the Phnom Da Vaishnava school with an early sixth-century ruler is excusable"[60] can be disputed. The Khmers gave ample, solid evidence of their knowledge of pre-Angkorian history and royal genealogies in Angkorian inscriptions. The name of the king (*rāja*) appears five times in the thirty-one lines of the text; this cannot be an error. On the contrary, this is a later but unassailable document proving the connection King Rudravarman had, at least, with the nucleus of foundations on the site. The later date of the inscription, mentioning events that happened almost six centuries before, can also be considered as evidence for the high prestige of the site at a time when, precisely, the main tower was restored at great expense. Another inscription, found in Phnom Da in 1923, is a fragment of a stele written during the reign of Rajendravarman (r. 944–967), which mentions the consecration of an image of Vishvarupa and of an ashram by a member of the court.[61] It is probably no coincidence that the names mentioned in the inscription, Vishvarupa and Shankaranarayana, can be linked to a Vaishnava context

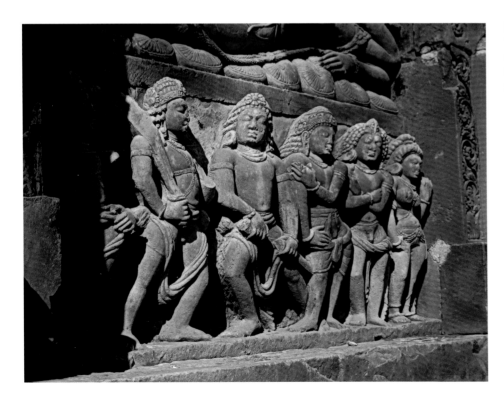

Figure 86. Relief on the south wall of the Vishnu Temple at Deogarh: Vishnu's personified weapon battles the demons Madhu and Kaitabha, 500s. Central India, Madhya Pradesh, Deogarh. Sandstone. Photo: Pierre Baptiste

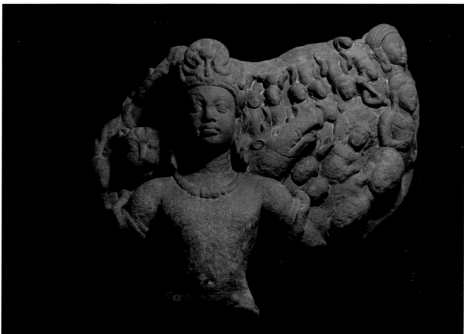

Figure 87. Fragment of a statue of Vishvarupa, c. 600. Southern Cambodia, Takeo Province, Angkor Borei. Sandstone; 136 x 55.5 x 29 cm. Angkor Borei Museum, TKA.Ka.003. Photo: Pierre Baptiste

Figure 88. *Vishvarupa*, c. 500. Northern India, Uttar Pradesh, Aligarh District, Bhankhri. Sandstone; h. 46 cm. Government Museum, Mathura, 42-43.2989. Photo: Pierre Baptiste

and to the iconographies appearing in this high Vaishnava place. Vishvarupa is the name under which Arjuna invokes Krishna when he sees him appearing with all the gods in his body, with multiple arms, multiple trunks, etc.[62] The Angkor Borei Museum keeps a fragment of a sculpture that corresponds to this iconography (fig. 87); to our knowledge it is unique in Southeast Asia in an aspect corresponding, moreover, to what is seen in the Gupta period (fig. 88).

As for Shankaranarayana, it is just another way of saying Harihara. The iconography of the Paris Harihara (pl. 2) is particularly interesting in that it brings together, in a single form, some characteristics of Vishnu and Shiva. Figured with four arms (*caturbhuja*) according to a Khmer constant for Vishnu, Harihara (Vishnu–Shiva) appears sculpted in the round in front of a support arch, now broken, whose shape evokes the form of the heavy stelae to which the Indian deities sculpted in high relief are attached. Vishnu can be recognized by the cylindrical miter with which he is crowned and by the discus (*cakra*) that still appears in his upper hand. The lower hand may have been resting on a club (*gadā*), which Khmer sculptors used as additional reinforcement by attaching it to the base of the sculpture, but it is not impossible that Vishnu held a lotus flower or that he simply made a gesture of grasping, the attribute being realized in a different material, or any other mudra. The god is clothed in a short lower garment with radiating folds that join a median piece of textile formerly falling to the feet and attached to the base. Shiva, wearing an ascetic hairstyle, has the crescent moon

(*indudala*, *śaśāṅkalekhā*), the third eye, and the trident (*triśūla*), which are among his distinctive elements. His upper hand could have held an attribute, possibly a rosary (*akṣamālā*). The god is dressed in a feline skin (*vyāghracarman*) enclosing his waist, responding symmetrically to the pleated garment of Vishnu.

Even though this iconography has been known in the Indian subcontinent since the Kushan dynasty (first to third century) and can still be seen today in various forms, at least in South India, the cult of Harihara in Southeast Asia experienced a particular, if not exclusive, favor in pre-Angkorian Cambodia, the later Khmer images becoming increasingly rare over time. Frontal and hieratic, in accordance with the texts, Harihara appears here in all the majesty of a powerful but benevolent god, with timeless youth (but nevertheless datable). Indeed, comparing it in detail with the three major sculptures found in the sanctum of Prasat Phnom Da—the great *Vishnu with Eight Arms*, *Rama*, and *Balarama*—it seems that the Paris Harihara was made by different sculptors at a slightly later date. The subtlety of the contours of the relief and the finesse of the details, as fine as they are, no longer have the virtuoso character that one can only admire in the so-called triad. A certain stiffness, still quite relative, appears in this sculpture, which is inspired by the characteristics of the triad but which seems to herald the much less graceful, less detailed, and more schematic treatment that characterizes the second Harihara found also at Phnom Da (pl. 8).

Now preserved in the National Museum of Cambodia, the Phnom Penh Harihara—with an astonishing destiny—was discovered in three stages (see Appendix). The head was found by Aymonier in the same circumstances discussed earlier, although he does not explicitly mention this in his works, which is not unusual for him (fig. 89). What is sure is that the head followed the same route as the other pieces from the Aymonier collection and has been exhibited in Paris at the Musée Guimet since 1889.[63] The lower hands with the rosary and the mace were found at the foot of the eastern slope by George Groslier in 1923. The body was described by Henri Parmentier in 1913 as having been in one of the caves on the northeastern hill of Phnom Da (Cave F). In 1944, as part of KAM Doum's archaeological work ordered by Pierre Dupont, it joined the collections of the National Museum of Cambodia in Phnom Penh. In 1955 Dupont recognized the probable connection between the head and body fragments, but it was not until 2015 and the signing of an agreement between the Musée Guimet and the National Museum of Cambodia that the head kept in France for one hundred and thirty years would again be placed on the shoulders, in Cambodia, during an impressive ceremony on January 21, 2016.

A continuation of the Phnom Da style, this work bears witness in many ways to a sensitive stage of evolution, through the more stylized treatment of the face, the features of which of course retain the general characteristics of

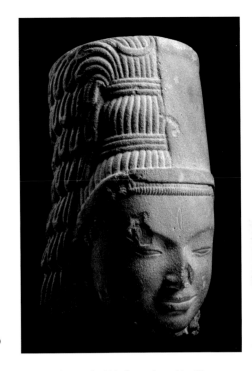

Figure 89. *Head of Harihara*, from the Phnom Penh Harihara (pl. 8). Musée national des arts asiatiques–Guimet, MG 14899. Photo © RMN-Grand Palais / Art Resource, NY / Thierry Ollivier

older-style images (known as "style A" by Dupont) but in a noticeably less subtle form. Likewise, the particular treatment of the splendid ascetic chignon in the crown (*jaṭāmukuṭa*) clearly derives from that of the Paris Harihara, with its horizontal braids enclosing vertical dreadlocks falling in a cascade of loops behind the ears and at the back of the head. But there is quite a difference in the artistic treatment. Compared to the heavy, finely incised locks textured with chevrons falling elegantly and naturally in a spirit so consistent with the Indian Gupta and, better still, post-Gupta traditions, the locks of the Phnom Penh Harihara evoke long gadroons that seem somewhat artificial. Relatively geometric, the hairstyle harmonizes more with the cylindrical miter, both in general proportions and in the presence of a small flat band, forming a diadem, bringing together on the forehead this double hairstyle of Harihara. This small band rests over the hair of Vishnu, which, astonishingly, extends across the entire forehead, whereas the hair of Vishnu on the Paris Harihara appears only on the corresponding left half (see fig. 76). Can this be seen as a sign of misunderstanding, as suggested by Dupont—the part corresponding to Shiva having received a hair overlay—or a deliberate desire to designate Vishnu as the main deity?[64] With the absence of contemporary inscriptions of these foundations on Phnom Da, the answer will probably never be known. What is sure is that the treatment of the body proportions and details and the simplified aspects of the costume lead to the same conclusion that the statue was made in a later period, probably not before the middle of the seventh century, if one considers its connections with other well-known pieces such as the famous Tuol Dai Buon Vishnu.[65]

Nevertheless, these two sculptures of Harihara show vividly that the statuary of Phnom Da was not produced in a single phase. Obviously, the major images of the so-called triad are the reference works that are suggested to be associated with Rudravarman's reign, going back to the proposals of Coedès and Dupont. The logic or meaning of this triad has so far never been clearly understood. It seems that the existence of these statues is connected to a wish expressed by the king himself, who ordered the group to represent Supreme Vishnu (later called "Hari Kambujendra," or Vishnu Lord of Kambuja/Cambodia) with two specific aspects of the same god as parallels to himself as supreme ruler: Rama, as the warrior and protector of the kingdom, on one side; and Balarama, as the manager and sponsor of land drainage, irrigation, and intensive rice cultivation, on the other. Though purely hypothetical, this would make sense in what is known, in later periods, about the connections Khmer kings and sponsors liked to emphasize with gods in a social and political staging, conceived to reinforce their future life after death as well as their own prestige during their lifetime. The second phase of foundation was (during Rudravarman's reign or more possibly

in the second half of the sixth century) when the Phnom Penh Krishna (pl. 5), the Cleveland Krishna (pl. 6), and the unidentified two-armed deity of the National Museum of Cambodia (pl. 7) would be installed on Phnom Da, in brick structures built in front of the caves, or inside some of the caves only for the Krishna Govardhana images. It was probably in this second phase of the Phnom Da period that the Wat Kompong Luong Buddha was sculpted (see fig. 46). Then, in a third stage (possibly during the late sixth to early seventh century), the Paris Harihara was probably added to the group (pl. 2). Then, it was certainly not before the middle of the seventh century that the second Harihara was sculpted, today shared between the two institutions, the National Museum of Cambodia and the Musée national des arts asiatiques–Guimet but preserved in Phnom Penh (pl. 8).

The question arises regarding the dating of the Krishna of Wat Koh and, with it, of certain Buddhist works from Wat Romlok that seem to present a more specifically "Khmer character." In that perspective, one would be tempted to place them also in the middle or at the end of the seventh century, or even in the eighth century. But recall that Dupont thought they form, on the contrary, a very early group.[66] As evidenced, the question of dating pre-Angkorian works is far from being resolved.

The Twelfth-Century Restoration

This brief presentation of the site is not complete without discussing the spectacular eponymous monument that stands with pride at the top of the northeast peak (see fig. 34a). This sanctuary "stands out among all by its gigantic proportions: it measures internally seven and a half meters deep, and eight and a quarter meters wide; its walls are two and a half meters thick."[67] Superbly constructed, the tower is built in laterite carved and adjusted with particular care. Although this stone does not generally allow the carving of fine details, the sculptors nevertheless managed to release a beautiful shape for the lower base, the proper base, and the cornice (fig. 90). Thus, for the secondary sides of the tower, there is a precise drawing of the capitals of the pilasters and of the multi-lobed pediment with ends depicting the heads of polycephalous serpents. Beyond the cornice, the superstructure is entirely made of brick and partly collapsed (frontispiece pp. 2–3).

In the course of Henri Mauger's work at the site in 1935, he noted that it appeared as though the internal and external laterite walls covered the original structure of a pre-Angkorian brick tower. Traces of it can still be seen under the western blind door.[68] This renovation, meticulous and respectful for an ancient monument, took place somewhere at the beginning of the twelfth century,

Figure 90. Prasat Phnom Da, west elevation: detail of cornice and side view of the pediment, c. 1100. Southern Cambodia, Takeo Province, Phnom Da. Laterite. Photo: Konstanty Kulik

taking into consideration the proportions of the pediments and the moldings of the base and cornice. But this is even more obvious considering the sandstone elements that once constituted the ornaments of the front door, located on the north face, in the direction of Angkor Borei (fig. 91). Along the axis of the temple, there is also, near the city, a large, rectangular-shaped artificial lake (the Eastern Baray), well oriented, whose foundation may be contemporary with the reconstruction of the monument in the beginning of the twelfth century (map 2). Elements of sandstone columns and lintels, broken into several pieces, were found by Étienne Aymonier, who sent some of them to the Musée Guimet (figs. 92a–b, 94, 96).[69] Their style is hard to analyze due to the local character of the sculpture, which differs from the conventions used much farther north in Angkor at the

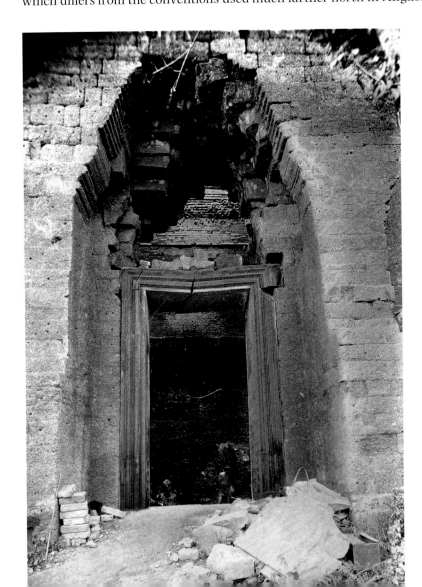

Figure 91. Prasat Phnom Da, north elevation: detail of entrance in 1935. Laterite, brick, and sandstone. Photo © EFEO

same time. However, elements of decoration, including the impressive columns with side moldings and small ascetics carved in architectural niches at their base (fig. 92a, b) and the costumes and adornments of the many figures appearing on the lintels (figs. 93–97), indicate a placement at the hinge of the Baphuon and Angkor Wat periods of the early twelfth century.

The lintels—if they are indeed two lintels and not a lintel and a pediment as I once thought—present an iconography in harmony with the Vaishnava site. On the first, a four-armed Vishnu presides over the churning of the Ocean of Milk, shown climbing the columnar shaft of the churning rod Mount Mandara (fig. 94), in accordance with the myth depicting gods and demons in the quest for the nectar of immortality, admirably described in the *Bhagavata Purana*. Kurma,

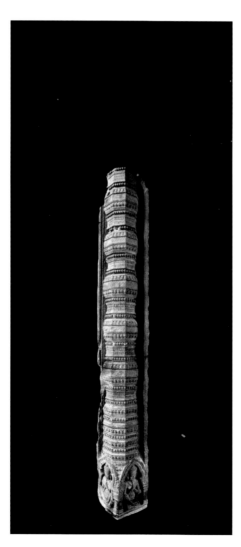

Figure 92a, b. Columns from the entrance to Prasat Phnom Da, c. 1100. Sandstone; 387 × 42 × 42 cm (a); 276 × 33 × 33 cm (b). Musée national des arts asiatiques–Guimet, MG 18324 (a) MG 18323 (b). Photos © RMN-Grand Palais / Art Resource, NY / Thierry Ollivier

Figure 93. Two joined fragments of a lintel from Prasat Phnom Da: *Churning of the Ocean of Milk*, early 1100s. Southern Cambodia, Takeo Province, Phnom Da. Sandstone; 94 x 96.5 x 59 cm. Angkor Borei Museum, TKA.Ka.011. Photo: Konstanty Kulik

Figure 94. Fragment of a lintel from Prasat Phnom Da: *Churning of the Ocean of Milk*, early 1100s. Southern Cambodia, Takeo Province, Phnom Da. Sandstone; 135 x 125 x 53 cm. Musée national des arts asiatiques–Guimet, MG 17860. Photo © RMN-Grand Palais / Art Resource, NY / Thierry Ollivier

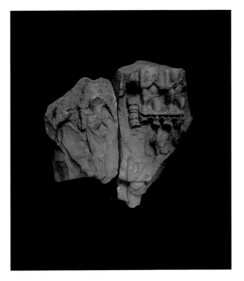

Figure 95. Fragment of a lintel from Prasat Phnom Da: *Vishnu Reclining on the Ocean of Milk*, early 1100s. Southern Cambodia, Takeo Province, Phnom Da. Sandstone; 83 x 203.2 x 34.3 cm. Angkor Borei Museum, TKA.Ka.005. Photo: Konstanty Kulik

the tortoise avatar of Vishnu, supports the columnar mountain that is being used as a churning rod. Two pieces belonging to the left side of this scene, in a much more damaged state of repair, are in the Angkor Borei Museum. Traces of the heads of the serpent used in the churning can be discerned at the far left, along with remains of two of the demons grasping the serpent's body and two worshippers from the upper register (fig. 93). On the second lintel, Vishnu reclines on Shesha, the Serpent of Eternity (*viṣṇu anantaśāyanamūrti*), floating on the Ocean of Milk, here designated by a row of fish (fig. 95). This image of the fundamental myth of the creation of the world is often found above the entrance of

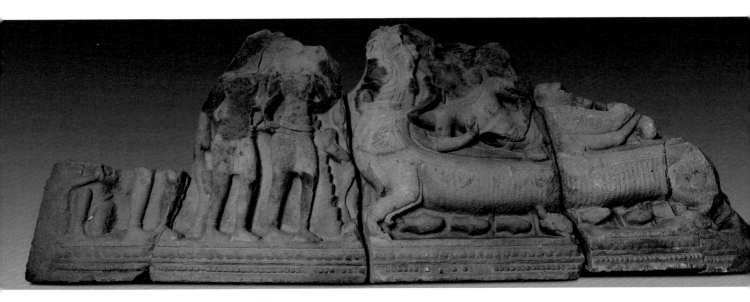

such a monument. Its most important sections are preserved in the Angkor Borei Museum (figs. 95, 97). A small fragment of the ensemble, probably the only visible element during the passage of Aymonier in 1882, was taken by him and sent to France (fig. 96). Belonging to the Musée Guimet, it is, for the time being, kept in Lyon's Musée des Confluences. The underside has been finished with a row of lotus medallions ringed in pearls with a double blue waterlily motif in between.

The fragmentary state of the main facade of the temple does not allow confirmation of the exact nature of the vestibule that once preceded the front door of the cella. What is certain is that the traces left by the collapsed masonry in the front of the pilasters of the door and under the upper pediment clearly show that a structure surmounted by a corbelled vault with a false tiled roof once existed (see fig. 91), but it is not certain whether it was an open porch (*antarala*) or an entry hall (*maṇḍapa*). The slightly smaller column in the Musée Guimet (see fig. 92b) and the second lintel (figs. 95–97) were perhaps part of the structure from the outer door to the vestibule, now disappeared.

In the end, historians and researchers can only deplore the lack of documentation that would allow for better knowledge of the sponsor of such a restoration of the temple structure. Is there any connection with the small stele found in Phnom Da mentioning a land grant offered in 1106 during the reign of Jayavarman VI to "*kamrateṅ jagat viśvarūpa*," or Vishvarupa, Lord of the Cosmos?[70] It is not totally impossible. There once again is the mention of Vishvarupa, which was perhaps an image of worship erected for the benefit of a dignitary having carried this name, certainly, but which especially recalls the cosmic and omnipresent dimensions of Vishnu as the god appeared in front

Figure 96. Fragment of a lintel from Prasat Phnom Da, early 1100s. Southern Cambodia, Takeo Province, Phnom Da. Sandstone; 88 x 53 cm. Musée national des arts asiatiques–Guimet, MG 14894

Figure 97. Fragment of a lintel from Prasat Phnom Da, early 1100s. Southern Cambodia, Takeo Province, Phnom Da. Sandstone; 62.2 x 60.9 x 34 cm. Angkor Borei Museum, TKA.Ka.005. Photo: Konstanty Kulik

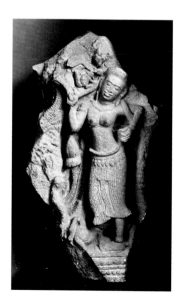

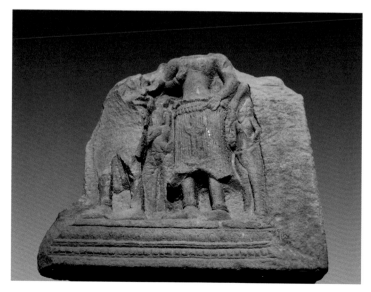

of Arjuna in Chapter XI of the *Bhagavad Gita*.[71] Isn't the iconographic program of the entire site of Phnom Da, developed gradually over the course of the sixth and seventh centuries, a vivid illustration of this universal dimension of Vishnu that generations of sponsors and sculptors wished to proclaim following the original foundation? We are convinced of it. Could this impressive revival of a major ancient Vaishnava site in the early twelfth century also be connected to a trend that would lead to the future consecration of Lord Vishnu as the major deity of the largest and finest temple ever made in Cambodia by a Khmer king, Suryavarman II (1113–1150), in Angkor Wat? We would not be surprised.

1. Aymonier 1900, 197; Lewitz 1967, 430–31.

2. Coedès 1964a, 35 and following.

3. Stark et al. 1999, 10, and Brocheux 1995.

4. Stark 2003, 95.

5. Stark et al. 1999, 8, 15; Stark 2001.

6. Stark et al. 1999, 21, fig. 4.

7. Indrawooth 2009.

8. For Angkor Borei, see K.24, K.555, K.557, and K.600 in Coedès 1942, 16–23; for K.548, see ibid., 154; for K.939, see Coedès 1953, 56.

9. Gerschheimer and Goodall 2014.

10. Ibid., 115.

11. Pelliot 1903.

12. Vickery 1994.

13. Paris 1932.

14. Malleret 1959–63.

15. Trinh 1996 and Vo 1998.

16. Stark et al. 1999, 9.

17. Higham 1989.

18. Dowling 1999.

19. Bourdonneau 2007.

20. Coedès 1930.

21. Bergaigne et al. 1882.

22. Bergaigne 1884.

23. Aymonier 1900, 197–202. Translated from the French by the author.

24. Baptiste and Zéphir 2008, 15.

25. Aymonier 1900, 200.

26. Baptiste and Zéphir 2008, 50–51. Translated from the French by the author.

27. Bénisti 1969. This motif also appears on the baton held in Vishnu's second right hand (pl. 1) and on the top slab of the pedestal from Phnom Bathep (see fig. 13).

28. See Carte Interactive des Sites Archeologiques Khmers (CISARK). Site: Kampong Luong (V.), photograph by Bruno Bruguier. https://cisark.mcfa.gov.kh/core/photo.php?id=659&src=https://cisark.mcfa.gov.kh/lib/thumbnail.php?image=0600_0699/659_01.jpg&width=60#photo

29. Aymonier 1900, 200. Translated from the French by the author.

30. Porte and Chea 2008.

31. Stark 2003, 96.

32. Groslier 1925a, 314 and pl. 29B. Translated from the French by the author.

33. See Zaleski 2009, 168–79.

34. See "Chronique," *Bulletin de l'École française d'Extrême-Orient* 31, no. 3/4 (1931): 648n98; Baptiste and Zéphir 2008, 64–67.

35. Aymonier 1900, 200; Coedès 1910, 47, no. 2.

36. Baptiste 2003.

37. Groslier 1925a, 305.

38. Guy 2014, 97–98.

39. Coedès 1931, 8–12.

40. *Head of Buddha*, NMC, Ka.1085, Boisselier 1955, pl. 86, and *Standing Buddha*, NMC, Ka.1595, Boisselier 1955, pl. 88A.

41. NMC, Ka.1085.

42. NMC, Ka.1595.

43. Groslier 1925a, 312.

44. Guy 2014, 226–27.

45. For the art of Shrivijaya, see Baptiste and Zéphir 2008, 29–33.

46. Guy 2014, 47, fig. 35.

47. Coedès 1942, 16–17.

48. Porte 2002.

49. Dupont 1955.

50. Aymonier 1900, 199. Translated from the French by the author.

51. Coedès 1940.

52. Bourdonneau 2011.

53. Porte 2016.

54. Mauger 1937, 71.

55. Aymonier 1900, 200. Translated from the French by the author.

56. "Note au sujet de deux sculptures du Musée Guimet, n°293, to M Stern and Boisselier." Signed H. Marchal. Archives Musée Guimet.

57. Porte 2016 and Porte and Chea in this book, 105.

58. Dupont 1955, 22–70.

59. K.549 (NMC, Ka.3065), see Coedès 1942, 155–56.

60. Guy 2014, 146.

61. K.549 (NMC, Ka.3065), see Coedes 1942, 155–56.

62. *Bhagavad Gita*, XI: 15–16; see also Maxwell 1990.

63. Baptiste and Zéphir 2008, 58–61.

64. Dupont 1955, 45.

65. Jessup and Zéphir 1997, 163–64.

66. Dupont 1955, 27.

67. Mauger 1937, 490. Translated from the French by the author.

68. Ibid., 491.

69. Baptiste and Zéphir 2008, 218–23. Another section of the columns is in the Angkor Borei Museum (TKA.Ka.007).

70. K.830, Coedès 1953, 278.

71. Zaehner 1966.

NOTE ON REPRESENTATIONS OF KRISHNA IN THE ANGKORIAN PERIOD

THIERRY ZÉPHIR

The archeological, technical, historical, and iconographic aspects of the famous representations of Krishna Govardhana highlighted by the Cleveland exhibition (pls. 5, 6)—along with the group of Vaishnava sculptures from Phnom Da (pls. 1–4, 7, 8), as well as nearby sites such as Wat Koh (see fig. 5)—have been analyzed in detail in the preceding essays of this book. They are among the most beautiful works of all Khmer art; they are also among the most ancient. Although little precise epigraphic data can be decisively linked to the first developments of Krishna worship in Cambodia, notably in his appearance as the god lifting Mount Govardhan (*govardhanadhara* in Sanskrit), the very existence of the images at Phnom Da attest to the importance of Vaishnavism in the southern Khmer countries where *pancharatra* (or *bhagavata*) sectarian worship has been well documented since the fifth century.[1] While developing conjointly with Shivaism and Mahayana Buddhism, Vaishnavism remained important in Cambodia until the end of the Angkorian era and even beyond, as seen in some sculptures that can be attributed to the fourteenth century or slightly later.[2]

All eras combined, Khmer art has bequeathed to us a great number of representations of Vishnu. In his most common depictions, the god is shown with four arms (*caturbhuja* in Sanskrit), holding his distinctive attributes in his hands: a conch shell (*śaṅkha* in Sanskrit), a mace (*gadā*), a discus (*cakra*), and a small sphere representing the Earth (Bhumi), variously referred to as *dharani* or *mahi* in Cambodian epigraphy. Despite this very frequent iconography, certain questions still arise. In inscriptions, the epithets used to designate the images apply as much to Vishnu as such and to certain of his characteristics, notably his various "incarnations" that are "descents [downward]" (*avatāra*[3] in Sanskrit), Krishna in particular. Thus, it is not impossible that some of the four-armed Vishnu figures, so numerous in Khmer statuary of the pre-Angkorian era, could have displayed precise and diverse forms of the god, while it might not be possible to formally distinguish them from one another today. If we exclude the bas-reliefs, which we will discuss later, we can rightly be surprised, for example, not to know of representations in the round of Krishna Govardhana from the Angkorian era, in a form more or less equivalent to that of the Phnom Da sculptures.

Some inscriptions, however, refer to images of Krishna lifting Mount Govardhan. For the record, I refer here to the setting up of a Krishna

Figure 98. *Krishna Lifting Mount Govardhan*, c. 1100–1150. Cambodia, Siem Reap Province, Angkor Wat, first story, southwest pavilion, east wall, north side. Sandstone. Photo: Jaroslav Poncar

Govardhana, in an inscription from Kdei Ang (K.56)[4] dating from the reign of Rajendravarman (r. 944–967); likewise, one of the numerous small inscriptions from the grand temple of Preah Khan in Angkor (K.626), a monument built by the great Buddhist king Jayavarman VII (r. 1182/83–c. 1220), mentions an image of Krishna Govardhana.[5]

In concrete terms, during the Angkorian era, only very few sculptures can be recognized, thus far, as unquestionably representing Krishna. One is the seated figure with four arms that was part of one of the spectacular groups in the round from the site of Koh Ker.[6] Originally housed in the west gate of the inner enclosure of Prasat Chen, this statue was part of the composition of a monumental diorama illustrating the battle of Bhima, one of the five Pandava brothers, against the powerful Duryodhana, the oldest of the hundred Kaurava brothers, as recounted in Book IX of the *Mahabharata*. In some form, obviously more vivid and animated, this same scene is illustrated in bas-relief on the tympanum of a fronton of the western entry pavilion of the second enclosure of the temple of Banteay Srei, now in the National Museum of Cambodia in Phnom Penh (fig. 99).[7] More lively, the scene shows the active role that Krishna and his brother Balarama play in the battle, while they are merely spectators in the group from Koh Ker. The four-armed Krishna is the leftmost standing figure grasping his brother's arm and the handle of his raised plow. Apart from the iconographic difference seen here, all the Angkorian bas-reliefs are characterized by a vivid and animated quality.

Chronologically, one can consider that the art of narrative bas-reliefs in Cambodia actually gains strength during the tenth century. In fact, this begins during the reign of Rajendravarman, particularly with the remarkable establishment of the temple of Banteay Srei in 967–68 by the Brahman Yajnavaraha, the sovereign's minister and spiritual master. Here, Khmer sculptors begin enhancing frontons and lintels of monuments with complex narrative scenes. The latter derive in large part from the corpus of sacred texts adopted by the Khmers, as a result of the so-called Indianization of Southeast Asia, in the early centuries of our era, abundantly attested by inscriptions and sculptures. The complex phenomenon of the adoption and, to a certain extent, the adaptation of foundational Indian textual sources in Cambodia thus allowed the gradual creation of the rich iconographic repertory deployed in Khmer temples during the Angkorian era. As the great epigrapher George Coedès stresses in *Les Etats Hindouisés d'Indochine et d'Indonésie*, "The literary culture to which Sanskrit inscriptions attest was based on the great Hindu epics, *Rāmāyana* and *Mahābharata*, and on the *Purāṇas*, which provided officially recognized poets [and, I would personally like to add, sculptors as well] with rich mythological material."[8] Thus, the essential texts of Hinduism on which artists relied were well known and widely disseminated throughout the

Figure 99. *Fight between Bhima and Duryodhana*, c. 967–68. Cambodia, Siem Reap Province, Prasat Banteay Srei, second enclosure, west gate, western fronton. Sandstone; 186.5 x 233.5 x 50 cm. National Museum of Cambodia, Ka.1660. Photo © John Gollings

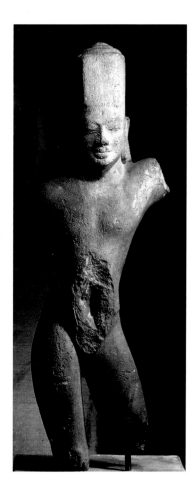

Figure 100. *Krishna Lifting Mount Govardhan*, c. 700s. Thailand, Petchabun Province, Si Thep. Sandstone; h. 119 cm. Bangkok National Museum, K.Kh.17. Photo © Francine Tissot, courtesy Thierry Zéphir

Khmer world as early as the pre-Angkorian era. A seventh-century inscription (known as Veal Kantel, K.359)[9] bears witness to this; this epigraph recounts the erection of a statue of the god Tribhuvaneshvara, "Lord of the Three Worlds" —a depiction of Shiva?—by a Brahman named Somashraman, as well as the concomitant gift of manuscripts of the *Mahabharata*, the *Ramayana*, and a Purana. The author of the text does not specifically identify the name of the Purana; it could possibly be the *Harivamsha*, the "supplement" to the *Mahabharata* that focuses on the golden legend of Krishna, or even the *Vishnu Purana*. The donor likewise establishes a daily recitation of these manuscripts. Here we can understand how important the texts were in the ritual workings of the sanctuaries and how their content was able to provide a source of inspiration for artists, who were only giving form to the iconographic and symbolic programs requested by the patrons of monuments. These textual sources moreover constitute what Coedès very pertinently designated the "stock of literary knowledge of image makers (*bagage littéraire des imagiers*)."

To arrive more precisely at the texts that most likely may have inspired the development of Khmer images transcribing the Krishna legend in visual terms, it seems necessary to consider the paramount importance of:

Mahabharata
> (The Great Epic of the Descendants of Bharata).[10] The "Descendants of Bharata" is understood as a designation for the inhabitants of the Indo-Gangetic geographic area, in the northern portion of the Indian subcontinent. The *Mahabharata* includes the *Bhagavad Gita* (Song of the Blessed Lord), the sublime discourse that occupies part of Book VI.

Harivamsha
> (The Genealogy of Hari, alternatively The Story of He Who Is a Fawn-Yellow Color—one of the multiple descriptions of Vishnu)[11]

Vishnu Purana
> (The Ancient Legend of Vishnu)[12]

Bhagavata Purana
> (The Ancient Legend of the Blessed Lord)[13]

There is still uncertainty regarding the dates for the shaping and drafting of these texts, which remain the subject of debate among historians of religion and linguists. A fragile consensus among specialists, however, encourages the proposition of a slow period of development for the *Mahabharata*, between the fourth century BC and the fourth century AD; and for the *Bhagavad Gita*, a date around the middle of the development of the *Mahabharata* is conceivable. For the

Harivamsha, a date between the third century and the fifth century AD might be acceptable, due to the intermediary content of its text, between the epical character of the *Mahabharata* and the more speculative nature of the Purana as a whole. The *Vishnu Purana*, for its part, considered to be one of the most ancient texts in its category, can be dated around the fifth century. As for the *Bhagavata Purana*, it can be linked to a later date, around the ninth century. But these dates obviously remain uncertain, and ultimately have only a limited impact on Khmer imagery, since texts already existed at the time the sculptures and bas-reliefs from which they take their inspiration were created. In addition, we know that Cambodia had recurring interactions with India, and that Brahmans who came from the subcontinent regularly went to Khmer countries, where they could also settle, and vice versa. These contacts were undoubtedly numerous, which makes it possible to understand the ceaselessly renewed enrichment of the body of sacred literary works in Cambodia during the Angkorian era. Among many of the attestations to these exchanges, we can point out certain data contained in the stele at Wat Preah Einkosei (K.263), a renowned Vaishnava temple established in 968 and situated at the heart of the city of Siem Reap, south of the site of Angkor. Leaving apart the list of the pious donations of the patron, the text of the inscription specifies that a Brahman by the name of Divakarabhatta was born "there where Krishna, the conqueror of the black serpent . . . played during his childhood," namely in the region of Mathura, on the banks of the Yamuna.[14]

As specified above, if we exclude the sculptures discovered at Phnom Da (pls. 5, 6) and Wat Koh (see fig. 5), it must be noted that practically no image in the round of Krishna, particularly in the guise of Govardhanadhara, can be identified from the Angkorian era. From the same general period as the Phnom Da and Wat Koh sculptures, however, are two examples from the site of Si Thep, in the province of Petchabun, Thailand, that evince the specific favor that Krishna Govardhana seems to have enjoyed at an early date in continental Southeast Asia. Independent from the date authors have attributed to them, between the sixth and eighth century, these two works, now in the national museum in Bangkok,[15] nevertheless reveal a conceptual approach that is quite different from that seen in the Krishna Govardhana figures from Phnom Da and Wat Koh. In fact, the sculptures do not have the basic characteristic of the stele against which the image stands out, as do the Krishna Govardhana sculptures from Phnom Da and Wat Koh, remaining more or less freestanding. In one of these pieces (fig. 100),[16] the god is represented standing, in a tilted posture; despite the complete absence of the two arms, it is clear that the left arm was raised, effectively evoking a representation of Krishna Govardhana. The second sculpture (fig. 101),[17] more sensitively modeled and, for this reason, often compared to the Krishna Govardhana figures of Phnom Da, with which it does have certain affinities, is

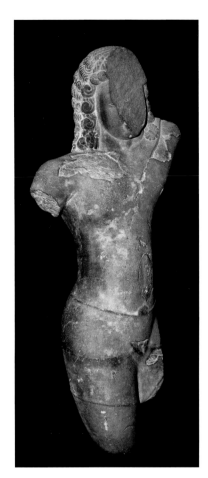

Figure 101. *Krishna Lifting Mount Govardhan*, c. 600s. Thailand, Petchabun Province, Si Thep. Sandstone; h. 104 cm. Bangkok National Museum, no. K.Kh.8. Photo: Thierry Zéphir

quite mutilated; only the torso and the rear portion of the head remain. Its tilted posture and the fact that, in this image as well, the left arm is raised, have led to its being identified as a Krishna Govardhana. In any case, the iconographic type remains rare in the statuary of Southeast Asia, which perhaps explains the technical issues to which these pieces cannot fail to fall victim.

Thus it is in the narrative bas-reliefs that Krishna appears, in a privileged and extremely frequent manner, in Angkorian Khmer art:[18] Krishna, as the bearer of Mount Govardhan, of course, but also Krishna represented in the multiple episodes of his childhood, as conveyed in the *Harivamsha*, the *Vishnu Purana*, or the *Bhagavata Purana*, where he had to defend himself against numerous demonical creatures that his cousin Kamsa sent to kill him. This first Krishna, the divine infant and adolescent who inspires *bhakti*,[19] is complemented by a second, adult Krishna, who is shown in sculptures enacting his "profession" as an ally and advisor to the Pandavas, as recounted in the *Mahabharata*.

Although the constituent elements of their respective legends gradually appear in the principal texts where they are developed, the *Mahabharata*, *Harivamsha*, *Vishnu Purana*, and *Bhagavata Purana*, these two Krishnas, in essence identical to one another, are in fact only one. They are the divine manifestation of the avatar type, par excellence, destined to free creation of harmful *asuras* (demons), in order to reestablish righteousness and a lawful kingdom, and thus rescue the *dharma*, or social-cosmic order, that had been threatened by the action of demonical creatures. In the great war of the *Mahabharata* between the Pandavas and the Kauravas, the heroes of the two sides are, in fact, none other than the "descents" onto earth of gods who have taken on human form, with Vishnu becoming incarnate as Krishna in his role as charioteer and advisor to Arjuna, the best of the Pandavas. The five Pandavas, in turn, are all children of the gods: Yudhishtira, son of the god Dharma (the "good Order," personification of the very concept of dharma); Bhima, son of Vayu (Lord of the Wind); Arjuna, son of Indra (king of the gods); and the twins Nakula and Sahadeva, sons of the Ashvins (celestial horsemen representing the morning and evening stars). Similarly, the demons, such as Duryodhana, firstborn of the one hundred Kauravas, is an incarnation of the asura Kali, who personifies malevolence and the causes of discord. In the *Harivamsha*, Kamsa, usurper of the throne of Mathura, of which king Ugrasena was the legitimate possessor, is in fact only an incarnation of the asura Kalanemi. It is precisely in order to kill this evil being that Krishna "descends" to make a decisive intervention. A struggle between good and evil, the divine action falls entirely within a goal of salvation, as much for the actors in the tales as for the devotees who participate in the great cycle of spirituality where the ultimate goal is access to salvation.

Returning to the bas-reliefs illustrating the heroic deeds of Krishna, it is necessary to note that the Khmer sculptors were not required to represent his story, like the story of any other god, in a rational form in which a series of scenes would lead from the beginning of the narration to its end. In Cambodia, the texts were not illustrated with the goal of transcribing the highlights of a myth, the development of which would be followed step by step. This sort of approach was not likely to have corresponded with what patrons desired. Undoubtedly, the symbolic aspects of a specific episode, of course represented in a precise location in the temple, granted value and spiritual impact to the iconographic programs of monuments, as though the scenes composed a sort of sacred geography transcribing in images the glorious body of the god and his actions. In any case, a curious visitor, passing from one building to another within the same architectural complex, if not passing from one sanctuary to another, will find numerous scenes depicting the essential moments of the life of Krishna, as well as that of Rama—the latter the major avatar of Vishnu whose story is recounted in the *Ramayana*[20]—both represented on almost all the Angkorian monuments.[21] Appearing over the course of the tenth century, the innumerable narrative reliefs of the Khmer temples, including scenes from epics, illustrations of heavenly exploits, episodes from the lives of the gods, and, for our purposes in particular, scenes of the life of Krishna, unfold in multiple locations: frontons, lintels, pilaster bases, exterior or interior walls of temples or galleries. In order to shed light on certain typical illustrations in Khmer narrative art, and for the benefit of readers who are not very familiar with Hindu legends, a brief summary containing a simplified description of some of Krishna's exploits may be useful.[22]

For Krishna, everything begins on the mythical Ocean of Milk. Vishnu was resting, spread out on the serpent Shesha (see fig. 95).Appearing as a cow, accompanied by all the gods to whom she had appealed for assistance, the Earth, who was succumbing beneath the weight of the evil actions of demons, requested the help of the Lord. The terrible asura Kalanemi, in fact, had been reborn in the guise of Kamsa and had seized the throne of Mathura at the expense of his own father, Ugrasena, king of the lineage of the Yadavas, thus putting in peril all of creation. Sensitive to the plea addressed to him by Brahma and to the distress of the Earth, Vishnu proclaimed that he himself and the serpent Shesha would soon be incarnated in the womb of Devaki, spouse of Vasudeva and relative of Kamsa, in order to eliminate the evil usurper. Informed by a prediction that he would die at the hand of a son of Devaki, the cruel Kamsa ordered that her infants perish at birth. The first six sons of Devaki and Vasudeva were thus put to death (fig. 102, lower panel); to protect the seventh infant at birth (Balarama), his embryo was transferred into the womb of Rohini, another spouse of Vasudeva, and the eighth

(Krishna) was exchanged at birth with the daughter of a cowherd couple, Yashoda and Nanda, who became his adoptive parents (fig. 102, upper panel).

Far away from Mathura, in order to be safe from any evil action that Kamsa might commit against them, the two brothers spent their childhood in Gokula, a pastoral village on the banks of the Yamuna, not far from Mathura. There, showing exceptional powers, the children thwarted, one by one, assassination attempts on the part of cruel demons that Kamsa dispatched to the vicinity of Mathura to exterminate all children who demonstrated great strength. On one occasion, Krishna had to deal with the wicked Putana, a female demon who, as narrated in the *Harivamsha*, came to Gokula in the guise of a bird and, assuming the shape of a beautiful lady, attempted to murder the infant by offering him her breast to suckle after coating it with the most lethal of poisons (fig. 103, right). Pressing his hand on her bosom, Krishna put Putana to death, draining her of her vital lifeblood. One after another, Krishna had to contend with demons, each with more surprising features than the last: a cart-demon, Shataka (possibly fig. 103, left), who tried to crush the child to death, but instead met his end when the baby Krishna upturned him and sent him into the air as if he were a mere wisp of straw; as well as a tornado-demon, Trinavarta, who

Figure 102. *Murder of the firstborn children of Vasudeva and Devaki* (lower panel); *Vasudeva and Devaki afflicted* (upper panel, left); *Vasudeva entrusting Krishna to Yashoda* (upper panel, right), c. 1050–75. Cambodia, Siem Reap Province, Angkor Thom, Baphuon, second story, south gate, south wall, west side. Sandstone. Photo © Patrick Seurat (France), 2016

Figure 103. Possibly *Krishna and the Cart-demon Shataka* (left); *Putana Attempting to Kill Krishna* (right), c. 1050–75. Cambodia, Siem Reap Province, Angkor Thom, Baphuon, south gate, southern vestibule, west face. Sandstone. © Photographic Archives, Musée des Arts Asiatiques–Guimet, Paris, France. Photo © RMN-Grand Palais / Art Resource, NY

carried him off in the air, but then Krishna miraculously became extremely heavy, so the demon had to put him down.

As soon as he was big enough to walk, Krishna proved to be as mischievous as he was turbulent, subjecting his mother and companions to innumerable pranks. One day when Yashoda was busy with household tasks, Krishna stole the newly churned butter and consumed it with his comrades. To prevent him from getting involved in further trouble, the young woman tied him to a large mortar in order to calm him down. It was to no avail: Krishna managed to free himself by trapping the mortar between two trees and pulling hard on the rope that tied him to its bulky constraint, breaking it. In doing so both trees were uprooted, freeing the two celestial beings, Nalakubara and Manigriva, who had been imprisoned there by a curse (fig. 104). While this event might seem anecdotal, it metaphorically illustrates Krishna's "liberating" nature.

Even though life unfolded peacefully in Gokula, Nanda and the elders of the village were alarmed by the disturbing events that occurred. Thus it was decided that the villagers and the herdsmen would move into the forest settlement of Vrindavan, not far from Mount Govardhan, a place farther away from Mathura than Gokula and where they hoped they would be beyond the reach of the demons (map 1). In this new abode, Krishna, Balarama, and their companions led a peaceful life as simple herdsmen, still engaging in all sorts of games, friendly fights, and combats. Doing this, constantly laughing and friendly, Krishna attracted the sympathy and affection of the inhabitants of Vrindavan. Despite all this, danger lay in wait and once again demons alternately disturbed the tranquility of the place. One day a calf-demon, Vatsasura, hid among the herd of cows with the intention of killing Krishna and Balarama. Seizing him from behind and by his rear legs, Krishna made him twirl upside down until he was dead. Another time, Bakasura, a crane-demon of colossal size, pounced on Krishna and, imprisoning him in its long, pointed beak, carried him into the air. The young boy made himself so hot that the terrifying bird had to let him go. Then came Aghasura, brother of Putana and Bakasura, who wanted to avenge their deaths. Assuming the form of a gigantic python, he placed himself in the middle of the road that Krishna and his companions had to travel when returning from a day of work in the forest. Sticking his lower jaw on the ground and opening wide his mouth to ensure that his head would disappear in the clouds, Aghasura waited for the group of young people to pass by. Unaware of the danger, they all entered the lethal cavern that opened up before them. Realizing the danger, Krishna swelled his own body in order to block the demon's nostrils. Deprived of breath, Aghasura perished.

No less strong and crafty than his brother, Balarama also undertook brilliant exploits. He eliminated Dhenukasura, the donkey-demon, who, in a part of

Figure 104. *Krishna Uprooting Two Trees in Which Nalakubara and Manigriva Were Imprisoned*, c. 1100–1150. Cambodia, Siem Reap Province, Angkor Wat, second story of the pyramid, cruciform pavilion, western gallery, half-fronton in the northern side aisle. Sandstone. Photo: Jaroslav Poncar

Figure 105. *Krishna Quelling the Serpent Kaliya*, c. 1050–75. Cambodia, Siem Reap Province, Angkor Thom, Baphuon, second story, south gate, south wall, west side. Sandstone. Photo © Patrick Seurat (France), 2016

the forest where the most delicious fruits could be found, terrorized those who ventured into the area.

Sometime later, Krishna had the disagreeable surprise of finding some of his companions and their herds unconscious on the banks of the Yamuna, whose usually pure waters, having become disturbed, gave off toxic vapors: Kaliya, the fearsome many-headed cobra, had chosen to live in the riverbed. At the end of a terrifying battle, Krishna managed to overpower the mighty serpent, performing a victory dance on his head (fig. 105). Nearly dead, Kaliya begged Krishna for clemency, and the latter, in his great mercy, allowed his vanquished enemy to return to the waters of the sea from which he had come. This episode, often depicted in Khmer bas-reliefs, illustrates the god's magnanimity regarding all beings, even the most evil and dangerous, provided they show remorse for their wicked actions.

Following the great rejoicing that celebrated Krishna's victory over the serpent Kaliya, life resumed its course, with its share of demons to be vanquished. One day, when Krishna and his companions were engaged in piggyback games, where each carried a comrade on his shoulders to demonstrate his strength, the asura Pralamba went after Balarama. Without difficulty, the young man shattered the skull of the demon, which died with a great roar. While the demons called for Krishna and Balarama to constantly be on the lookout, for which the herdsmen were grateful, natural dangers could also occur. Krishna thus had to display his salvific powers when a violent fire unexpectedly broke out in the forest, threatening to destroy men and beasts; gathering the blaze between his hands, the divine herdsman swallowed it, as if it were simply a glass of water. If everyone felt increasing admiration and affection for Krishna, the women and girls of the cow-herding community (*gopi* in Sanskrit) truly fell in love with him.

150

All their thoughts turned to the young man who lured them not only by his bravery and beauty, but also by his talent for playing the flute. This is the passage in the Krishna story in which a collection of episodes center on the licentious and charming games to which the young man devoted himself with the gopis, concretely illustrating the concept of bhakti. The image of Krishna playing the flute—(Venugopala), one of the most important forms of Krishna in the art of India—was not adopted in Cambodia; undoubtedly it hardly resonated alongside the reserved, modest mentality of the Khmers. It is noteworthy that, regardless of the religion—Hinduism or Mahayana Buddhism—Khmer sculptors did not adopt iconographies in which sensuality or sexuality was explicitly expressed. Only one bas-relief from the temple of Angkor Wat can possibly be linked to the erotic mysticism in which each young woman feels she alone is loved by Krishna and the only one to benefit from the generosity of his divine grace (fig. 106).

Figure 106. *Krishna and the Gopis*, 1100–1150. Cambodia, Siem Reap Province, Angkor Wat, first story of the pyramid, northwest corner pavilion, west wall, south side. Sandstone. Photo: Jaroslav Poncar

Figure 107. *Krishna Lifting Mount Govardhan*, c. 1100–1150. Cambodia, Siem Reap Province, Angkor Wat, third story of the pyramid, central tower, west face, lower fronton. Sandstone. Photo: Jaroslav Poncar

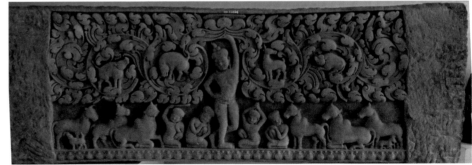

Figure 108. *Krishna Lifting Mount Govardhan*, c. 1050–1100. Cambodia, Kompong Thom Province, Robang Romeas, Prasat Srei Krup Leak. Sandstone; 51 x 158 x 32 cm. Museum of Kompong Thom Province, Cambodia, Ka.595. Photo: Sonya Rhie Mace

While Krishna attracted their devotion, the inhabitants of Vrindavan still continued to pay homage to the gods, particularly Indra, the ancient Vedic god-sovereign who freed the celestial waters held prisoner by the demon Vritra, and in which each recognized the beneficent divinity whereby the fecund and refreshing rains would assure the survival of the herds and the fertility of the soil. Considering that, for a population of herdsmen, the cows and the mountains where they grazed and drank water were the only things worthy of tribute, Krishna undertook to convince his companions to consecrate offerings of the worship of Indra to ceremonies directed to Mount Govardhan, in the shadow of which the population lived. And to build greater confidence in the villagers, Krishna told them, "I am the mountain." So as a protector of men and their

herds, Krishna, identifying himself as the mountain, received the offerings designated for Indra. In the wake of this upheaval of the established order—an upheaval marking a complete paradigm shift in the means of gaining access to salvation, in which the bhakti cults replaced the ancient sacrificial cults—the wrathful Indra resolved to punish those who turned away from him and triggered a terrible storm.

Once again revealing the preeminence of his protective power, Krishna then seized Mount Govardhan and raised it up with one hand, thus offering protection and safety to the herds as well as the villagers (figs. 98, 107–109).[23] For seven days and seven nights, Krishna kept the mountain in a state of balance, until Indra understood that it was useless for him to attempt to battle against the new spiritual order that was now in place. Bringing the torrential rains to an end, Indra himself even came to pay homage to Krishna and, pouring the lustral water of consecration over Krishna's hands, recognized the latter's superiority. Far from being anecdotal, the episode of Mount Govardhan shows itself to be rich in symbols; this undoubtedly explains the strong presence of its depictions in Cambodia. Illustrating the change in the spiritual order just alluded to, and the effective protection of the god for his devotees, the story also evokes, in the

Figure 109. *Krishna Lifting Mount Govardhan*, c. 1100–1150. Cambodia, Siem Reap Province, Angkor Wat, second story of the pyramid, cruciform pavilion, western gallery, base of a pilaster. Sandstone. Photo: Pierre Baptiste

historical and religious context of ancient Cambodia, the very action of the sovereigns, perceived on a terrestrial level as equivalent to the action of the god on a cosmic level; in fact the king assures the protection of his realm and the well-being of his subjects, just as the god guarantees the good outcome of creation and the salvation of all creatures.

According to the season, life carried on amid the cow-herding community of Vrindavan; Krishna pursued his games with the gopis, although demons, like the bull-demon Arishtasura, continued to arouse great trouble and disagreements (fig. 110). But the duty assigned to Vishnu at the beginning of the story was now to be completed. It was at the instigation of Narada, the divine sage and messenger of the gods to men, renowned for being a master in his way of presenting events, that ultimately Kamsa was eliminated and the legitimate monarchy restored to Mathura. One day Narada went to the court of Mathura and informed Kamsa of the events that took place at the time of the birth of Balarama and Krishna, notably the exchange of Krishna for the newborn daughter of Nanda and Yashoda, as perpetrated by Vasudeva.[24] Realizing that he had been tricked, Kamsa then sought to definitively get rid of the two brothers, since he now knew where they resided. He appealed to the demon Keshin, a fearsome asura who assumed the form of a gigantic horse, rapid, powerful, and cruel, in order to put an end to Krishna. Once again, Krishna fought valiantly against the demon and defeated him (fig. 111).

Since his demonical emissaries proved unable to hurt Krishna and Balarama where they resided, Kamsa conceived a plan to lure the two brothers to Mathura, hoping that it would then be easier to kill them. He decided to host an elaborate bow festival to be accompanied by a great competition, in which Krishna and Balarama would have to confront the best wrestlers in the kingdom. To avoid arousing the distrust of the herdsmen of Vrindavan, he made the excuse that these festivities were to celebrate the arrival in the capital of the inhabitants of the region of Mathura on the occasion of paying the annual tribute required of all the people. To assure that these ends were achieved, Kamsa demanded that the powerful elephant Kuvalayapida be placed at the entrance of the contest area, with a heavy iron bar in his trunk, to destroy Krishna and Balarama when they arrived to participate in the contest. And for additional security, he also appealed to his two best wrestlers, Chanura and Mushtika, to murder the two brothers in hand-to-hand combat, in the event that they managed to get as far as the arena. Having laid his deadly plans, Kamsa dispatched the noble Akrura to extend his invitation to the inhabitants of Vrindavan. Although he was informed of Kamsa's evil intentions, Akrura, who worshipped Krishna in his heart, accepted the mission. The invitation was obviously accepted, and guided by Akrura, Krishna and Balarama

Figure 111. *Krishna Fighting the Horse-demon Keshin*, c. 1100–1150. Cambodia, Siem Reap Province, Angkor Wat, second story of the pyramid, cruciform pavilion, western gallery, half-fronton in the southern side aisle. Photo: Jaroslav Poncar

departed for the city, much to the chagrin of the gopis, who were saddened to momentarily lose their Lord. Along the way, on a stop during which he sought to proceed with his ritual ablutions, Akrura immersed himself in a river where he had the strange vision of the two brothers floating in the waters, though he had just left them in their chariot the moment before.[25] This mirage, soon doubled by the beatific vision of Vishnu stretched out upon the serpent Shesha, only served to reinforce Akrura's devotion to the "Lord who is the entire universe."

Arriving at the gates of Mathura, Krishna and Balarama took their leave of Akrura and entered the city. While strolling through the populous streets, the two brothers refreshed their clothes and adornments in order to appear worthy of the tournament. Along the way, they stopped in the hall where the bow festival was to be held and saw the famous bow—ornamented with precious stones the likes of which they had never seen—to which Kamsa wished to dedicate the upcoming games. Foreshadowing his imminent challenge to the prowess of the usurper monarch, Krishna, deceiving the vigilance of the guards, grabbed the fabulous weapon, "great and resplendent as a rainbow." He drew the string so tightly that the bow snapped in two, producing the most frightening sound. Hearing this on the eve of the start of the tournament, Kamsa did not fail to experience great concern, becoming anxious about what would transpire the following day. That day arriving, Krishna and Balarama went to the large arena where the combat was to take place. As Kamsa had arranged, the gigantic Kuvalayapida was at the doorway and blocked their way. Worked up by his keeper, the pachyderm rushed onto Krishna, who, at the end of a fearsome confrontation, vanquished the powerful animal (fig. 112). The two young men then entered the

Figure 112. *Krishna Fighting the Elephant Kuvalayapida*, c. 1050–75. Cambodia, Siem Reap Province, Angkor Thom, Baphuon, second story, west gate, west vestibule, south face. Sandstone. Photo: Thierry Zéphir

space set aside for the combat, where, as soon as the signal was given, they faced the two vigorous wrestlers Chanura and Mushtika. Under the watchful eye of the audience, Krishna and Balarama tackled the two champions of Kamsa. The conflict was long and violent, but it ended, of course, with the victory of the two young men. As soon as the fight was over, Kamsa, filled with fear for his life, ordered the expulsion of the two brothers from the town. But for Kamsa, the hour of his demise had arrived. Landing on him like "a hawk from the sky," Krishna grabbed Kamsa by the hair and dragged him into the arena, where he took his last breath (fig. 113). For the people of Mathura, the death of the usurper marked the end of tyranny. The rightful king Ugrasena was returned to the throne that Kamsa had robbed from him, and Vasudeva and Devaki were able to embrace the children from whom they had been separated since their birth, and everyone could rejoice in the happy outcome.

Figure 113. *Krishna Slaying Kamsa*, c. 967–68. Cambodia, Siem Reap Province, Banteay Srei, northern "library" in first enclosure, western fronton. Sandstone. Photo © EFEO

As an adult, Krishna experienced a destiny equally rich in adventures as the time of his childhood and adolescence. Particularly in Cambodia, scenes pertaining to the *Mahabharata* were the focus of attention of sculptors. In the epic, the god intervenes to guide and lead the chariot of Arjuna. And it is in this capacity, among others, that he appears in the famous depiction of the great battle of Kurukshetra at Angkor Wat (fig. 114).

Curiously, an aspect of Vishnu-Krishna that one would most expect to see in the bas-reliefs, in that it makes explicit the cosmic and supreme nature of the god known as Vishvarupa (Universal Form), was not depicted by the Khmer artists on any surviving monuments of Angkor. Krishna offered this theophany to Arjuna on the field of the climactic battle of Kurukshetra. As the *Bhagavad Gita* describes it, having indicated to Arjuna the pathways allowing him to access the divine through meditation, contemplation, knowledge, and selfless action, Krishna then revealed his multiform appearance to the hero. As Pierre Baptiste noted in his essay in this book, the only known sculpture of Krishna-Vishnu as Vishvarupa, only a fragment of which survives, was found at Angkor Borei (see fig. 87), dating to around the same time as the early sculptures of Phnom Da, providing yet further evidence for the significance of the site. Why this spectacular vision of divine Being, including in itself the whole of creation, was not depicted in the Khmer art

of the Angkorian period, we cannot say. In any case, the ecstatic vision that is presented to Arjuna could not be better expressed than in the hero's own words, faced with the Omniform:

> Oh God, I see in your body all the gods as well as the different groups of beings: the Lord Brahma, seated on the Lotus throne, all the visionaries and the divine serpents.
>
> I see you with your multiple arms, your multiple trunks, your faces, your eyes, with your form of unlimited parts. I see neither your end, nor middle, nor beginning, oh universal and omniform Lord!
>
> I see you—you, whose contemplation is difficult to access—with your diadem, your mace, your disk, and that ardent glow that illuminates on every side, inaccessible to our means and our measures.
>
> You are the Imperishable, the supreme object of knowledge, you are the supreme receptacle of all that is different, you are the Immutable, the guardian of eternal law, you are the eternal Spirit: such is my belief.[26]

1. Bhattacharya 1961, 12.

2. For example, two large statues representing Vishnu in his avatar of the tortoise (Kurma) are now housed in the south gallery on the second floor of the pyramid of the Vaishnava temple at Angkor Wat, a monument built during the reign of Suryavarman II (r. 1113–1150), one of the rare Angkorian sovereigns to have had Vishnu as a chosen deity. See Coedès, Finot, and Goloubew 1929, pl. 108.

3. Vaishnava literature does not specifically provide a canonical list of avatars. According to certain texts, they may even be innumerable. In India, it is during the medieval era, around the ninth to eleventh century, that the classic list of the ten avatars (*daśāvatāra* in Sanskrit) is established, which includes: 1) Matsya, "the Fish"; 2) Kurma, "the Tortoise"; 3) Varaha, "the Boar"; 4) Narasimha, "the Man-Lion"; 5) Vamana, "the Dwarf" (a story at the end of which Vishnu assumes the appearance of Trivikrama, "the Conqueror of the Three Worlds"); 6) Parashurama, "Rama with an axe"; 7) Rama, "he who is Graceful"; 8) Balarama, "Rama at the Plow"; 9) Buddha, "The Awakened One"; and 10) Kalkin, the avatar of the future, who appears as a horseman at the end of the Kali Yuga—"the worst era" in which we find ourselves—in order to restore purity and prosperity to creation. In the list there are a few small variations to the ten avatars, such as in certain representations where they appear to come together; Krishna, "he who has dark-colored skin," sometimes replaces Balarama or, particularly in southern India, the Buddha.

4. Coedès 1964b, 3–19 (stanza XXII). Kdei Ang is a site in the Kompong Trabek district, in the province of Prei Veng, in southern Cambodia.

5. Coedès 1947–50, 97–119. It should be recalled that theoretically incompatible iconographies—here a Hindu image in a Buddhist complex—are constantly seen in Angkorian temples. In Cambodia, great religious tolerance is expressed, regardless of religious affiliation (Hindu or Buddhist) or sectarian orientation (Shaiva or Vaishnava).

6. One can see good photographic reproductions of this work in *Visions of the Orient: South East Asian Sculpture*, sales catalogue, Spink & Son, London, October 17 to November 3, 1995, 60–65. We do not know where this sculpture is located today. Like other images in the composition of the scene, this Krishna—and there is nothing that allows us to truly recognize it as such, other than the iconographic context of the group to which it belongs—was illegally "removed" from the site, perhaps in the 1980s. The other pieces in this spectacular sculptural group (statues of Bhima, Duryodhana, Balarama, and two of the four Pandava brothers who were present at the battle) were returned to Cambodia in recent years.

7. Represented with four arms, Krishna is recognizable at the far left. He tries to prevent Balarama, holding the plow, from interfering in the fight opposing the Pandava, Bhima, and the Kaurava, Duryodhana. The scene illustrates an episode of Book IX in the *Mahabharata*. The elder of the five Pandavas, Yudhishthira, had imprudently told the elder of his one hundred Kaurava cousins, the mighty Duryodhana, that he could assume the crown of Kuru, the common ancestor of both the five Pandavas and the one hundred Kauravas, if he could defeat one of the five brothers in a club contest. Being more capable than anyone in this kind of single combat, Duryodhana was sure to win. As the strongest of the five Pandavas, Bhima would face Duryodhana. During the fight, however, realizing that he was weaker than his antagonist, Bhima tried to use a forbidden blow and attempted to strike Duryodhana's thighs. At seeing this unfair movement, Balarama, though an ally of Bhima, tried to prevent him from striking Duryodhana. All of Krishna's strength was necessary to restrain Balarama from interfering and, in the end, although under disputable conditions, Bhima won the contest.

8. Coedès 1964a, 140.

9. The inscription known as Veal Kantel (K.359) seems to come from Prasat Boran (n. 321 in the inventory of Cambodian monuments), a small pre-Angkorian temple also known as Prasat Preah Ko, belonging to the group of monuments of Thala Borivat, north of the city of Stung Treng, in the northeastern region of Cambodia that goes by the same name (map 1). The inscription is published in Barth and Bergaigne 1885–93, 28–31.

10. Indian tradition attributes the writing of the *Mahabharata* to the sage Vyasa. This is an epic poem, one of the longest in global literature (nearly 90,000 verse lines divided into 18 books), involving two related but nonetheless rival clans: the Kauravas and the Pandavas. An ally of the Pandavas, Krishna provides the best of them, Arjuna, with an education that celebrates the notions of duty, the renunciation of the immediate benefits of action, and love for the Absolute in the *Bhagavad Gita* (a poem of 700 verse lines, divided into 18 chapters and part of Book VI of the *Mahabharata*).

11. The *Harivamsha* is a poem comprising more than 16,000 verse lines divided into three sections and 326 chapters. It is a collection of myths celebrating Vishnu. The second section, the *Vishnu Parvan*, essentially covers the story of Krishna.

12. The *Vishnu Purana* is the third of the 18 Puranas, the leading "ancient [stories]" of Indian tradition. In six sections, in which there are 126 chapters, the nearly 7,000 verse lines of text particularly glorify Krishna.

13. With a relatively late date compared to the other major Purana texts, the *Bhagavata Purana* considerably develops the legends of the *Vishnu Purana*. It is one of the most celebrated Vaishnava texts, in which the notion of *bhakti* ("devotion," "adoration," in total support of the divinity) is particularly prominent. The text is composed of some 18,000 verse lines, divided into 12 books and an epilogue. Book X, devoted entirely to the mythical biography of Krishna, is the most popular.

14. Coedès 1952, 118–39, stanza XXXI.

15. Boisselier 1974, 104–6, and ill. 8 and 70.

16. Although fragmentary, it is possible to identify this beautiful sculpture discovered in Si Thep in 1929 as representing Krishna lifting up Mount Govardhan. It shows great affinities with the Pallava image of Krishna Govardhanadhara in the Krishna Mandapa in Mamallapuram (India, Tamil Nadu, c. 600s; see fig. 4). For a brief introduction to the site of Mamallapuram, see, among others, Sivaramamurti and Narasimhaiah 2006.

17. As for fig. 101, we can here recognize a representation of Krishna lifting up Mount Govardhan. A little older, this image may be compared with the magnificent Krishna Govardhanadhara from the Gupta age preserved in the Bharat Kala Bhavan in Varanasi, inv. no. 147, c. 400s. For the Bharat Kala Bhavan Krishna, see fig. 3 and, among others, Harle 1974, 20, 46, and pls. 63, 64.

18. One large-scale mural depicting Krishna lifting Mount Govardhan survives from the temple of Neang Khmau in southern Cambodia (n. 26 in the inventory of Cambodian monuments) (Roveda 2005, 51). There were certainly many more murals in Angkorian temples that no longer survive.

19. Fundamental in religious thinking in India, *bhakti*, a term derived from the Sanskrit root *bhaj-* (to share, to participate), can be defined as the expression of devotion or the exclusive love of the devotee with regard to the divinity. In this particular relationship of the devotee to his god, and the converse, liberation (*moksa* in Sanskrit) is obtained by the grace (*anugraha* in Sanskrit) that the divinity extends to the participating worshipper.

20. Traditionally attributed to the sage Valmiki, the *Ramayana* is, after the *Mahabharata*, the second of the great epics of Indian literature. Compiled between the second century BC and the second century AD, the work is entirely devoted to the story of Rama. The text is made up of around 24,000 verse lines divided into seven books, themselves subdivided into 645 chapters. For a remarkable and recent comprehensive French translation, see *Le Ramayana de Valmiki* 1999.

21. To give a precise idea of the iconographic wealth of the Khmer monuments, as well as the diversity of the iconographic themes that are illustrated, see Roveda 2005, and for the temple of Angkor Wat, site of the greatest number of scenes relating to the mythology of Vishnu, see Roveda 2002.

22. Details of the Krishna story vary from one source to another. The following summary reflects the stories as the Khmers during the Angkorian period of the ninth to thirteenth century seem to have known them.

23. Depictions of Krishna vary widely among the bas-reliefs of the Angkorian period. Four types are illustrated in this essay: one from a wall panel, one from a fronton, one from a lintel, and one from the base of a pilaster. Krishna stands in three different postures and sometimes uses his right hand, sometimes his left. Sometimes he has the three tufts of hair; in other examples he has only one. For an inventory and analysis of most known depictions of Krishna lifting Mount Govardhan, see Narayanan 2015.

24. This girl, just like the other offspring of Vasudeva and Devaki, was slain by Kamsa as soon as he learned she had come into the world. Fearing elimination by one of the couple's children, Kamsa still did not wish to run any risk, so he did not hesitate, despite Devaki's desperate pleas, to put the innocent little girl to death by smashing her body on a slab. This little girl, however, was none other than an incarnation of the great goddess whom Vishnu himself had asked to be incarnated as the daughter of Yashoda. At the time of her death, the little body rose up in the air and took on the appearance of an eight-armed goddess who then declared to Kamsa (but without telling him, of course, what had happened to Krishna) that the one who was supposed to kill him was already born. This is why Kamsa appealed to the demons, albeit in vain, to attempt to find and eliminate the one who was to destroy him.

25. This episode can be seen in the northwestern corner pavilion of the first story of Angkor Wat. For a thorough explanation and illustrations, see Roveda 2002, 142–45 and figs. 123–24.

26. *Bhagavad Gita*, XI: 15–18. French translation by Anne-Marie Esnoul and Oliver Lacombe; translation from French by Marguerite Shore.

The Origin Myths of the Dynasties in Ancient Cambodia

The various sources on the history of Cambodia often begin in part with legend. The oldest are Chinese records, the very first of which date from the second half of the third century. It was not until around the middle of the seventh century that direct data on this subject from Khmer sources emerged, more precisely through inscriptions from Cambodia written in Sanskrit. Around the same time, a Sanskrit inscription in neighboring Champa—an ally during that period—became crucial regarding our focus in this text.

It goes without saying that myths were influential not only in the past. In modern times, there is a version that is still alive and may surface again as specific events arise.

Chinese Sources

Let us turn as far back as research allows to learn about Cambodia's foundation myth. With regard to Funan,[1] Chinese records from the third to seventh centuries trace its origin to the union between a foreign-born civilizing hero named Huntian and the indigenous queen Liuye. The union was sealed following a show of force: Liuye, who at first led her army to fight the foreigner who had come by sea in a junk ship, was quickly won over when she realized the invincible power of the invader. And so the people of Funan, a population that knew not of clothing and other things, became civilized through the cultural teachings of Huntian, who henceforth governed the country.[2] That is the legend behind the history of Funan as recounted by various Chinese texts from different periods, with little variation. Traditionally, scholars thought the Funanese were not Khmers, but rather an Austronesian people. The most recent theories seem to definitively regard the ethnicity of Funan as "Mon-Khmer." Insofar as the genuinely historical Cambodia—a Cambodia based on stone inscriptions—emerged in the sixth to seventh century along with, among other things, the collection of monuments at Angkor Borei, there are no qualms considering Funan as the precursor to Cambodia as it developed starting in the seventh century.[3]

However, Chinese records also speak of the Brahman Kaundinya (the phonetic rendering of the Sanskrit name being Jiao-chen-ru), who came from India

Figure 115. View of Phnom Da along the canal from the west, October 2019. Photo: Konstanty Kulik

163

at the end of the fourth century or at the beginning of the fifth in order to civilize Funan.[4] This Kaundinya directly echoes Khmer sources, as will be noted.

Khmer Sources

Around the middle of the seventh century, two Sanskrit inscriptions from Cambodia launched the Khmer dynasties partly by legend. K.483 is an inscription in ruins marked on the doorjamb of the Phnom Bayang temple located in the Cambodian south (map 1). The reading is interrupted in multiple places. The inscription speaks of "the queen of Shri Kaundinya" (stanza I). We are not able to read her proper name, the concerned area being severely abraded.[5] Fortunately, a replica of this section with the legend exists in another inscription (K.1142) from the same era, but its provenance is unknown. In stanza I, we read "Soma, the glorious one, who was the most important queen of Shri Kaundinya. . . ."[6] And so in the mid-seventh century, Khmer sources began referring to Kaundinya-Soma as the founding couple of the dynasties of Cambodia.

Three hundred years later, around the middle of the tenth century, during the reign of Rajendravarman (r. 944–967), this mythical couple would once again emerge as the founding couple, invoked in three different inscriptions.[7] Under the reign that followed—still in the tenth century—Jayavarman V (r. 968–1001), son and successor to the throne of the preceding king, was easily recognized in inscriptions at Prasat Komphus (K.669, stanza VI) and at Wat Preah Einkosei (K.263, stanza V) as being "born into the race of Soma and of Kaundinya. . . ."[8]

In one of the inscriptions, however, another founding couple of the Khmer people is introduced, Kamvu and Mera,[9] in parallel with Kaundinya and Soma.[10] The Kamvu-Mera couple, encountered only once in the epigraphy of Cambodia, seems to be an anomaly and will be set aside in this discussion. However, the recurrence of Kaundinya-Soma, introduced as the ancestral founding couple, remains striking.

Cham Source (My Son, C.96)

Practically contemporaneous with the first group of inscriptions from Cambodia (around the middle of the seventh century) is a Cham source, the Sanskrit inscription C.96 from My Son on the eastern coast of what is today Vietnam (map 1), which speaks of the same couple in more detail with regard to the origin of the Cambodian dynasties. In stanzas XVI to XVIII, Kaundinya is introduced as a Brahman, a hero of civilization from India (referencing Ashvathaman, son of Drona, both characters from the *Mahabharata*), arriving to marry Soma, "daughter of the king of the *naga* [water serpents]."[11] It is with regard to this latter point that the Cham inscription offers additional information to the inscriptions in

Cambodia itself: Soma is an ondine. Although there is no mention of it in Khmer sources from the period, the myth of Cambodia's founding as it is told today invariably renders a female serpent deity (Sanskrit: *nāginī*; Khmer: *nāṅ nāg*) as the female ancestor of the Khmers.

A Late but Direct Chinese Source
For more than a year, around the end of the thirteenth century, the Chinese emissary ZHOU Daguan (1266–1346) lived in Angkor. In chapter 2 of his famous memoirs, referring to the Phimeanakas temple located in the royal palace of Angkor Thom, he says:

> Inside the palace there is a gold tower, at the summit of which the king sleeps at night. The local people all say that in the tower lives a nine-headed snake spirit, which is lord of the earth for the entire country. Every night it appears in the form of a woman, and the king first shares his bed with her and has sex with her. Even his wives do not dare go in. At the end of the second watch he comes out, and only then can he sleep with his wives and concubines. If for a single night this spirit does not appear, the time has come for this foreign king to die. If for a single night he stays away, he is bound to suffer a disaster.[12]

ZHOU Daguan's account of the belief is of critical importance. Admittedly, it does not name the snake-woman as the female ancestor of the Khmers, nor does it describe her as having a submarine nature.[13] However, in referring only to the oldest of accounts, it must integrate into the collection of the country's foundation myths (via the royal dynasties), on which the Sanskrit epigraphy is relatively verbose. Let us emphasize that ZHOU Daguan was fully aware of the Chinese records dating from several centuries, even a millennium, before him. As proof, he reiterates almost word for word several Chinese stereotypes about the Khmers that had prevailed for ages among his compatriots. For example: physical ugliness, the darkness of people's skin, the punishment of plunging the hand of an accused into boiling oil. Yet he makes no mention of the myth recounted regularly in Chinese records from that time regarding Funan, which introduces the Huntian-Liuye couple. On the other hand, his accounts of statements made by indigenous people confirm the content of the Cham inscription from My Son (C.96). At the end of the thirteenth century, there was indeed a snake-woman asserting herself as the mythical partner of the real Khmer king. Thus, the snake-woman emerged from myth in order to better actualize and affirm her presence. In the eyes of the people, the myth is forever reenacted every night, even literally, as it were.

Figure 116. A waterspout forming and touching down along the Mekong River near the Chatamuk Junction during an afternoon storm in the Cambodian capital Phnom Penh, August 29, 2006. Photo: James M. Heston / AFP via Getty Images

Summary and First Teaching

In comparing all the enumerated ancient sources, the couple with the Chinese names Huntian-Liuye mentioned in the Chinese records might, at first glance, seem to have no counterparts in other sources. However, the fact that Liuye is an indigenous woman and that Huntian comes from across the ocean makes the hero of civilization a pure foreigner. That point corroborates the Kaundinya-Soma tradition in that Kaundinya descends directly from the heroes of the *Mahabharata*, and therefore was from India. However, the name Kaundinya is also known in Chinese records (Jiao-chen-ru), since they make it the surname of the kings of Funan, at least in the second half of the fifth century.[14] Truth be told, if we only consider the name Kaundinya, without concern for the rest, there is consensus between the Chinese records, the epigraphy of Cambodia (until about the end of the tenth century), and the epigraphy of Champa (seventh century). However, this name is lost in the periods that follow. Nevertheless, certain traits or characteristics survive in the later version of the myth, more precisely, the myth that is currently told, in particular the underwater origin of the female ancestor. Moreover, all the important elements appear together in this final inscription: the Kaundinya-Soma couple, the former implicitly a foreigner, the latter originally a nagini associated with the ocean.[15] In fact, while there is a gap between the Cham inscription C.96 and ZHOU Daguan, it is only a gap in time. ZHOU Daguan was speaking in the present tense, that is, about what was happening (by hearsay) while he was living in Angkor. He was not describing a mythical time, but rather what was being perpetuated and expounded upon in real time. The Khmer king of whom he speaks[16] was not the founder of the race but the living successor of a long line of kings. In short, with the Cham inscription from My Son, the seventh century emerges as the earliest period in which we find traces of the first part of the myth recounted today.

Modern Times

On August 29, 2006, in the early afternoon (12:45 p.m. to be precise), an absolutely spectacular atmospheric phenomenon took place in Phnom Penh.[17] A whirlwind lasting about thirty minutes occurred across from the royal palace. It was fully in view at the "Four Arms," in other words, the junction of the Mekong River and Tonle Sap. The whirlwind touched the surface and drew upward a mass of water. It was an impressive spectacle because the miniature tornado landed at a spot where it could be seen in full and from all around. The image in figure 116 seems to have been taken from the boardwalk across from the palace.

People immediately began talking about *nāg leṅ ḍịk*, about "naga frolicking [on the surface] of the water," a reaction or reflex that surprised many from

abroad. And so, at the dawn of the twenty-first century, the Khmers continue to draw on the origin myth of their country to explain an unusual phenomenon.

Today's Myth of the Foundation of Cambodia

I have summarized this myth in an article that also contains the beginnings of an analysis.[18] For this essay, it is included here with some minor modifications.[19] The story unfolds in two parts.

Part One

In the beginning there was nothing but ocean. There emerges only an island called Gok Dhlak,[20] its only vegetation a *dhlak* tree. Brah Thon lives alone on this minuscule scrap of dry land.

One day Nan Nag, daughter of the king of the naga, comes to the surface to take her bath. On seeing her, Brah Thon falls in love with her and insists that she take him to her father to ask for her hand in marriage. To prevent his drowning, Nan Nag tells him to hold tight to her scarf, and the two descend to the very bottom of the ocean where Brah Thon is granted the hand of the nagini. Soon, Brah Thon makes known his wish to take his spouse to live on dry land, in fact on Gok Dhlak.

Aware of the need to turn the minute habitat into a kingdom worthy of the name, the naga chases away the water surrounding the island with his tail and, at the same time, pumps out the water with his mouth, so that its surface is extended. From Gok Dhlak, the place becomes the center of Nagar Gok Dhlak, or "the kingdom born from the island of the dhlak tree."

That is the basis of the first part of the myth. What follows varies, with the story taking place in different regions. The important part of the core story is that Nan Nag ("Lady Naga") is ultimately severed from her submarine world when she settles on earth once and for all. On this point, the overlap between modern oral versions and the seventh-century Cham inscription irrevocably emerges. The nagini is so popular that she is represented on various functional objects, especially those used in rituals, such as *popil*.[21] We also find her in works of contemporary art, such as a recent mixed-media painting by Cambodian artist LEANG Seckon (fig. 117).

Part Two

Various people attempt to take ownership of the myth, hence the adaptation of the second part, which varies depending on geographical location and local historical tradition, which is regional. The most coherent adaptation, and therefore the most successful, is the version told by villagers in the area around Angkor Thom, in the heart of Angkor.

Figure 117. *Lucky Crocodile Stars*, 2020. LEANG Seckon (Cambodian, b. 1970). Mixed media on canvas; 182 x 100 cm. Photo © LEANG Seckon. Image courtesy of the artist

Brah Thon planned to construct his palace there (the Bayon), marking the center of the royal capital (Angkor Thom). The naga king approved the project with the one stipulation that no image of Brahma be erected, for it is in the nature of naga to fear representations of Brahma. Brah Thon willfully disregarded the injunction.

One day the king of the naga visited the couple. He emerged from the ocean through the very heart of the kingdom; that is, he came to terra firma through the "Ancient Well."[22] He immediately saw faces of Brahma everywhere, even on the gates of the city. Overcome by panic, but at the same time furious with his son-in-law, he challenged the latter to single combat. Brah Thon was finally the vanquisher, having cut the body of his father-in-law in two.

This version of the second part of the myth—the variable part—cannot date further back than the end of the twelfth century or the beginning of the thirteenth century. As its backdrop, and as its proof, it wonderfully uses the gates and moats of Angkor Thom and also the Bayon, which were constructed during the reign of Jayavarman VII (r. 1181–1218): the waters of the moats surrounding the ancient city are the edge of the ocean forced back by the king of the naga; the gates of the rampart and the towers of the Bayon clearly present images of Brahma constructed by Brah Thon;[23] the Bayon itself stands on the old mound, or island, emerging from the ocean's surface; the (real) underground wells of the Bayon comprise the route used by the naga king to reach the surface in order to communicate with the couple; and finally, certain figures rendered in the monument's bas-reliefs are interpreted as representing Brah Thon and the naga king.[24] The fact that this version is so consistent with the monumental site means that all the other known versions have borrowed the same name, Nagar Gok Dhlak. However, the term *gok* is only used by people in the north as a noun to designate any more or less large surface emerging from water, like an island. Without the influence of the people of Angkor, this term would not have appeared in the legend's name. Another word would have been used.[25]

The Support of Archaeology

Let us now turn to another account, one of the most eloquent. A few years ago, a team of archaeologists, headed by Jacques Gaucher and working on Angkor Thom and its royal palace for two decades, discovered the entire trunk of a dhlak tree buried more than fifteen feet into the ground like a kind of foundational unit in the construction of the royal palace. "Beyond all doubt," says Gaucher, it had a ritual purpose. It was located near and to the southeast of Phimeanakas, the monument mentioned by ZHOU Daguan as the place where the Khmer king and a nine-headed snake-woman were united every night. Laboratory analysis dates the trunk to between the end of the seventh century and the end of the ninth

century.[26] That the foundation of a building is a tree is unique in itself, revealed by the archaeological excavations. That the tree is a dhlak leaves no doubt: the species was an intentional choice, one that accords with the myth that must have already been hugely popular at the time, at least at Angkor.

It was mentioned earlier that the second part of the myth as it is told today in the region of Angkor could not date back earlier than the end of the twelfth century. But the presence of the dhlak clearly used as part of the foundation shows that the very theme of the dhlak as a primordial tree, growing on a small island destined to expand and become Cambodia—in other words, the terra firma conquered from the sea—existed well beforehand. With its theme of the man and the snake-woman as a couple, the C.96 inscription is convincing evidence that the first part of the myth of Nagar Gok Dhlak is ancient.

Possible Origins of the Foundation Myth of Cambodia

Even so, must the idea be rejected that the region of Angkor was where the myth might have originated and developed? It is a difficult question because, although as the center of a unified state, Angkor only emerged at the beginning of the ninth century. The vast site also includes a certain number of pre-Angkorian monuments. In any case, without bias, let us attempt to imagine other possibilities.[27]

The Nagini and the Rupture with the Ocean
The two elements are clearly connected. They are highlighted, as it were, to designate the female ancestor of the Khmers, her world of origin, and then the rupture with that world. In the myth of Nagar Gok Dhlak, that rupture is gradual. In a first phase, Nan Nag follows her spouse Brah Thon to live in the world of humans. However, the contact with the depths of the oceans had not yet been entirely severed; her father, the king of the naga, could come up and visit the couple. It is the father's brutal death that severs ties with the ocean forever. In the C.96 inscription, the rupture with the submarine world also occurs. Described in the inscription as "daughter of the king of the naga," Soma ". . . founded on earth the race that bears the name of Soma; having adopted that state, a remarkable fact, she inhabited a human home" (stanza XVII). It is only later that Kaundinya comes from afar to marry her. The difference with the Nagar Gok Dhlak version is in the form that she takes; in the latter, she becomes fully human when she marries a human. The theme of the indigenous female and the civilizing male, noted in both C.96 and the Chinese sources, is not important in the Nagar Gok Dhlak version of the myth, which does not discuss who is indigenous and who is foreign. Its primary message concerns the earth as won from the sea.

Turning back briefly to the Chinese narrative of the beginnings of Funan and the Huntian-Liuye couple, Huntian was a hero of civilization who has come from beyond the ocean, and Liuye was not an ondine. In contrast, in the Nagar Gok Dhlak version, Brah Thon is a native. As for Nan Nag, she certainly originates from a distant world, but not in terms of horizontal distance. It is simply a submarine world. Moreover, she left it forever to adopt the human way of life but did not bring any drive for civilization with her. Hers is not the ocean of seafarers and, in the Khmer myth, there is no junk ship. The sea is phantasmagorical. Everything is different in the two narratives. The myth told by the third-century Chinese, abundantly reiterated thereafter in records, ceased to be perpetuated starting in the sixth to seventh century; similarly, from that time on, Funan is no longer relevant.

Southern Cambodia

We have determined that the coastal territories were likely not rejected, but rather mostly neglected by the centralized Angkor Empire. Yet, for approximately three centuries, Funan developed primarily in relationship to the sea through various ports. Nevertheless, with the advancement of research, there was no longer any serious reason not to consider this state as the precursor of historical Cambodia. Funan did not disappear as a civilization. Its territory was simply absorbed by Zhenla. Moreover, the latter, before being unified, was divided into Land Zhenla and Water Zhenla.

In terms of antiquity, except for pre-Angkorian settlements along the Mekong and a few others in different plain areas, it is the southern provinces, some of which are today part of Vietnam, which hold most of Cambodia's archaeological heritage. The temples built in several Kampot caves are among the oldest remains (Phnom Khyorng, Phnom Chngok, Phnom Trotoung, for example).[28] In Takeo, there are no limestone mounds and therefore no caves; however, its hills of varying size and height were endowed with high-quality monuments, the most prominent being those of Phnom Bayang and Phnom Da. In the case of Phnom Da, there is even excavated cave architecture: no less than five man-made caves at the foot and on the sides of the hill (frontispiece pp. 4–5; figs. 41c, 51, 68). The large laterite and brick sanctuary that is found at the top (frontispiece pp. 2–3) in all likelihood dates from the Angkorian era, but it was built at the site of a much older temple, in all probability from the same period as the caves. From this site have come a significant number of very fine pieces, statues, and other objects that are on view at the National Museum in Phnom Penh and elsewhere.[29] Even farther south, toward the Mekong delta, there are many monumental sites where pre-Angkorian statues were transformed into Buddhist images by Vietnamese populations.[30] In the provinces of Kandal, Prei Veng, and

Svay Rieng, there are plenty of pre-Angkorian sites as well, yet a great number of them have been defaced or even destroyed.

Most of the elements that can be dated are generally from a period of confluence. In referring to Chinese records, it is around the end of Funan and the beginning of Zhenla.

Beginning in the ninth century, centralized Cambodia expanded, especially toward the north.[31] Periodically, kings attempted to pay more attention to the south. Ancient sites were equipped with secondary constructions and even new buildings. The sculptures of Phnom Da, especially the famous *Vishnu with Eight Arms* (pl. 1), had their antique prestige reaffirmed with the renovation and renewal of the site during the twelfth century (see pp. 133–38). Plus, Phnom Chisor, built in the eleventh century, emerged as one of the four Angkorian sanctuaries disseminated throughout the country, bearing the royal linga Suryavarmeshvara (map 1). Not to be overlooked are the small hills in the surrounding area: Phnom Ta Mao and Phnom Thmor Doh, which were provided with buildings during that same period.[32]

Nevertheless, the coastal regions, with a direct relationship to the sea, were neglected for a long time. It was not until the twentieth century that the concerned provinces, which did not have strong ties to the capital until then, gradually reestablished the relationship.[33]

Jacques Dolias, who studied the theme of the sea in Khmer culture,[34] notably analyzed literary and artistic sources on the subject. The lesson seems to be that Cambodians have turned away from the sea for a very long time.[35] More concretely, regarding the population of Cambodia and its mobility through history, are the profound initial thoughts of Bernard Philippe Groslier.[36] This excerpt can be shared from his attempt to define the historical Khmer "country": "It is easier to see it as where they [the Khmers] were not able to prosper or where they declined to settle: the maritime coast, the swampy plains. . . ."

Aside from the truly coastal region, even though it was overshadowed by Angkor for approximately five centuries, the south both continued and attempted to develop. And it is not unrealistic to locate the genesis of historical Cambodia there.

Mythical Cambodia Today

While in the general Angkor region there is at least one village with the name Gok Dhlak,[37] there is also one with the same name right next to Angkor Borei. It is therefore not surprising that local populations have made Phnom Da the Gok Dhlak that presided over the birth of Cambodia. The topography of the region lends itself perfectly to it: during flood periods, the hill is surrounded by water, which gradually retreats as the dry season arrives (fig. 115). The situation

in Phnom Bayang (still in Takeo Province) is somewhat similar. The theme of reaching land from the ocean is to a certain extent reflected in nature itself, unlike the Gok Dhlak of Angkor Thom, where all the elements are man-made. The Bayon itself stands on the site of the gok with the dhlak tree, without there being a hill; the ocean shore kept back by the king of the naga is represented by the geometric moats that surround Angkor Thom, even though there is no natural body of water, for example.

Clearly there is no infallible or definitive proof that can be provided, but southern Cambodia offers a series of clues that lead one to believe that at least the first part of the myth of Nagar Gok Dhlak[38] emerged from there. Let us remember, it was during the seventh century that the nagini Soma (inscription C.96) appeared for the first time. Yet that period corresponds to the beginnings of the genuinely historical Cambodia, where the Chinese locate Zhenla's absorption of Funan.

Two pre-Angkorian basalt temples, one known as Ashram Maha Rosei, situated on the southwestern peak of Phnom Da, and the other at Han Chey along the Mekong, in Kompong Cham (map 1),[39] have stone finials in the shape of what some art historians recognize as a kind of fruit called *āmalaka* in Sanskrit (fig. 118). This fruit, commonly known as dhlak in Khmer, was traditionally

rendered as "myrobalan."[40] Although botanically unconfirmed, dhlak is identified as the *Parinari anamense*. In other words, until now "dhlak," "amalaka," and "myrobalan" have all been used interchangeably without much questioning.

Aside from those two seventh-century monuments, I know of no other use of the motif on ancient monuments from any era. What is remarkable, however, is that it is often used as a crowning element on provisional cremation pavilions, as well as on pavilions built for a rite of passage in reverse, meant to prolong the life of an elderly person. This latter ritual consists of enclosing the person (like a fetus) in a lightweight pavilion that is shut with a piece of cloth (like the mother's womb). In the final part, the postulant comes out, a fetus from the mother's womb.[41] The examples that I have encountered were from the Angkor region. Figure 119 presents a cremation scene in a rural village. One can see the amalaka crown, topped by a multilevel parasol. Figure 120 shows the framework of the amalaka as it is being made. In figure 121, which presents a pavilion that has been pitched for the "prolongation of life" ritual, one notices an amalaka topped by a multilevel parasol, just like the cremation pavilion.

Whether for cremation or the prolongation of life, the symbolism of the two rituals stems from the idea of "naissance" or birth; death becomes a death-naissance. From there, the question arises: is the incorporation of the myrobolan /

Figure 119. Cremation scene in a rural village near Angkor, 2001. Photo: ANG Choulean

Figure 120. Framework of the finial of a cremation structure in a rural village near Angkor, 2001. Photo: ANG Choulean

Figure 121. Pavilion for the "prolongation of life" ritual in a rural village near Angkor, 2004. Photo: ANG Choulean

amalaka / dhlak coincidental, or does it relate to the idea of birth (of both the person and the country)?

These two examples, drawn from religious ethnography, reveal the vitality of themes encountered in the Angkor region that have monumental iconography that either originated or was adopted from the south in the seventh century. It is tempting to find a parallel with the voyage in the initial myth of Nagar Gok Dhlak.

Addendum

It is quite possible that at first, perhaps around the beginning of pre-Angkorian times, and notably in southern Cambodia, the "primordial tree" did not refer to the dhlak species, which was abundant in the Angkor region, but rather to the emblic myrobalan (*Phyllanthus emblica*): *kanduot* in Old and Middle Khmer and *kanduot brai* in modern Khmer.[42] In Khmer there is the expression *sruk danle sñuot kanduot muoy ṭoem*, which literally translates as "land of the dried sea with a single kanduot tree," meaning, more concisely, "country of origin." It seems that the expression is only familiar to southern Khmers, including those in Kampuchea Krom (today's south Vietnam). In any case, they use it at the conclusion of the Pchum Ben,[43] the Cambodian religious festival when the souls of ancestors, having come to be among loved ones for a fortnight, are "sent back" to their residence through offerings made in miniature boats. They will be welcomed again the following year.

Whether called dhlak or kanduot, Parinari anamense, or Phyllanthus emblica, the theme of the primordial tree remains the same; it grows from a tiny bit of land, gradually reclaimed from the sea and steadily continues to expand. The topographies of southern Cambodia do not contradict the country's origin myth. It is true that, known only as Nagar Gok Dhlak, the myth that has survived and is told today was developed by people in the north. One might suspect an unconscious desire on the part of the rulers in Angkor to appropriate the south.

Translated from the French by Molly Stevens.

1. Funan is the subject of numerous studies and much debate. The pioneer was Paul Pelliot (in particular, Pelliot 1903).

2. Pelliot 1903, 256.

3. See also Vickery 2003, 125. This very rich site is directly related archaeologically to Oc-Eo, which is older.

4. Pelliot 1903, 293. The premise here is not to discuss the historical reality of such statements. This is to simply show that the Indian name Kaundinya was heard and noted by the Chinese.

5. Coedès 1937, 254.

6. Ishizawa, Jacques, and Khin 2007, 49.

7. K.528, East Mebon temple, dated 952, stanza VIII: "[T]he race of Kaundinya and of Soma. . . ." (Finot 1925, 332); K.806, Pre Rup temple, dated 961, stanza VI: "[A] descendent of Soma and of Kaundinya. . . ." (Coedès 1937, 106); K.286, Baksei Chamkrong temple, dated 948, stanza XVI: "Then appeared the kings . . . their origins descending from Shri Kaundinya and the daughter of Soma" (Coedès 1952, 95).

8. Coedès 1937, 174, and Coedès 1952, 130, respectively.

9. The name "Cambodia" (Kamvu~ja / Kambu~ja) means "born of Kamvu~Kambu." The Baksei Chamkrong inscription has this mythical ascetic be born "of himself" (*svāyambhuva*). George Coedès says, without much emphasis, that the name Mera is thought to have been coined after the fact to explain the name "khmer" (Coedès 1952, 95n5).

10. K.286, Baksei Chamkrong temple, dated 948, stanzas XI–XII: "Honor [to] Kamvu *svāyambhuva* . . . I plead [to] Mera, the most illustrious of celestial women, that Hara . . . offered from up high in the sky as queen to *mahāṛṣi* [the Great Sage]." The "Great Sage" refers to Kamvu, who is an ascetic (Coedès 1952, 95).

11. Finot 1904, 923.

12. Harris 2007. The French translation by Paul Pelliot is practically the same (Pelliot 1951, 12).

13. It is not expressly mentioned in any case.

14. Pelliot 1903, 257.

15. In contrast, the theme of the ocean is explicit in today's myth of the founding of Cambodia, the Nagar Gok Dhlak myth, discussed in this essay's next section.

16. The historical Indravarman III.

17. The *Phnom Penh Post* reported on it in the September 8, 2006, issue.

18. Ang 2007, 365.

19. This section does not duplicate the 2007 essay.

20. "Knoll (or island) of dhlak."

21. *Popil* are metal plates on which a lighted candle is attached. An audience, sitting in a circle around one or more ceremonial postulants, pass it around a specified number of times. A post-Angkorian example in bronze with the nagini motif is in the collection of the National Museum of Cambodia, Ga.5502.

22. The Bayon is equipped with a genuine underground well that has a symbolic function, as do several other Khmer monuments, above all Angkor Wat.

23. The Khmers see the faces of the god Brahma in the four faces of the towers.

24. Most of these details are presented in Ang 2007.

25. Ang 2007, 364.

26. Personal communication with Jacques Gaucher from February 4, 2020.

27. In Ang 2007, I was clumsy with my words or unclear; I may have suggested the idea that the people of Angkor were at the origin of the myth in its entirety.

28. Even though there are the same types of limestone hills in Battambang, where there are also caves, they do not contain anything as old, save for sites that are in fact prehistoric.

29. The 2021–22 *Revealing Krishna* exhibition at the Cleveland Museum of Art reflects a Cambodia that is historically young but blossoming in terms of its religious and artistic expression.

30. Some can be seen in Porte 2016.

31. The enterprise was already underway in the eighth century with Mahendravarman, although still tentatively.

32. Ang 1993.

33. It is true that around the middle of the nineteenth century King ANG Duong (r. 1841–1844 and 1845–1860) built a road between the captial at Oudong and Kampot, but that remains an exception.

34. Dolias 2012.

35. Ibid., 162, 180, among others.

36. Groslier 1973.

37. Some sixty kilometers to the east of Siem Reap.

38. See this essay, 167.

39. Two basalt temples, including Kuk Preah Theat, are located at the foot of Han Chey hill, below Han Chey temple, about fifteen kilometers north of the city of Kompong Cham, on the west bank of the Mekong River (map 1).

40. In some French-language sources on Cambodia, Gok Dhlak is rendered as "Myrobalan Isle."

41. See Ang, Preap, and Sun 2007, 71.

42. The fluted crowning element of the basalt temple at Han Chey faithfully depicts the form of the pit of the emblic myrobalan fruit, except that the stone finial has eight parallel ridges instead of six.

43. Pchum Ben is the most important religious event in Cambodia. Over the course of fifteen days in September to October, collective offerings are made to ancestors and all the dead, without exception. See Ang 2006 and Siyonn 2020.

Overleaf: Canal from Phnom Da to Angkor Borei, October 2019. Photo: Konstanty Kulik

EIGHT GODS OF PHNOM DA: TABLE OF DISCOVERIES AND TRANSFERS

In chronological order of discovery:

Paris Harihara (pl. 2)

Sculptural Section	First Recorded Sighting on Phnom Da	Transfers	Location in 2020
Body with head, legs, and arm sections	1874 by Etienne Aymonier, north slope of southwestern peak	1882–89 Phnom Da to Paris by Étienne Aymonier	Musée Guimet, MG 14910
Feet with base and tenon in three pieces	1923 by George Groslier, a cave(?)	1944 Phnom Da to Phnom Penh by KAM Doum representing Pierre Dupont	National Museum of Cambodia, Ka.230, Ka.242, and Ka.302

Phnom Penh Harihara (pl. 8)

Sculptural Section	First Recorded Sighting on Phnom Da	Transfers	Location in 2020
Head	1882 by Etienne Aymonier, southwestern peak	1882–89 Phnom Da to Paris by Étienne Aymonier 2016 Paris to Phnom Penh by exchange and long-term loan agreement between the National Museum of Cambodia and the Musée national des arts asiatiques–Guimet	National Museum of Cambodia, MG 14899
Body with legs	1911 by Henri Parmentier, Cave F	1911–23 Cave F to a new shrine between the two peaks of Phnom Da by local residents 1944 Phnom Da to Phnom Penh by KAM Doum, representing Pierre Dupont	National Museum of Cambodia, Ka.1614
Hand with rosary; hand with mace	1911 by Henri Parmentier, base of the northeastern peak, east side (H on map 3.1)	1923 Phnom Da to Phnom Penh by George Groslier	National Museum of Cambodia

Cleveland Krishna (pl. 6)

Sculptural Section	First Recorded Sighting on Phnom Da	Transfers	Location in 2020
Body with head	c. 1910, probably by members of the recently relocated Vietnamese Buddhist community, probably Cave D	c. 1910–15 Phnom Da to Saigon to Marseille to Paris anecdotally by a young French sailor 1920 Paris to Amsterdam by Léonce Rosenberg 1920 Amsterdam to Brussels by Suzanne and Adolphe Stoclet 1965 Brussels to Barcelona by Michèle Leon-Stoclet 1973 Barcelona to Cleveland by Eugene Thaw on behalf of Sherman E. Lee	Cleveland Museum of Art, 1973.106
Upper stele with hand	1923 by George Groslier, one of the caves	1936–37 Phnom Da to Brussels reportedly by Victor Goloubew 1977 Brussels to Cleveland by Stanislaw Czuma 2005 Cleveland to Phnom Penh by Stanislaw Czuma 2015 Phnom Penh to Cleveland by National Museum of Cambodia and the Ministry of Culture and Fine Arts of the Kingdom of Cambodia	Cleveland Museum of Art
Right elbow; upper left leg	1935 by Henri Mauger, vicinity of the caves	1936–37 Phnom Da to Brussels reportedly by exchange between Adolphe Stoclet and EFEO 1977 Brussels to Cleveland by Stanislaw Czuma	Cleveland Museum of Art
Lower right leg	1935 by Henri Mauger, vicinity of the caves	1936–37 Phnom Da to Brussels reportedly by exchange between Adolphe Stoclet and EFEO 1977 Brussels to Cleveland by Stanislaw Czuma 2005 Cleveland to Phnom Penh by Stanislaw Czuma 2020 Phnom Penh to Cleveland by exchange between the National Museum of Cambodia and the Cleveland Museum of Art	Cleveland Museum of Art

Phnom Penh Krishna (pl. 5)

Sculptural Section	First Recorded Sighting on Phnom Da	Transfers	Location in 2020
Body with head, upper left arm; right forearm; two additional fragments	1911 by Henri Parmentier, Cave D	1944 Phnom Da to Phnom Penh by KAM Doum representing Pierre Dupont (without upper left arm)	National Museum of Cambodia, Ka.1641
Lower stele with feet, base, and tenon	1911 by Henri Parmentier, Cave D	1936–37 from Phnom Da to Brussels reportedly by exchange between Adolphe Stoclet and EFEO 1977 Brussels to Cleveland by Stanislaw Czuma 2020 Cleveland to Phnom Penh by exchange between the National Museum of Cambodia and the Cleveland Museum of Art	National Museum of Cambodia
Upper right arm; upper left leg; upper left arm (detached from body between 1911 and 1923)	1935 by Henri Mauger, vicinity of the caves	1936–37 Phnom Da to Brussels reportedly by exchange between Adolphe Stoclet and EFEO 1977 Brussels to Cleveland by Stanislaw Czuma 2005 Cleveland to Phnom Penh by Stanislaw Czuma	National Museum of Cambodia
Upper right leg; lower right leg; lower left leg	1935 by Henri Mauger, vicinity of the caves	1936–37 Phnom Da to Brussels reportedly by exchange between Adolphe Stoclet and EFEO 1977 Brussels to Cleveland by Stanislaw Czuma 2020 Cleveland to Phnom Penh by exchange between the National Museum of Cambodia and the Cleveland Museum of Art	National Museum of Cambodia
Right forearm	2005 in storage of the National Museum of Cambodia by the sculpture conservation workshop	n.d. Phnom Da to Phnom Penh	National Museum of Cambodia

Deity (pl. 7)

Sculptural Section	First Recorded Sighting on Phnom Da	Transfers	Location in 2020
Full figure with base and tenon	1923 by George Groslier, probably Cave B	1944 Phnom Da to Phnom Penh by KAM Doum, representing Pierre Dupont	National Museum of Cambodia, Ka.1608
Left wrist; lower section of the right forearm and wrist	1935 by Henri Mauger, vicinity of the caves	1936–37 Phnom Da to Brussels reportedly by exchange between Adolphe Stoclet and EFEO 1977 Brussels to Cleveland by Stanislaw Czuma 2005 Cleveland to Phnom Penh by Stanislaw Czuma	National Museum of Cambodia

Vishnu with Eight Arms (pl. 1)

Sculptural Section	First Recorded Sighting on Phnom Da	Transfers	Location in 2020
Upper left hand	Before 1935 by Henri Mauger, who called it a "lower right hand"	1934(?) Phnom Da to Siem Reap; 1936 Siem Reap to Phnom Penh by Henri Mauger	National Museum of Cambodia
Base with tenon and toes	1935 by Henri Mauger, north slope of northeastern peak	1936 Phnom Da to Phnom Penh by Henri Mauger	National Museum of Cambodia
Fragment of a foot (left?) and calf (right?)	1935 by Henri Mauger, north slope of northeastern peak, on the ground in front of Caves D and E	1936 Phnom Da to Phnom Penh by Henri Mauger	National Museum of Cambodia
Body with head, arms, and legs	1935 by Henri Mauger, Prasat Phnom Da	1936 Phnom Da to Phnom Penh by Henri Mauger	National Museum of Cambodia, Ka.1639
Left foot section with heel	Early 1990s by Michel Tranet	Early 1990s Phnom Da to Phnom Penh by Michel Tranet	National Museum of Cambodia, previously Ka.268, now Ka.1639

Balarama (pl. 4)

Sculptural Section	First Recorded Sighting on Phnom Da	Transfers	Location in 2020
Body with head and upper legs; lower legs, feet with base and tenon; upper front section of the plow	1935 by Henri Mauger, Prasat Phnom Da	1936 Phnom Da to Phnom Penh by Henri Mauger	National Museum of Cambodia, Ka.1640

Rama (pl. 3)

Sculptural Section	First Recorded Sighting on Phnom Da	Transfers	Location in 2020
Body, legs, feet with base and tenon, bow	1935 by Henri Mauger, Prasat Phnom Da	1936 Phnom Da to Phnom Penh by Henri Mauger	National Museum of Cambodia, Ka.1638

BIBLIOGRAPHY

Ang 1993
ANG Choulean. "Recherche récente sur le culte des mégalithes et des grottes au Cambodge." *Journal Asiatique* 281, no. 1–2 (Paris, 1993): 183–210.

Ang 1997
———. "Nandin et ses avatars." In *Angkor et dix siècles d'art khmer*, edited by Helen I. Jessup and Thierry Zéphir, 62–69. Exh. cat. Paris: Réunion des musées nationaux, 1997.

Ang 2006
———. "Vom Brahmanismus zum Buddhismus Betrachtungen zum Totenfest in Kambodscha." In *Angkor. Göttliches Erbe Kambodscha*, edited by W. Lobo and Helen Ibbitson Jessup, 238–42. Bonn: Kunst- und Ausstellungshalle der Bundesrepublik Deutschland, 2006.

Ang 2007
———. "In the Beginning Was the Bayon." In *Bayon: New Perspectives*, edited by Joyce Clark, 363–77. Bangkok: River Books, 2007.

Ang, Preap, and Sun 2007
ANG Choulean, Chanmara Preap, and Chandeup Sun. *The Course of Individual Khmer Life Seen through Rites of Passage*. Phnom Penh: Hanuman Tourism, 2007.

Aymonier 1900
Aymonier, Étienne. *Le Cambodge I: Le Royaume actuel*. Paris: Ernest Leroux, 1900.

Bakker 1997
Bakker, Hans. *The Vakatakas*. Groningen Oriental Studies Series 5. Groningen, the Netherlands: Egbert Forster, 1997.

Banks 1979
Banks, Philip. "Petrographic Study of Stone from a Cambodian Sculpture." Unpublished report, July 1979.

Baptiste 2003
Baptiste, Pierre. "Le piédestal de Van Trac Hoa: un *bali-pīṭha* d'un type inédit. Note sur l'iconographie des *dikpāla* au Champa." *Arts asiatiques* 58 (2003): 168–76.

Baptiste and Zéphir 2008
Baptiste, Pierre, and Thierry Zéphir. *L'art Khmer les collections du musée Guimet*. Paris: Réunion des musées nationaux, 2008.

Barth and Bergaigne 1885–93
Barth, Auguste, and Abel Bergaigne. *Inscriptions sanscrites du Cambodge et de Campa*. Paris: Imprimerie nationale, 1885–93.

Bénisti 1969
Bénisti, Mireille. "Recherches sur le premier art khmer II: la bande à chatons, critère chronologique?" *Arts asiatiques* 20 (1969): 99–120.

Bergaigne et al. 1882
Bergaigne, Abel, Auguste Barth, and Émile Sénart. *Les Inscriptions sanscrites du Cambodge, examen sommaire d'un envoi de M. Aymonier, Rapport à M. le président de la Société asiatique*. Paris: Imprimerie nationale, 1882.

Bergaigne 1884
Bergaigne, Abel. "Chronologie de l'ancien royaume Khmêr, d'après les inscriptions." *Journal asiatique*, series 8, vol. 3 (1884): 51–76.

Bhagavad Gita 1976
La Bhagavad Gita. Translated by Anne-Marie Esnoul and Olivier Lacombe. Paris: Seuil, 1976.

Bhattacharya 1961
Bhattacharya, Kamaleswar. *Les Religions Brahmaniques dans l'ancien Cambodge: d'après l'épigraphie et l'iconographie*. Vol. 49. Paris: École française d'Extrême-Orient, 1961.

Bhattacharya 1964–65
———. "Hari Kambujendra." *Artibus Asiae* 27 (1964–65): 72–78.

Bhattacharya 1996
Bhattacharya, Sunil Kumar. *Krishna-cult in Indian Art*. New Delhi: M. D. Publications, 1996.

Bishop 1989
Bishop, A. C. "Aplite." In *Petrology*, edited by Donald R. Bowes, 29–30. Encyclopedia of Earth Sciences Series. Boston: Springer US, 1989.

Biswas and Jha 1985
Biswas, Taran Kumar, and Bhogendra Jha. *Gupta Sculptures: Bharat Kala Bhavan*. New Delhi: Boks & Books, 1985.

Boisselier 1955
Boisselier, Jean. *La statuaire khmère et son evolution*. Saigon: Publication École française d'Extrême-Orient, 1955.

Boisselier 1966
———. *Le Cambodge*. Manuel d'Archéologie d'Extrême-Orient, pt. 1, Asie du Sud-Est: I. Paris: A. et J. Picard et Cie, 1966.

Boisselier 1974
——. *La sculpture en Thaïlande*. Fribourg, Switzerland: Office du Livre, 1974.

Bourdonneau 2007
Bourdonneau, Éric. "Réhabiliter le Funan: Óc Eo ou la première Angkor." *Bulletin de l'École française d'Extrême-Orient* 94 (2007): 111–58.

Bourdonneau 2011
——. "Nouvelles recherches sur Koh Ker (Chok Gargyar). Jayavarman IV et la maîtrise des mondes." *Monuments et mémoires de la Fondation Eugène Piot* 90, no. 1 (2011): 93–141.

Briggs 1951
Briggs, Lawrence Palmer. "The Ancient Khmer Empire." *Transactions of the American Philosophical Society* 41, pt. 1, no. 1 (1951): 36.

Brocheux 1995
Brocheux, Pierre. *The Mekong Delta: Ecology, Economy and Revolution, 1860–1960*. Madison: Center for Southeast Asian Studies, University of Wisconsin, 1995.

Brodbeck 2019
Brodbeck, Simon. *Krishna's Lineage: The Harivamsha of Vyāsa's Mahābhārata*. New York: Oxford University Press, 2019.

Brown 2017
Brown, Robert L. "The Trouble with Convergence." In *India and Southeast Asia: Cultural Discourses*, edited by Anna L. Dallapiccola and Anila Verghese, 38–50. Mumbai: KR Cama Oriental Institute, 2017.

Carò 2000
Carò, Federico. "From Quarry to Sculpture: Understanding Provenance, Typologies, and Uses of Khmer Stones." New York: Metropolitan Museum of Art, 2000–ongoing. https://www.metmuseum.org/about-the-met/conservation-and-scientific-research/projects/khmer-stones (June 2009, updated January 2014).

Carò 2009
——. "Khmer Stone Sculptures: A Collection Seen from a Material Point of View." *Metropolitan Museum of Art Bulletin* 67, no. 1 (2009): 26–32.

Carò and Douglas 2014
Carò, Federico, and Janet G. Douglas. "Stone Types and Sculptural Practices in Pre-Angkorian Southeast Asia." In *Lost Kingdoms: Hindu-Buddhist Sculpture of Early Southeast Asia*, edited by John Guy, 265–66. Exh. cat. New York: Metropolitan Museum of Art; New Haven, CT: Yale University Press, 2014.

Carò and Im 2012
Carò, Federico, and IM Sokrithy. "Khmer Sandstone Quarries of Kulen Mountain and Koh Ker: A Petrographic and Geochemical Study." *Journal of Archaeological Science* 39, no. 5 (2012): 1455–66.

Cecil 2021
Cecil, Elizabeth A. "A Natural Wonder: From Liṅga Mountain to Prosperous Lord at Vat Phu." In *Primary Sources and Asian Pasts*, edited by Peter Christiaan Bisschop and Elizabeth A. Cecil, 341–83. Berlin and Boston: De Gruyter, 2021.

Cecil and Bisschop 2019
Cecil, Elizabeth A., and Peter C. Bisschop. "Columns in Context: Venerable Monuments and Landscapes of Memory in Early India." *History of Religions* 58, no. 4 (May 2019): 355–403.

Coedès 1910
Coedès, George. *Catalogue des pièces originales de sculpture khmère conservées au Musée Indochinois du Trocadéro et au Musée Guimet*. Paris: Imprimerie nationale, 1910.

Coedès 1929
——. "Etienne-François Aymonier (1844–1929)." *Bulletin de l'Ecole française d'Extrême-Orient* 29 (1929): 542–48.

Coedès 1931
——. "Études cambodgiennes XXV: Deux inscriptions sankrites du Fou-Nan." *Bulletin de l'École française d'Extrême-Orient* 31, no. 1 (1931): 1–12.

Coedès 1937
——. *Incriptions du Cambodge*. Vol. I. Hanoi: École française d'Extrême-Orient, 1937.

Coedès 1940
——. "Études cambodgiennes XXXIII: La destination funéraire des grands monuments khmers." *Bulletin de l'École française d'Extrême-Orient* 40, no. 2 (1940): 315–49.

Coedès 1942
——. *Inscriptions du Cambodge*. Vol. II. Hanoi: Imprimerie d'Extrême-Orient, 1942.

Coedès 1947–50
——. "Études cambodgiennes XXXIX. L'épigraphie des monuments de Jayavarman VII." *Bulletin de l'Ecole française d'Extrême-Orient* 44, no. 1 (1947–50).

Coedès 1952
——. *Inscriptions du Cambodge*. Vol. IV. Paris: E. de Boccard, 1952.

Coedès 1953
——. *Inscriptions du Cambodge*. Vol. V. Paris: École française d'Extrême-Orient, 1953.

Coedès 1964a
——. *Les Etats Hindouisés d'Indochine et d'Indonésie*. Paris: E. de Boccard, 1964.

Coedès 1964b
——. *Inscriptions du Cambodge*. Vol. VII. Paris: École française d'Extrême-Orient, 1964.

Coedès, Finot, and Goloubew 1929
Coedès, George, Louis Finot, and Victor Goloubew. *Le Temple d'Angkor Vat. Mémoires archéologiques de l'EFEO*, tome II, première partie: L'architecture du monument–II. Paris: G. Van Oest, 1929.

Cooler 1978
Cooler, Richard M. "Sculpture, Kingship, and the Triad of Phnom Da." *Artibus Asiae* 40, no. 1 (1978): 29–40.

Coomaraswamy 1927
Coomaraswamy, Ananda K. *History of Indian and Indonesian Art*. New York: Weyhe, 1927.

Coomaraswamy 1929
——. "A Royal Gesture and Some Other Motifs." In *Feestbundel, 150 Jarig Bestaan 1778–1928*, 57–61. Vol. I. Koninklijk Bataviaasch Genootschap van Kunsten en Wetenschappen. Weltevreden: Kolff, 1929.

Couture 1991
Couture, André. *L'enfance de Krishna: traduction des chapitres 30 à 78 (éd. cr.), y compris la traduction de passages figurant dans les notes ou dans l'apprendice*. Sainte-Foy, Québec: Presses de l'Université Laval, 1991.

Couture 2015
———. *Krishna in the Harivamsha*. New Delhi; DK Printworld, 2015.

Cuisinier 1928
Cuisinier, Jeanne. "Collections of Oriental Art in Belgium." *Indian Art and Letters*. New Series II, no. 2 (1928): 77–85.

Czuma 1974
Czuma, Stanislaw. "A Masterpiece of Early Cambodian Sculpture." *Bulletin of the Cleveland Museum of Art* 61, no. 4 (1974): 119–27.

Czuma 1979
———. "The Case of the Buried Fragments." *Bulletin of the Cleveland Museum of Art* 66, no. 7 (1979): 288–95.

Czuma 2000
———. "The Cleveland Museum's Kṛṣṇa Govardhana." *Ars Orientalis* 30, Suppl. 1 (2000): 127–35.

Dalet 1940
Dalet, Robert. "Chronique de l'année 1940: Cambodge." *Bulletin de l'Ecole française d'Extrême-Orient* 40, no. 2 (1940): 485–94.

De Coral-Rémusat 1936
De Coral-Rémusat, Gilberte. "L'activité Archéologique Dans L'Inde Extérieure." *Revue des Arts Asiatiques* 10, no. 4 (1936): 211–26.

De Havenon 2006
De Havenon, Michael. "The Earliest Viṣṇu Sculpture from Southeast Asia." *Journal of the Walters Art Museum* 64–65 (2006): 81–98.

Delaporte (1880) 1999
Delaporte, Louis. *Voyage au Cambodge*. Paris: Maisonneuve et Larose, 1999, First published 1880.

Delvert 1963
Delvert, Jean. "Recherches sur l'érosion des grès des monuments d'Angkor." *Bulletin de l'Ecole française d'Extrême-Orient* 51, no. 2 (1963): 453–534.

Dolias 2012
Dolias, Jacques. *Le Crocodile ou la Nâgî: l'ocean dans l'imaginaire cambodgien*. Paris: Les Indes Savantes, 2012.

Dottin 1972
Dottin, Olivier. *Carte Géologique de Reconnaissance 1/200,000, Phnom Penh*. Paris: Editions du Bureau de Recherches Géologiques et Minières, 1972.

Douglas, Carò, and Fischer 2008
Douglas, J. G., Federico Carò, and Christian Fischer. "Evidence of Sandstone Usage for Sculpture during the Khmer Empire in Cambodia through Petrographic Analysis." *UDAYA: Journal of Khmer Studies* 9 (2008): 1–16.

Dowling 1999
Dowling, Nancy. "A New Date for the Phnom Da Images and Its Implications for Early Cambodia." *Asian Perspectives* 38, no. 1 (Spring 1999): 51–61.

Dumoulin 2011
Dumoulin, Michel. *Les Stoclet microcosme d'ambitions et de passions*. Brussels: Le Cri, 2011.

Dupont 1955
Dupont, Pierre. *La Statuaire préangkorienne*. Suppl. XV. Ascona, Switzerland: Éditions Artibus Asiae, 1955.

Epinal and Gardere 2013
Epinal, Guillaume, and Jean-Daniel Gardere. "The Hoard of Angkor Borei, Discovery, Description and Interpretive Essay." Phnom Penh: National Bank of Cambodia, 2013.

Finot 1904
Finot, Louis. "Note d'épigraphie: XI. Les inscriptions de Mi-Son." *Bulletin de l'École française d'Extrême-Orient* 4 (1904): 897–977.

Finot 1925
———. "Inscriptions d'Angkor. IV: Mébon." *Bulletin de l'École française d'Extrême-Orient* 25 (1925): 309–52.

Fischer 1928
Fischer, Otto. *Die Kunst Indiens, Chinas und Japans*. Berlin: Im Propyläen-Verlag, 1928.

Francis, Gillet, and Schmid 2005
Francis, Emmanuel, Valérie Gillet, and Charlotte Schmid. "L'eau et le feu: chronique des etudes pallava." *Bulletin de l'École française d'Extrême-Orient* 92 (2005): 581–611.

Fromaget 1941
Fromaget, Jacques. "L'Indochine Française: sa structure géologique, ses roches, ses mines et leurs relations possibles avec la tectonique." *Bulletin du Service Géologique de l'Indochine* 26, fasc. 2 (1941): 1–133.

Gerschheimer and Goodall 2014
Gerschheimer, Gerdi, and Dominic Goodall. "Que cette demeure de Śrīpati dure sur terre. L'inscription préangkorienne K.1254 du musée d'Angkor Borei." *Bulletin de l'École française d'Extrême-Orient* 100 (2014): 113–46.

Goetz 1951
Goetz, Hermann. "The Earliest Representations of the Myth Cycle of Kṛṣṇa Govinda." *Journal of the Oriental Research Institute of Baroda* 1 (1951): 51–59.

Goloubew 1927
Goloubew, Victor. "Ananda K. Coomaraswamy: *History of Indian and Indonesian Art*." *Bulletin de l'École française d'Extrême-Orient* 27 (1927): 413–17.

Griffiths et al. 2012
Griffiths, Arlo, Amandine Lepoutre, William A. Southworth, and Thành Phân. *The Inscriptions of Campā at the Museum of Cham Sculpture in Đà Nẵng*. In collaboration with École française d'Extrême-Orient, Hanoi. Ho Chi Minh City: VNUHCM Publishing, 2012.

Groslier 1924
Groslier, George. *Arts and Archéologie Khmers* II. Paris: Société d'Éditions Géographiques, Maritimes et Coloniales, 1924.

Groslier 1925a
———. "Note sur la sculpture khmère ancienne." *Études Asiatiques* 1 (1925): 310–11.

Groslier 1925b
———. *La sculpture khmère ancienne*. Paris: G. Grès et Cie, 1925.

Groslier 1931
———. *Les collections khmères du Musée Albert Sarraut à Phnom Penh*. Paris: G. Van Oest, 1931.

Groslier 1973
Groslier, Bernard-Philippe. "Pour une géographie historique du Cambodge." *Cahiers d'Outre-Mer* 104 (1973): 337–79.

Guy 2014
Guy, John. *Lost Kingdoms: Hindu-Buddhist Sculpture of Early Southeast Asia*. Exh. cat. New York: Metropolitan Museum of Art, 2014.

Harle 1974
Harle, James Coffin. *Gupta Sculpture–Indian Sculpture of the Fourth to Sixth Centuries A.D.* Oxford: Clarendon Press, 1974.

Harris 2007
Harris, Peter. *Zhou Daguan: A Record of Cambodia; The Land and Its People.* Chiang Mai, Thailand: Silkworm Books, 2007.

Hawley 1979
Hawley, John Stratton. "Krishna's Cosmic Victories." *Journal of the American Academy of Religion,* 47, no. 2 (1979): 201–21.

Hawley 1983
———. *Krishna, the Butter Thief.* Princeton, NJ: Princeton University Press, 1983.

Higham 1989
Higham, Charles. "The Later Prehistory of Mainland Southeast Asia." *Journal of World Prehistory* 3 (1989): 235–82.

Hubbard 1991
Hubbard, Roberta. "Legacies of Ancient Kingdoms." *CWRU: The Magazine of Case Western Reserve University* (February 1991): 8–12.

Indrawooth 2009
Indrawooth, Phasook. "Un antique royaume urbanisé de Thaïlande." In *Dvāravatī, aux sources du bouddhisme en Thaïlande,* edited by Pierre Baptiste and Thierry Zéphir, 30–45. Exh. cat. Paris: Réunion des musées nationaux, 2009.

Ishizawa, Jacques, and Khin 2007
Ishizawa, Yoshiaki, Claude Jacques, and Sok Khin. *Manuel d'épigraphie du Cambodge.* Vol. 1. Paris: École Française d'Extrême-Orient, 2007.

Jessup and Zéphir 1997
Jessup, Helen I., and Thierry Zéphir, eds. *Angkor et dix siècles d'art khmer.* Exh. cat. Paris: Réunion des musées nationaux, 1997.

Kam 1945
KAM Doum. "Report on the Transfer of Buddha Statues and a Pedestal from Angkor Borei, Village of Prey Kabbas, Takeo Province." *Kampuchea Soriya* XVII (1945): no. 1, 1–14; no. 2, 70–93; no. 3, 137–55. (In Khmer)

Lavy 2014
Lavy, Paul. "Conch-on-Hip Images in Peninsular Thailand and Early Vaisnava Sculpture in Southeast Asia." In *Before Siam: Essays in Art and Archaeology,* edited by Nicolas Revire and Stephen A. Murphy, 152–73. Bangkok: River Books, 2014.

Lavy 2020
———. "Early Vaisnava Sculpture in Southeast Asia and the Question of Pallava Influence." In *Across the South of Asia: A Volume in Honor of Prof. Robert L. Brown,* edited by Robert DeCaroli and Paul A. Lavy, 213–49. New Delhi: D. K. Printworld, 2020.

Levetus 1914
Levetus, A. S. "Das Stoclethaus zu Brüssel." *Moderne Bauformen* XIII (1914): 1–34.

Lewitz 1967
Lewitz, Saveros. "La toponymie khmère." *Bulletin de l'Ecole française d'Extrême-Orient* 53, no. 2 (1967): 375–451.

Litt 2015
Litt, Steven. "Cambodia Returns Sculptural Fragment after 3-D Scans Show It Fits Cleveland Museum of Art's Krishna." *Cleveland.com,* October 30, 2015. https://www.cleveland.com /arts/2015/10/cambodia_returns_sculptural _fr.html.

Lorillard 2010–11
Lorillard, Michel. "Par-delà Vat Phu: Donées nouvelles sur l'expansion des espaces khmer et môn anciens au Laos." *Bulletin de l'Ecole française d'Extrême-Orient* 97/98 (2010–11): 205–70.

Lunet de Lajonquière 1902
Lunet de La jonquière, Étienne Edmond. *Inventaire descriptif des Monuments du Cambodge.* Series: Inventaire archeologique de l'Indo-Chine I. Publications de L'École française d'Extrême-Orient 4. Paris: Imprimerie Nationale, Ernest Leroux, 1902.

Mace 2018
Mace, Sonya Rhie. "Restorations and Reconstructions: Cambodian Art to and from Cleveland." *Arts of Asia* 48, no. 3 (2018): 57–67.

Malleret 1959–63
Malleret, Louis. *L'archéologie du delta du Mékong.* 4 vols. Paris: Publications de l'École française d'Extrême-Orient, 1959–63.

Mauger 1935
Mauger, Henri. "Chronique." *Bulletin de l'École française d'Extrême-Orient* 35, no. 2 (1935): 488–91.

Mauger 1935–36
———. "Conservation Cochinchine Cambodge." Unpublished reports. Paris: L'École française d'Extrême-Orient Archives, 1935–36.

Mauger 1936
———. "L'Àsram Mahà Rosei." *Bulletin de l'École française d'Extrême-Orient* 36, no. 1 (1936): 65–95.

Mauger 1937
———. "Le Phnom Bayang." *Bulletin de l'École française d'Extrême-Orient* 37 (1937): 239–62.

Maxwell 1990
Maxwell, T. S. *Viśvarūpa.* Oxford University South-Asian Studies Series. Bombay: Oxford University Press, 1990.

Narayanan 2015
Narayanan, Vasudha. "The Hero at Play: Depictions of the Govardhana-Līlā Story in Khmer Art." *Journal of Vaishnava Studies* 23, no. 2 (2015): 131–47.

Pal 1978
Pal, Pratapaditya. *The Ideal Image: The Gupta Sculptural Tradition and Its Influence.* Exh. cat. New York: Asia Society, 1978.

Paris 1932
Paris, Paul. "Anciens canaux reconnus sur photographies aériennes dans les provinces de Tà Kèv et de Châu-Dôc." *Bulletin de l'École française d'Extrême-Orient* 31 (1932): 221–24.

Parmentier 1913
Parmentier, Henri. "Complément à l'inventaire descriptif des monuments du Cambodge." *Bulletin de l'École française d'Extrême-Orient* 13, no. 1 (1913): 4–5.

Parmentier 1927
———. *L'art Khmèr primitif.* Publications de L'École française d'Extrême-Orient 21–22. Paris: Librairie Nationale d'Art et d'Histoire G. Vanoest, 1927.

Pelliot 1903
Pelliot, Paul. "Le Fou-Nan." *Bulletin de l'École française d'Extrême-Orient* 3 (1903): 248–303.

Pelliot 1951
———. *Mémoires sur les coutumes du Cambodge de Tcheou Ta-kouan.* Paris: Adrien-Maisonneuve, 1951.

Pettijohn, Potter, and Siever 1987
Pettijohn, Francis John, Paul Edwin Potter, and Raymond Siever. *Sand and Sandstone.* New York: Springer-Verlag, 1987.

Podany et al. 2001
Podany, Jerry, Kathleen M. Garland, William R. Freeman, and Joe Rogers. "Paraloid B-72 as a Structural Adhesive and as a Barrier within Structural Adhesive Bonds: Evaluations of Strength and Reversibility." *Journal of the American Institute for Conservation* 40, no. 1 (Spring 2001): 15–33.

Porte 2002
Porte, Bertrand. "La remise au jour du Bouddha de Vat Kompong Luong." *Arts Asiatiques* 52 (2002): 119–222.

Porte 2006
———. "La Statue de Krishna Govardhana du Phnom Penh du Musée National du Phnom Penh." *UDAYA: Journal of Khmer Studies* 7 (2006): 199–206.

Porte 2016
———. "Chroniques: Sculptures transformées du Phnom Da au Núi Ba Thê." *Arts Asiatiques* 71 (2016): 141–58.

Porte and Chea 2008
Porte, Bertrand, and CHEA Socheat. "Sur les chemins de Tuol Kuhea: note sur un site préangkorien." *UDAYA: Journal of Khmer Studies* 9 (2008): 151–68.

Ramayana de Valmiki 1999
Le Ramayana de Valmiki. Edited and translated by Madeleine Biardeau and Marie-Claude Porcher. Series Bibliothèque de la Pléiade. Paris: Gallimard, 1999.

Revire 2016a
Revire, Nicolas. "'L'habit ne fait pas le moine': note sur un Buddha préangkorien sis à Longvek (Cambodge) et accoutré en Neak Ta." *Arts Asiatiques* 71, no. 1 (January 2016): 159–66.

Revire 2016b
———. "Dvāravatī and Zhenla in the Seventh to Eighth Centuries: A Transregional Ritual Complex." *Journal of Southeast Asian Studies* 47, no. 3 (October 2016): 393–417.

Riccardelli et al. 2014
Riccardelli, Carolyn, Jack Soultanian, Michael Morris, Lawrence Becker, George Wheeler, and Ronald Street. "The Treatment of Tullio Lombardo's *Adam*: A New Approach to the Conservation of Monumental Marble Sculpture." *Metropolitan Museum Journal* 49 (December 2014): 49–116.

Roveda 2002
Roveda, Vittorio. *Sacred Angkor: The Carved Reliefs of Angkor Wat*. Bangkok: River Books, 2002.

Roveda 2005
———. *Images of the Gods: Khmer Mythology in Cambodia, Thailand and Laos*. Bangkok: River Books, 2005.

Rowland 1954
Rowland, Benjamin. *Art and Architecture of India*. London: Penguin, 1954.

Sanderson 2003
Sanderson, Alexis. "The Śaiva Religion among the Khmers (Part I)." *Bulletin de l'École française d'Extrême-Orient* 90–91 (2003): 349–462.

Schmid 2010
Schmid, Charlotte. *Le Don de voir: Premières representations krishnaïtes de la region de Mathurā*. Paris: L'École française d'Extrême-Orient, 2010.

Sivaramamurti and Narasimhaiah 2006
Sivaramamurti, Calambur, and Barkur Narasimhaiah. *Mahābalipuram*. New Delhi: Archaeological Survey of India, 2006.

Siyonn 2020
SIYONN Sophearith. "Indo-Khmer *śrāddha*: Assisting the Inauspicious Dead and the Worship of the Ancestors." In *Liber Amicorum. Mélanges réunis en hommage à Ang Chouléan*, edited by Grégory Mikaelian, SIYONN Sophearith, and Ashley Thompson, 35–64. Paris and Phnom Penh: Péninsule & Association des Amis de Yosothor, 2020.

Sotheby Mak van Waay B. V. 1920
Sotheby Mak van Waay B. V. "Collection Léonce Rosenberg, Paris, deuxième et dernière partie." June 1, 1920, Amsterdam, p. 34, lot 214.

Soutif 2009
Soutif, Dominique. "Organisation religieuse et profane du temple khmer du VIIe au XIIIe siècle, vol. I: Les biens du dieu." PhD diss., Université Sorbonne Nouvelle, Paris 2009.

Soutif and Ésteve forthcoming
Soutif, Dominique, and Julia Ésteve. "Texts and Objects: Exploiting the Literary Sources of Medieval Cambodia." In *The Angkorian World*, edited by Damian Evans, Miriam T. Stark, and Mitch Hendrickson. London: Routledge, forthcoming.

Spink 1990
Spink, Walter. *Ajanta: A Brief History and Guide*. Ann Arbor: Asian Art Archives, University of Michigan, 1990.

Srinivasan 1964
Srinivasan, K. R. *Cave Temples of the Pallavas*. New Delhi: Archaeological Survey of India, 1964.

Srinivasan 2008
Srinivasan, Doris Meth. "Saṁkarṣaṇa/Balarāma and the Mountain: A New Attribute." In *Religion and Art: New Issues in Indian Iconography and Iconology*, edited by Claudine Bautze-Picron, 93–104. London: British Association for South Asian Studies, British Academy, 2008.

Stark 2001
Stark, Miriam T. "Some Preliminary Results of the 1999–2000 Archaeological Field Investigations at Angkor Borei, Takeo Province." *UDAYA: Journal of Khmer Studies* 2 (2001): 19–35.

Stark 2003
———. "Angkor Borei and the Archaeology of Cambodia's Mekong Delta." In *Art and Archaeology of Fu Nan, Pre-Khmer Kingdom of the Lower Mekong Valley*, edited by James M. Khoo, 87–105. Bangkok: Orchid Press, 2003.

Stark et al. 1999
Stark, Miriam T., P. Bion Griffin, Chuch Phoeurn, Judy Ledgerwood, Michael Dega, Carol Mortland, Nancy Dowling, James M. Bayman, Bong Sovath, Tea Van, Chhan Chamroeun, and Kyle Latinis. "Results of the 1995–1996 Archaeological Field Investigations at Angkor Borei, Cambodia." *Asian Perspectives* 38, no. 1 (1999): 7–36.

Thun-Hohenstein, Murr, and Franz 2012
Thun-Hohenstein, Christoph, Beate Murr, and Rainald Franz. *Gustav Klimt: Erwartung und Erfüling; Entwürfe zum Mosaikfries im Palais Stoclet*. MAK Studies 21. Vienna: MAK, 2012.

Trinh 1996
Trinh Thi Hoà. "Réflexions sur les vestiges de la culture d'Oc Eo." *Etudes vietnamiennes* 50, no. 12 (1996): 111–23.

Vats 1930
Vats, M. S. "Sarnath Museum." In *Annual Report of the Archaeological Survey of India, 1926–27*, edited by Sir John Marshall, 218. Calcutta: Government of India, Central Publication Branch, 1930.

Vickery 1994
Vickery, Michael. "What and Where Was Zhenla?" In *Recherches nouvelles sur le Cambodge*, edited by François Bizot, 197–212. Paris: École française d'Extrême-Orient, 1994.

Vickery 1998
———. *Society, Economics, and Politics in Pre-Angkor Cambodia*. Tokyo: Centre for East Asian Cultural Studies for UNESCO, Toyo Bunko, 1998.

Vickery 2003
———. "Funan Reviewed: Deconstructing the Ancients." *Bulletin de l'École française d'Extrême-Orient* 90–91 (2003): 101–43.

Visser 1948
Visser, Herman Floris Eduard. *Asiatic Art in Private Collections of Holland and Belgium*. Amsterdam: De Spieghel, 1948.

Vo 1998
Vo Si Khai. "Plans architecturaux des anciens monuments du delta du Mékong du 1er au 10e siècles A.D." In *Southeast Asian Archaeology, 1994: Proceedings of the 5th International Conference of the European Association of Southeast Asian Archaeologists*, edited by Pierre-Yves Manguin, 207–14. Kingston upon Hull, UK: University of Hull Centre for Southeast Asian Studies, 1998.

Wilson 1961
Wilson, Horace Hayman. *The Vishnu Purana: A System of Hindu Mythology and Tradition*. Calcutta: Punthi Pustak, 1961. First published 1840.

Woodward 2014
Woodward, Hiram. "Stylistic Trends in Mainland Southeast Asia, 600–800." In *Lost Kingdoms: Hindu-Buddhist Sculpture of Early Southeast Asia*, edited by John Guy, 122–29. Exh. cat. New York: Metropolitan Museum of Art, 2014.

Workman 1977
Workman, D. R. "Geology of Laos, Cambodia, South Vietnam and the Eastern Part of Thailand." *Overseas Geology and Mineral Resources*. 50 (1977): 1–33.

Zaehner 1966
Zaehner, Robert C., ed. and trans. *Hindu Scriptures*. London: Dent, 1966.

Zaleski 2009
Zaleski, Valérie. "Les décors de stuc et de terre-cuite: témoins de la cosmologie bouddhique?" In *Dvāravatī, aux sources du bouddhisme en Thaïlande*, edited by Pierre Baptiste and Thierry Zéphir, 168–79. Exh. cat. Paris: Réunion des musées nationaux, 2009.

INDEX

Italic numbers represent images; plate numbers are in brackets.